So You've Been in an Accident...

Now What?

A Practical Guide to Understanding
Personal Injury Law

Daniel C. Cuppett, Attorney

D1378073

SILVER LAKE PUBLISHING

LOS ANGELES, CA ◆ ABERDEEN, WA

So, You've Been in an Accident...Now What?
A Practical Guide to Understanding Personal Injury Law

First edition, 2008
Copyright © 2006-2008 by Daniel C. Cuppett

Silver Lake Publishing
101 West Tenth Street
Aberdeen, WA 98520

For a list of other publications or for more information, please call 1.360.532.5758. Find our Web site at **www.silverlakepub.com**.

Library of Congress Catalogue Number: Pending

Cuppett, Daniel C.
So, You've Been in an Accident...Now What?
A Practical Guide to Understanding Personal Injury Law
Pages: 288

ISBN: 978-1-56343-795-3
Printed in the United States of America.

Contents

Acknowledgments

I would like to thank all of the people who encouraged me to write this book and helped me to assemble it into its final form. In particular, I thank my wife, Elizabeth Ackerman, M.D., for her unlimited encouragement; my friend Travis Fitzwater, Esq., of Morgantown, West Virginia, for brainstorming ideas with me and spending many hours editing the final draft; my parents, for encouraging me to become a lawyer and always having enormous faith in my abilities; Jacques R. Williams, Esq., of Hamstead Williams & Shook in Morgantown, West Virginia, for giving me my first job as a lawyer and being a great role model, as well as reading and offering helpful suggestions for this book; and Mark A. Schneider, Esq., of Plattsburgh, New York, for reading the final draft and making many helpful suggestions.

—Daniel C. Cuppett, Esq.

What to Do When You've Been in an Accident

Every day, thousands of Americans experience personal injuries. Whether from a car accident, a slip and fall on an icy sidewalk, a defective product or one of many other causes, people often do not know under what circumstances someone else may be at fault for their injuries. In addition, the legal system is complex and often frightening to a person with no legal training. (Frankly, it's *designed* to be this way.) Terms such as "torts," "guardian ad litem," "underinsured motorist coverage," "contributory negligence" and "subrogation" can be overwhelming to someone who, for the first time in his life, has to deal with the legal system.

> This book isn't meant to be a guide to handling a legal claim on your own. Rather, it is designed to help you choose a lawyer and then understand the complex process that the lawyer will guide you through. By doing this, you, as a client, will require less lengthy explanations from your attorney and will be better able to help your attorney by making fewer of the mistakes that clients often make.

Some people are not afraid of making a personal injury claim or bringing a lawsuit against someone else, but for others it is terrifying. Also, some people are hesitant because they think that other people will look disapprovingly at them, as if it is somehow "bad" to sue someone or bring a claim against them. The information about per-

sonal injury law that you'll learn from this book should help calm some of your fears; and, of course, it should also give you a better understanding of your legal rights.

It's not wrong to make a legal claim, when you have truly been wronged by another.

If you are hurt by the fault of another, you deserve to be fairly compensated for your medical bills, lost income and a reasonable amount of money for your pain and suffering. This is not greed, this is part of the American system of capitalism and the legal system that we have developed as a result of that capitalism. You should be no more ashamed of bringing a legitimate personal injury claim than a store is of selling a product at a reasonable price and making a profit.

> That said, frivolous lawsuits have become a problem in modern America. Those claims give the system a bad name and are the reason that so many people are embarrassed to bring legitimate claims.

This book is not intended to encourage people to lie or to bring frivolous claims. It's designed to help honest people, using licensed attorneys, to better understand and therefore maximize their participation in the personal injury legal system.

What You'll Find in the Pages Ahead

The book is divided into six easy-to-understand chapters and an Appendix of checklists, worksheets, sample documents and contact information. Together, these provide a groundwork of how to choose and hire a lawyer and an explanation of how personal injury claims and lawsuits work. This book will help you to better understand what your lawyer is doing and help you to help your lawyer. As I've already mentioned (and will repeat throughout this book), different states have somewhat different legal systems—so not all specific answers can be provided here. Nevertheless, the information in this book will help you to understand how the system works generally...and will provide some practical questions to ask your lawyer during your claim. It should help you understand and participate in your claim, thereby increasing your chances of receiving the best possible resolution.

How to Use This Book

This book generally follows the order in which most personal injury claims progress, beginning with advice on how to choose a lawyer and progressing through types of personal injury cases, insurance claims, filing a lawsuit and ultimately trial. Throughout the book, some concepts will tie together with other concepts and in those cases it is beneficial to refer to a different part of the book.

> You will notice that in some instances the term "attorney" is used and in others "lawyer" is used. I use these terms interchangeably. The reason that I use both terms is that you'll find both commonly used—and there's often no reasoning behind the use of one term rather than the other.

Some Words You Need To Know Right Away

The first important term to know is "tortfeasor." This is not a complicated term to understand—but few people other than lawyers have ever heard of it. A tortfeasor is simply someone who commits a tort against someone else.

A tort is breach of the law by one person against another person in the form of a wrongful act which causes an injury. Thus, a tortfeasor is someone who commits a wrongful act, whether intentionally or negligently, in violation of the law, which injures another. For example, if Joe negligently runs a stop sign and runs into another car, then Joe has committed a tort and is thus a tortfeasor.

Another term that will be important for following along in this book is "negligent" or "negligence." Basically, negligence means doing something careless. More technically, negligence is doing an act in breach of a duty imposed upon you by law with regard to your actions toward others. For example, everyone has a duty, imposed by law, to stop at stop signs. If someone breaches this duty by accidentally failing to stop at a stop sign, they have committed an act of negligence.

Although there are many specific duties provided in the law, the most common, general duty is that everyone has a duty to act toward others in a reasonably prudent manner. This term is explained in more detail in Chapter 1.

Finally, you will need to understand what "damages" are. Damages are those negative repercussions that you suffer as the result of an accident. Damages include monetary losses, often called economic damages, such as medical bills, lost wages, damages to property, and other losses which have an easily calculable monetary value.

Damages can also include nonmonetary effects of the accident, including such things as injuries, pain and suffering, emotional distress, and inability to function at pre-accident levels.

Therefore, when you're discussing a personal injury lawsuit, the losses and negative effects of an accident—taken as a whole—are referred to as the "damages" that someone suffered from an accident.

What to Do After an Accident

WHILE STILL AT THE SCENE

I am not a physician; so, I'm not qualified to tell you what to do after an accident with regard to injuries. However, if you are able to, and you have a mobile telephone, you should call 911 and ask for police assistance and—if needed—emergency medical personnel. Do not take any chances. If you have any question that someone may be injured, including yourself, request an ambulance.

> **From a strategic standpoint, if there is any indication that you might be injured, you should agree to be transported to the hospital by ambulance.**

There have been many occasions where my clients refused transport by ambulance because they were in shock or the pain had not fully set in yet at the time of the accident, even though it turned out that they had severe injuries. Later, during negotiations or at trial, the defendant's lawyer will inevitably claim that the plaintiff's injuries could not have been bad or that some event after the accident must have actually caused the injuries, otherwise the plaintiff would have accepted transport to the hospital by ambulance. Make no mistake, if you decline the ambulance, this will be used against you later—even if it's not fair for the other side to do so.

With regard to the legal, rather than medical, issues immediately following an accident, it is usually preferable not to move the vehicles

unless they pose a potential danger to other motorists because the placement of the vehicles after the accident might be crucial to determining who was at fault. In any event, when you call 911 explain the situation and ask whether you should move the cars. Also, it is a good idea to contact your local and state police and find out in advance what the regulations are regarding moving vehicles from travel lanes following an accident.

> **I recommend that everyone carry a camera in the glove box of their car. Even a disposable camera is sufficient (get one with a flash in case an accident happens at night). And it makes sense to have this camera, even if your cell phone or other devices have camera functions.**

If you are not too injured and are physically able, once the situation is stabilized and if the area is safe, and preferably before the cars are moved, take photographs from many angles showing the vehicles in relationship to each other, to the road, and to other landmarks. Also, photograph any skidmarks in relationship to the vehicles. In addition, make sure that you take close-up photos of the visible damage to your vehicle and the other vehicles involved.

Another thing that you will want to do if you are able is gather information. Even though the police officer will probably get most of the information that you will need and list it on the police accident report, there is certain information that you should get yourself in case the officer does not.

First, you will want the name and insurance information of the other drivers involved in the accident. It is also a good idea to write down their license plate numbers. In addition, get the names and contact information of any witnesses to the accident, as well as a summary of what they say they saw. Also, give the names of witnesses to the police so that they can get statements from them.

At some point, at the scene of the accident if conditions allow or later if injuries so require, the police officer will want to take your statement. When you tell the police officer what happened, tell the truth, but do not make assumptions and do not, under any circumstances, say that you were at fault (do not say this to anyone else either, including witnesses or other drivers and passengers involved in the accident).

Even if you think you were at fault, the evidence might show that you were not—and then you are stuck with the statement potentially being used against you later.

> Tell the officer what you saw and what you remember. Don't lie. But keep your statements limited to the facts of the accident. Don't talk about your feelings, opinions or emotions. Don't talk about fault or blame. There will be time to deal with those issues later.

Anything you say could end up in writing.

One other tip in this regard is that if the *other* driver said anything to you that was incriminating, such as telling you that they were sorry and it was all their fault, tell the police officer what they told you—it just might end up written in the accident report.

> If you do not accept treatment by paramedics, the officer will likely ask you, for purposes of the report, whether you are hurt. Do not take this question lightly.

If you have *any* pain or *any* symptoms of injuries, tell the officer about them. There is nothing worse than developing pain the day after the accident, finding out that you have a serious injury, and realizing that the police report indicates that you said you had "no pain" at the scene of the accident. The adjuster and defendant's lawyer will use this against you. So report any pain to the officer, and if you do not feel any pain, perhaps you should say you do not know yet because you feel shaken up. I am not suggesting that you lie or exaggerate your symptoms. However, I have had many clients who did not have any pain immediately after the accident, but developed it within a few hours to a couple of days after. So be mindful of what you say, realizing that any or all of it might end up in the accident report and will be used against you if possible.

In addition, where the accident appears to be the fault of the other driver or drivers, ask the police officer—respectfully, of course—whether he or she plans to issue a ticket to the other driver or drivers. The reason for this is that, when the other driver is cited by the police with

regard to the accident, the citation can give you some leverage in later negotiations.

> Some police officers do not issue citations when they see an accident as just a "typical" motor vehicle accident. Asking them whether they plan to issue a citation sometimes encourages them to do so when they otherwise might not. Don't argue with the officer about it, just ask politely.

AT THE EMERGENCY ROOM

I can't stress enough that anything you say to police, doctors, nurses, investigators, insurance adjusters and the like can end up in written form—and every word will be scrutinized by the insurance adjuster and defendant's attorney. You words will be used against you, if at all possible. So, you must be careful what you say in the emergency room.

> Anything that you say in the presence of a nurse or doctor—even if you are saying it to a member of your family—can potentially end up written in your medical records.

Obviously, you need to be honest and tell the doctors and nurses what happened to your body in the accident so that they can properly treat you. They may very well need to know the speeds that vehicles were traveling, what part of the car hit what and where, how your body was thrown about in the accident, whether any part of your body hit anything, and so on. However, there is absolutely no reason why you should be discussing who was at fault for the accident to or in the presence of the doctor, nurse or other medical personnel.

> Do not under any circumstances say in the presence of a doctor, nurse or other medical personnel that you plan to bring a lawsuit against another driver. If your medical records from right after the accident contain a note that you said you planned to sue another driver, you will look like a golddigger to a jury.

So, tell the truth. Be thorough and complete with the medical personnel; tell them every symptom you are having from the accident—no matter how insignificant it seems at the time. But do not talk about liability or lawsuits.

Finally, I want to mention that there have been *many* times when I ordered the emergency room records and showed them to my client only to have them gasp in horror to see that either the records include statements that my client says were never made, misinterpretations of what they said or failed to note significant useful things that the client did say.

For example, the records might not indicate that the client complained of lower back pain and the client will insist that he or she told the ER doctor about it. Or, the records will have a note along the lines of "prior back injuries" when the client actually said "no prior back injuries."

These mistakes or oversights are usually not intentional, they're simply limitations on the ability to communicate effectively in a busy emergency room. As such, before you leave, you should go over the notes with the doctor to make sure that all of your symptoms are noted, that none of the notes contain inaccurate representations of what you said, and that the writing is legible. It is much better to fix mistakes there at the emergency room before they become part of your records file—rather than months or even years later, when the doctor has little or no recollection of who you are or what you said. At that point, the doctor may insist that what he or she wrote is what you said, even if it isn't.

AFTER YOU LEAVE THE SCENE

If you did not go by ambulance to the emergency room and you have *any* pain or have any indication that you might have been injured, go to the hospital or your doctor on the day of the accident (keep in mind the tips above).

If you develop pain or indications of injury at any time in the hours or days after the accident, go to the hospital or doctor as soon as you have any such evidence of injury.

On the day of the accident, after you have received treatment or as soon as you otherwise have access to a telephone, you should contact your insurance company to report the accident. Also, if you have injuries or have legal questions regarding the accident, it is never too early to contact an attorney for advice regarding the accident.

> Another important thing that you should do, on the day of the accident or as soon thereafter as possible, is write down in detail everything that you remember about the accident from what was happening a few minutes before the accident, up to the time that the police arrived.

Write down as much detail as you can remember. How exactly did the accident happen? What exactly did you do to try to avoid the accident. Spare no detail from your writing as long as it is a detail that you are certain about. Your attorney will appreciate this later.

But do not tell anybody *except* your attorney that you made this written record.

If you did not get photographs of your car at the scene of the accident, take some photos of the damage as soon as possible. Also, if you have visible injuries, such as bruises, cuts, and the like, take photographs of them.

Check with your attorney to see if he or she also wants you to take photos of your injuries at various intervals as you heal.

> Also, begin an injury diary. Every day you should keep a journal describing pain you experienced, difficulties you had doing your normal activities—such as bathing or picking up your kids—and places or events that you were unable to attend because of your injuries, such as your planned vacation or your weekly bowling league.

Every time you go to the doctor, write down the name of the doctor, the date of the visit, a description of the tests or examination, what you told the doctor and what the doctor told you.

Again, this injury diary is for your attorney *only*. He or she will decide if anyone else should see it.

There is a form that you can use to create this diary (and numerous other forms, that I will discuss throughout this book) in the Appendices section starting at page 259.

So, You've Been in an Accident...

1 Common Types of Personal Injury

Automobile Accidents

The auto accident is the personal injury lawyer's bread and butter. I, for one, prefer this type of case to any other. As far as the law is concerned, there are variations throughout the states as to the law of auto accidents, but many of the core concepts are essentially the same. Here, I will outline the basic types of legal systems used by the states with regard to auto accidents.

> These laws can be broadly grouped into two categories, traditional tort liability law systems and various versions of "no-fault" systems.

Traditional tort liability law is still used by many states, although modifications seem to be increasing every year. Even in states with no-fault laws, if injuries are serious enough, the case may fall out of the no-fault system and back into a traditional tort liability law system. I realize this may be confusing, but it should make more sense as you read along.

Traditional tort liability is based upon fault. That is all well and good, but what does it mean. Simply put, it means that you cannot successfully sue another person for causing your injuries unless they were at fault for causing the injuries, at least to some degree.

How do you know if someone is at fault for an auto accident? Fault in personal injury cases (including auto accidents, as well as other types of personal injury cases) is based on either negligent or intentional acts. Someone is "at fault" only if the accident was caused by an act of negligence or an intentional wrongful act.

In the next several pages, we'll consider negligent acts—since car accidents are usually not intentional. Negligence is an action that breaches a duty toward others. Although there are many specific duties imposed on peoples' behavior, it is also generally required that people act in a reasonably prudent manner in their actions toward others. Thus, negligence in its most general form is the failure to act in a reasonably prudent manner toward others.

There are certain elements that must be met in order to prove a cause of action based on negligence and have a successful personal injury case. The elements of a negligence cause of action are: duty, breach, causation and damages. Let's look at each of these separately.

Duty

First, the person who injured you must have had some duty under the law to act or not act in a certain way. This duty can generally be based on one of two types of law—common law or statutory law. Let us begin with an explanation of common law.

> Some duties are created by courts through statements published in cases. This is called "case law." Judges issue written opinions which are published in books called "reporters" and later used again in future cases.

Essentially, this collection of case law makes up the "common law." There are many types of duties created by case law which are thus part of the "common law." For example, in most states the common law provides that people must use "reasonably prudent care under the circumstances" with regard to all of their behavior towards others. An example of this would be that everyone has a duty to use reasonable care to avoid bumping into others on a public staircase. If you don't use reasonable care and you bump into someone, you have violated that duty to use reasonable care.

The other type of law upon which duties can be based is statutory law. Statutory law is law based on statutes, which are laws enacted by legislatures, whether a state legislative body or the United States Congress. Statutes are then published, often in the form of a Code, such as "The Montana Code" or "The United States Code."

In most states, statutory laws can form the basis of a personal injury lawsuit if the duty outlined in the statute is breached. For example, a statute might require a person to have functioning headlights in order to drive a vehicle at night. If a person drives at night with no headlights, she has breached the duty provided in the statute; and, if this causes an accident, then there is a potential personal injury case based on this breach of duty. Of course, using headlights at night might be both a common law duty and a statutory duty.

Breach

The second element of a negligence claim is breach of duty. In order to have a successful personal injury lawsuit based upon negligence, the defendant must have had some duty toward you and he or she must also have breached or failed to follow, that duty.

> **For example, people generally have the duty to drive their vehicles in such a manner as to not run stop signs. If a person breaches this duty—by running a stop sign—and hits you, then you have the first two elements of a negligence claim: duty and breach.**

Fact or Myth: The Rear Driver Is Always at Fault

Going back as far as my teenage years, I have often heard people say that, when there is a rear-end collision, the driver in the rear is *always* at fault. With no exceptions. But is this true?

The best answer is that it is mostly, but not entirely, true.

In some states by statute and in some by case law, there is a presumption that the rear driver in a rear-end collision is at fault. That means that when there is a rear end collision, the law assumes that the rear driver is at fault—and that is usually a reasonable assumption.

However, the law will allow the rear driver the opportunity to overcome the assumption by trying to prove that because of some unusual or extenuating circumstance the rear driver is not at fault or at least not entirely at fault.

For example, the rear driver might argue that the collision is partly the fault of the front driver because the brake lights on the front driver's car were not working.

> **Also, there have been cases where it was proven that the front driver slammed on his or her brakes with the intention of trying to cause a rear-end collision. In those cases, the rear driver might not be at fault and the front driver might be charged with criminal violations as well.**

The point is that—although they are unusual—there *are* situations in which a rear-end collision could be the fault of the front driver; and the rear driver will have the opportunity to try to prove this. Also keep in mind that not every state's law makes the assumption that the rear driver is at fault. In that case, the plaintiff would have to prove fault in the traditional manner—although in a rear-end collision case that is usually not very difficult.

Causation

The third element of a negligence claim is causation. In order to recover damages for injuries caused by the negligence of another person, the breach of duty (the first two elements) must have been the cause of your injuries.

For example, if the defendant ran a stop sign and t-boned your car and you suffered whiplash because of the accident, then there is causation between the breached duty and your injury and you can recover damages for the whiplash. However, if you develop leg pain because you fell earlier in the day and the pain has nothing to do with the accident, then you cannot blame the car accident for the leg pain, as there is no causation—no connection between the breached duty and your injury.

It is important to note that not only must the defendant's behavior be the cause of the injury, it must also be the *proximate cause* of the injury.

> **Proximate cause is a complicated subject that even law students and some lawyers struggle to fully understand. It is enough for our purposes that you have a basic idea of what it means.**

Above, I gave some examples of where the breach of a duty clearly did or did not cause an injury. But sometimes causation is questionable. In other words, the actions of another may have played a part in the injury but there is not a crystal clear link. For example, imagine that your car is rear ended but you are not injured. Then, just as the accident appears to be over, a big truck hits your car and injures you.

Is the first driver's negligence the proximate cause of your injuries? The truck? Both? In other words, is there a close enough connection to warrant liability? This is essentially asking whether there was proximate cause, it is one of the questions that the jury must answer.

> **The elements of a negligence claim presented above are the elements of a claim for any type of negligence tort, not just auto accidents. Thus, the same elements would apply to prove negligence in a slip and fall case or a product liability case...and so on.**

Damages

The next element of a negligence claim is damages. This one is simple. You must have suffered damages of some sort in order to have a cause of action. In other words, if you have no personal injuries or property damage, you have no lawsuit. Damages include monetary losses, often called economic damages, such as medical bills, lost wages, damages to property and other losses which have an easy calculable monetary value.

> **Damages can also include nonmonetary effects of the accident—including such things as injuries, pain and suffering, emotional distress and inability to perform activities at pre-accident levels.**

So, You've Been in an Accident...

As you might have guessed, the most important elements of a personal injury lawsuit based on an auto accident are breach of duty and damages. If you are confident that you can convince a jury that the defendant breached a duty which caused you damages, you and your attorney must next consider what kinds of damages you can claim in order to determine if it will be worth spending the legal fees and costs necessary to sue. In other words, if your only damage from an accident is a bruise on your arm that had little pain and got better in a few days, a jury is not likely to give you much money, if any.

On the other hand, the expenses of bringing suit, including filing fees, deposition fees and other such costs can be hundreds or thousands of dollars. So, an attorney will not want to sue someone on your behalf if in the end you and the attorney will ultimately lose money rather than make money.

In order to be worthwhile, it has to be reasonable to believe that a jury would give enough money so that after you pay your attorney fees (usually one third) plus the costs of brining the action, you have enough left over for you to have made it worthwhile to sue.

No-Fault Systems

Traditionally, personal injury lawsuits centered around the question of who was at fault for an accident. Some states have modified this system in some circumstances so that liability becomes more about insurance and less about fault. To give you an idea of a no-fault system in extreme form, consider the system in Quebec, Canada. (Granted, Quebec is not in the United States; but its system is an extreme example of a no-fault system and will help you to understand the lesser versions used in the U.S.)

In Quebec, there are no lawsuits for personal injuries caused by car accidents. None. First, in Quebec—as in all of Canada—there is universal healthcare. All citizens are covered by the government healthcare system. So, when there is an auto accident, there are no medical bills to worry about.

In addition, if someone cannot work because of their injuries, there are government programs to help with lost wages. Finally, everyone gets paid, by the Quebec government, for pain and suffering that they experience as a result of the accident. Furthermore, *everyone* involved in the accident gets all of these benefits. It does not matter at all who was at fault for the accident.

This is a true no-fault system because fault is not even considered.

In the U.S., some states have begun to implement watered down versions of this type of system. What these systems usually do is categorize personal injuries from car accidents by levels of severity. If the injuries are below a certain level of severity, then each person's own insurance pays for their medical bills and lost wages and usually there is no payment at all for pain and suffering.

However, if the injuries go over a threshold level of severity, then the traditional fault system kicks in and a lawsuit can be filed for additional medical bills and pain and suffering that exceed the threshold.

To help this make more sense, I will use the New York no fault system as an example. In New York, every motorist is required to purchase $50,000 in no-fault insurance coverage, called Personal Injury Protection or PIP. This coverage will pay for the owner's medical bills and lost wages (and those of their passengers or someone driving their car with permission) up to $50,000 when caused by an accident. As such, you can never collect the first $50,000 of medical bills and lost wages from the at-fault party to an accident in a lawsuit. In addition, you may only sue an at-fault party to an accident if you sustained what New York calls a "serious injury."

"Serious injury" means a personal injury which results in:

- death;
- dismemberment;
- significant disfigurement;
- a fracture;
- loss of a fetus;
- permanent loss of use of a body organ, function or system;
- permanent consequential limitation of use of a body organ or member;
- significant limitation of use of a body function or system; or
- a medically determined injury or impairment of a non-permanent nature which prevents the injured person from performing substantially all of the material acts which constitute such person's usual and customary daily activities for not less than ninety days during the one hundred eighty days immediately following the occurrence of the injury or impairment.

(§ 5102 New York Consolidated Statutes).

In New York, if you sustain a serious injury—such as a ruptured disk in your back or a broken leg—you can sue the person at fault; but the first $50,000 in medical bills and lost wages given by the jury will be deducted from the total verdict amount by the judge because those expenses were paid or will be paid by your own insurance.

> **So, if your medical bills and lost wages are less than $50,000 but you have a serious injury, you can only get damages for pain and suffering.**

The levels of injuries required in order to go beyond the no-fault system and into the traditional fault system vary in those jurisdictions which have no-fault systems. The threshold may be based on an amount of medical bills, the severity of injury or a combination of the two, like in the New York example above. Generally, contrary to traditional fault based systems, in no-fault systems, the insurance company that pays the no-fault benefits is usually not entitled to subrogation for the amounts it paid.

There is one additional wrinkle that has popped up on the no-fault landscape. Pennsylvania has instituted a system wherein a consumer in that state has the option of purchasing one of two different types of automobile insurance policy. First, the consumer may purchase a traditional tort policy. In that situation, if they are in an accident, the traditional tort system will apply to any claim that they might make against another driver. Second, the consumer may purchase a no-fault policy.

> **No-fault policies are less expensive than traditional polices. However, in Pennsylvania, if the consumer who purchases a no-fault policy is in an accident he cannot make a claim against another driver. Instead, he can only make a claim for no-fault benefits from his own policy.**

Just so this is clear, the distinction applies only with regard to what claims one can make if the other driver is at fault for the accident. If you are at fault for the accident, your policy will pay for *your*

liability if the people you injure have a traditional tort policy. Conversely, if they have no-fault policies, *their* policies—not yours—will pay them.

Workers' Compensation

One common type of no-fault systems in the United States are workers' compensation systems. Workers' compensation systems are a form of no-fault insurance set up by state governments and imposed upon employers and employees. If an employee is hurt while "on the job," his or her medical bills and lost wages will be paid by the workers compensation system.

Because workers' compensation is a no-fault system, an injured employee gets paid whether the injury was caused by the negligence of the employer, a third party or the employee himself. The employee need only show that he or she was injured while on the job or developed a disease because of their job.

On the other hand, the employee does not have the option of suing the employer even if the injury or disease is the result of negligence on the part of the employer. The employer is "immune" from lawsuit. The only remedy available to an injured employee is the workers' compensation system.

> **However, in some states, there are a few occasions when an injured worker is not limited to the workers compensation system and can sue an employer for negligence.**

First, in many places an employer can be sued if the employer failed to pay the required premiums or fees to the workers' compensation system. This does not necessarily mean that the employee cannot use the workers' compensation system; it just means the employer does not benefit from immunity from being sued.

Also, in some states, an injured employee is not limited to the workers' compensation system if the employer intentionally hurts him or if the employer's conduct reaches a particularly high level of recklessness.

> Finally, workers' compensation systems only protect employers (and fellow employees) from being sued for their negligence. If an employee is injured on the job by a third party, not related to the employment, that third party can be sued.

For example, if an employee is at work and is negligently hit by a delivery truck—and the delivery company is not affiliated with the employee's employer—the injured employee can sue the delivery company for his or her injuries.

Because the employee was at work, he or she could collect workers' compensation benefits *and* sue the delivery company, although the workers' compensation system may have to be paid back if damages are collected from the delivery company.

Workers' compensation systems are frequently complicated and difficult to navigate. Because of that, if you have difficulty with your claim, you should have an attorney represent you in your claim. Also, it's a good idea to consult an attorney about whether there is anyone who is *not* protected by workers' compensation immunity that might be liable to you for your injuries.

Property Damage in Auto Accidents

Property damage is not in and of itself a personal injury. However, I believe that no introduction to the law of auto accidents would be complete without a summary of issues involving property damages to your car.

> Many people do not know their rights with regard to damages to their car. Remember that different states have different rules, so you should look into the particular rules in your state governing property damage in order to know what will apply to you.

I'll go over the different categories of damages that you should know about and mention some particular areas of interest within each category.

The types of damages that you can claim when your car is damaged often vary, depending on whether the accident was your fault or someone else's.

In general, when the accident is *your* fault, you can recover whatever damages your own insurance policy provides and based on what coverages you have paid for. Keep in mind that your state's law may have certain things that your insurer must cover if you have purchased coverage.

When the damage is the fault of the *other driver*, you are typically entitled to recover damages from him or her in several categories. First, and most obvious, you are entitled to have your car fixed or—if it is not cost effective to fix the car—the insurance company may elect to "total" the car and simply pay you for its value.

In some states, if the estimate to repair the car exceeds a certain percentage of the "book" or market value of the car, then the car *must* be totaled.

For example, the law might provide that if the cost to repair a damaged vehicle exceeds 80 percent of the value of the car, then the insurance company must declare the vehicle totaled. In that example, if a car is worth $10,000 and the cost to repair the vehicle is more than $8,000, the car has to be declared totaled.

Another issue that you may want to pay particular attention to if the insurer elects to repair the vehicle is the use of aftermarket or used repair parts. Aftermarket parts are parts manufactured by companies other than the manufacturer of your car. Used parts typically come from the non-damaged portions of otherwise totaled and "junked" cars which are sold off for parts.

Insurance companies can save a lot of money by purchasing aftermarket or used repair parts rather than new parts from the car's original manufacturer. These cheaper parts may or may not be as good as new original manufacturer's repair parts. Your state's law might allow the insurance company to repair your vehicle with used parts, especially if your car is older.

However, some states require that new parts—made by the vehicle's manufacturer—be used under certain circumstances, such as when the vehicle is within a certain number of years old and/or under a certain mileage.

> Check your state's laws to see when or if the insurance company is entitled to use cheaper parts before you accept such repairs.

If the insurance adjuster declares your vehicle a "total" loss, then the adjuster must pay you the value of the vehicle, as provided by law. In many states, insurance companies must pay you the value as determined by some government approved used car valuing guide, such as the NADA (National Automobile Dealers Association) guide, and they often must pay retail.

> In addition, the insurance company often must pay you an additional percentage of the value of the car to cover sales or use tax, plus any other typical government motor vehicle type fees.

Another category of damages that you may be entitled to in some states and that often insurance companies fail to point out to you if you do not know about it is "diminution in value" damages. This type of damage applies when another party is at fault and your vehicle is repaired rather than declared a total loss.

The concept of diminution in value damages is relatively simple. You have most likely had the experience of trading in a car at the dealership and had the salesperson ask you whether your car has ever been wrecked. They ask you this because if the vehicle has ever been wrecked, even if it was properly repaired, its value is reduced, especially if there were repairs to the frame. Thus, they will give you less money for your trade-in than if it had never been wrecked. Since this is a loss that was the fault of the other driver, you are entitled to make a claim at the time of settlement with the wrongdoer's insurance company for this lowered vehicle value, called diminution in value.

> A common way to prove the amount of diminution in value is to get a letter from the trade-in appraiser at a car dealership indicating how much less the vehicle is worth because it had been previously damaged.

Finally, a property damage claim would also include any damages to items within the car. For example, suppose the car is rear-ended and that destroys a guitar in the trunk. The property damage claim would include the value of the guitar.

Also be careful to make sure that you are properly paid for the value of expensive aftermarket additions to your car, such as custom wheels or an expensive stereo added by you after the car was initially purchased. The "book" value applies to the originally equipped car including its original factory or dealer added options. You may not be entitled to additional payment for tires that happened to have been recently purchased because tires are a usual part of the car and the "book" value usually assumes the car has tires of reasonably new condition.

On the other hand, if you put new rims on the car, which are much more valuable than the car's original rims, you may be entitled to additional money (or you could keep the new rims and put the old rims back on).

If You Are "Upside Down" on a Car Loan

There is another issue that often comes up in situations in which a vehicle is totaled. Many people purchase their vehicles with loans; sometimes cars lose their value faster than the loan gets paid off, especially in the first two years of the loan. As a result, sometimes the amount that an insurance company has to pay for a totaled vehicle is less than the remaining balance on the loan.

For example, suppose someone still owes $10,000 on her car, but the value of the car is only $8,000. The insurance company has to pay the value of the car—not the amount left on the loan. This person therefore has a deficit of $2,000 which her bank or lender will probably want to collect immediately.

So, this person may be in an accident in which the other person is completely at fault and yet, despite her innocence, owe more than the insurance settlement and have no easy means of getting out of the debt. One way to avoid this is to purchase gap insurance. Gap insurance is a type of insurance that is often offered in conjunction with an auto loan. If the car is totaled and the remaining balance of the loan is more than the value of the car, the gap insurance will pay the bank the difference—so that, at the very least, you break even.

> If you make a significant down payment, so that it's unlikely the loan balance will ever be more than the value of the car, then gap insurance would be a waste of money. But, if you're financing heavily, you should consider gap insurance. Your lender may insist that you carry the coverage.

Slips, Trips, Falls and Other Premises Liabilities

Many people think that if they fall and get hurt, they automatically have a good case against the owner of the property on which they fell. However, things are not quite that simple.

As we have already learned, liability is generally based upon fault (negligence in these cases) and no-fault systems do not usually apply to premise liabilities—only car accidents.

> In order to have a claim against a landowner (or renter, in some cases) for your slip and fall, you must show that the other party is somehow at fault for your fall. In other words, you must show that the actions or inactions of the property owner somehow were negligent and caused you to fall. You cannot sue someone else for your own carelessness.

Personally, I rarely take slip and fall cases because of what I call the 50/50 factor. When presenting a slip and fall case to a jury, the jury has to decide what percentage the plaintiff is at fault and what percentage the landowner is at fault. Often, a jury is likely to find that the landowner is half to blame and the injured person is half to blame; and in many states with comparative fault systems a 50 percent fault on the part of the plaintiff means that the plaintiff gets nothing. (Of course, if *your* state allows the injured person to recover damages even if he or she is greater than 50 percent at fault, it is more likely that it might be a worthwhile case.)

When are slip and fall cases more likely to win? Falls because of clear construction defects seem to have the best chance of winning in my opinion. Falls on slippery surfaces, such as on ice or spills, can vary. For example, during a snow storm it might not be negligent for a shopowner to be unable to keep up with clearing the snow; but,

many hours after the snow has stopped, there's more chance that the shopowner is at fault.

Also, in many states, private landowners have less of a duty than store owners to clear snow or other slippery surfaces.

Spills in stores that cause a fall may only be good cases if the spill has been there awhile...and you can prove that it has been there quite awhile.

> In other words, a landowner or shopowner has to know about or reasonably have had time to discover a spill before they have a duty to clean it up. The shopowner cannot be expected to know the moment a customer spills a bottle of laundry detergent.

But a shopowner must make reasonable efforts to discover spills within a reasonable amount of time. Such efforts might include training employees to check the aisles at certain intervals.

Dog Bites

Liability of dog owners for their dogs biting people generally falls along one of two types of legal theories.

First, an injured person might sue the dog's owner on a theory that the owner was negligent in allowing the dog to be in a situation to bite the injured person. In that case, the injured person will have to prove the elements of negligence, including duty, breach, causation and damages.

Second, in some states—and under certain circumstances—a dog owner might be "strictly liable" for bites inflicted by their dogs.

> The details of strict liability can be fairly complicated, but the basic idea is that when a defendant is strictly liable for a dog bite, it means that the defendant is liable for the bite regardless of whether the defendant committed any acts of negligence.

In other words, if the bite happened, the owner is liable. The injured person need not prove negligence; he only has to prove that

the dog bit him, it was the defendant's dog and that he (the injured person) was injured.

Again, strict liability is not available in every state and certain circumstances may be necessary in order to apply strict liability, such as knowledge that the dog has been violent in the past or that the dog is listed on a dangerous breed list.

Regardless of the theory of the case, several factors will play into whether an injured person will be successful in a lawsuit involving a dog bite. Such factors may include whether the injured person was trespassing on the dog owner's property; whether the injured person was taunting the dog in some way; the severity of the bite; and whether the dog has a history of being aggressive and whether the dog is of a breed that is considered to be dangerous.

> I'm not making a judgment as to whether any particular breed of dog is predisposed to being dangerous or vicious. However, the law in your state might recognize certain dog breeds as being particularly dangerous and an injured person might, in some states, be able to use this against you if the dog in question is on one of these lists.

If you're bitten by a dog, you should be aware that many insurance companies will not cover an owner's liability for dog bites inflicted by dogs of certain breeds—which the company will typically list in their policy as being excluded. Some of the breeds commonly listed include pit bulls, rottweilers, chows, dobermans, German shepherds and akitas.

If the dog owner's insurance does not cover your dog bite, your only option will be to try to go after the owner's personal assets. In the end, you may be out of luck in that situation.

Here is a sample of Colorado statute regarding dog bite liability:

(1) As used in this section, unless the context otherwise requires:

(a) "Bodily injury" means any physical injury that results in severe bruising, muscle tears or skin lacerations requiring professional medical treatment or any physical injury that requires corrective or cosmetic surgery.

(b) "Dog" means any domesticated animal related to the fox, wolf, coyote or jackal.

(c) "Dog owner" means a person, firm, corporation or organiza-

tion owning, possessing, harboring, keeping, having financial or property interest in or having control or custody of, a dog.

(d) "Serious bodily injury" has the same meaning as set forth in section 18-1-901 (3) (p), C.R.S.

(2) A person or a personal representative of a person who suffers serious bodily injury or death from being bitten by a dog while lawfully on public or private property shall be entitled to bring a civil action to recover economic damages against the dog owner regardless of the viciousness or dangerous propensities of the dog or the dog owner's knowledge or lack of knowledge of the dog's viciousness or dangerous propensities.

(3) In any case described in subsection (2) of this section in which it is alleged and proved that the dog owner had knowledge or notice of the dog's viciousness or dangerous propensities, the court, upon a motion made by the victim or the personal representative of the victim, may enter an order that the dog be euthanized by a licensed veterinarian or licensed shelter at the expense of the dog owner.

(4) For purposes of this section, a person shall be deemed to be lawfully on public or private property if he or she is in the performance of a duty imposed upon him or her by local, state or federal laws or regulations or if he or she is on property upon express or implied invitation of the owner of the property or is on his or her own property.

(5) A dog owner shall not be liable to a person who suffers bodily injury, serious bodily injury or death from being bitten by the dog:

(a) While the person is unlawfully on public or private property;

(b) While the person is on property of the dog owner and the property is clearly and conspicuously marked with one or more posted signs stating "no trespassing" or "beware of dog";

(c) While the dog is being used by a peace officer or military personnel in the performance of peace officer or military personnel duties;

(d) As a result of the person knowingly provoking the dog;

(e) If the person is a veterinary health care worker, dog groomer, humane agency staff person, professional dog handler, trainer or dog show judge acting in the performance of his or her respective duties; or

(f) While the dog is working as a hunting dog, herding dog, farm or ranch dog or predator control dog on the property of or under the control of the dog's owner.

(6) Nothing in this section shall be construed to:
(a) Affect any other cause of action predicated on other negligence, intentional tort, outrageous conduct or other theories;
(b) Affect the provisions of any other criminal or civil statute governing the regulation of dogs; or
(c) Abrogate any provision of the "Colorado Governmental Immunity Act", article 10 of title 24, C.R.S.

Inadequate Security

Sometimes a defendant can be liable for injuries incurred by a plaintiff as the result of inadequate security. Some common examples include plaintiffs being attacked by criminals in parking lots of stores, parking garages, bars, night clubs and common areas (stairways, hallways, courtyards) of apartment buildings.

> **Cases of this type commonly rely on a theory that the area where the plaintiff was attacked was an area known for criminal activity and as such the landowner had a duty to take steps to prevent people from being attacked in those areas.**

Some typical claims made by plaintiffs are that the defendant failed to provide adequate lighting, fencing, doors, locks or even security guards. If the plaintiff can prove that under the circumstances the defendant had a duty to take such steps and did not, then the plaintiff might be successful.

Falling Items

Shopowners can often be liable for injuries to patrons caused by items falling from shelves. Assuming the patron did not pull the item down on top of them, it should be pretty easy to prove negligence. Presumably items do not ordinarily fall off shelves if properly placed.

Swimming Pools

Swimming pool owners are often the subject of lawsuits for injuries or deaths caused by people falling in the water. Typical negligence theories include that the area around the pool was unreasonably slip-

pery or that there was not adequate fencing around the pool to keep children and others away from the pool. Another type of liability, especially for commercial pool owners such as at hotels or public pools, involves claims of inadequate supervision by lifeguards which leads to patrons in the pool being injured or drowning.

Injuries from Defective Products

A great many of the class action lawsuits that you hear about on the news result from injuries caused by defective products. There are many different types of cases that fall into this category.

> **Some of the more common types of defective product cases involve injuries caused by the following situations: when a machine breaks during use; failure to include safety features on a product which could have prevented injuries (such as a guard on a lawn mower); food poisoning; injuries caused by inadequately tested or abnormally dangerous medications; and defects in cars.**

The actual law of product liability is quite complicated, even for law students. As such, I will summarize the basic ideas, but do not be concerned if you do not fully understand. Product liability law can be generally broken down into two types: negligence and warranty/strict liability. In many cases, a lawsuit will allege both of these types against the defendant, as more than one may apply. Let's look at each type individually.

Product Liability/Negligence

We have already learned that most personal injury lawsuits are based on negligence and what the elements required to prove a negligence claim are. In a product liability case, you are simply claiming that the manufacturer or distributor of a product committed some act of negligence that led to the defect and therefore the injury. You must show a duty and a breach of the duty. For example, suppose that a manufacturer of a power saw negligently fails to tighten a bolt on a saw. The duty was to tighten the bolt, the breach was in not tightening the bolt.

When the ultimate customer uses the saw, the blade comes loose and injures him—hence causation and injury. The customer can sue the manufacturer for negligently causing the injury by not tightening the bolt.

As you will see as you read further, unlike in warranty/strict liability type cases, in a negligence type product liability case, you can only sue whoever was negligent. Thus, in our saw case, if the store that sold the saw did not do anything negligent with regard to the saw, then the injured customer could not sue the store for negligence, he or she could only sue the manufacturer.

Product Liability/Warranty and Strict Liability

Generally, when you buy a product, everyone in the "chain of distribution" of the product legally warrants, whether they intend to or not, that the product is reasonably safe.

The "chain of distribution" includes the manufacturer, distributors and stores where you bought the product (assuming that it is a store that commonly sells those products, as opposed to a seller of used goods, a flea market or the like). If you are injured by a defective product, you can potentially sue all of these entities. Furthermore, you do not have to prove negligence, it is enough that the product was defective.

However, you do have to prove that the injury was caused by a defect in the product. In other words, if you misused the product, by using it in a way that was not intended by the manufacturer or you damaged the product, you cannot sue. The product has to have something wrong either with its design or have a part that breaks because it was not manufactured properly or something of that sort.

For example, suppose you try to tow a 5,000 pound boat using your car that is designed and clearly marked as being able to tow only 1,000 pounds. If a wheel falls off because of the excess weight and you are injured, that is misuse of the car and you cannot sue.

However, suppose you are driving your car and the wheel falls off because the axle holding the wheel on had a crack in it from the manufacturing process. If you are injured, then you can sue under a warranty/strict liability type of action.

There are actually some differences between warranty and strict liability legal theories—and some states may not allow personal injury cases on a warranty theory. However, strict liability and warranty claims are similar enough that the end result is usually the same.

The key is, you do not have to prove negligence. Here, the law favors the consumer.

Class Actions Lawsuits

Most people know generally what class action lawsuits are, but few know the technical details of how they work. Because class action lawsuits can be very complicated, I will not attempt a detailed explanation but will try to give a general understanding.

Sometimes a large number of people are harmed by the same act of negligence of some entity, commonly a large company.

For example, these situations frequently involve injuries caused to large numbers of people by a defective product. Imagine that a food manufacturer negligently sells food that is tainted by some sort of bacteria or toxin and hundreds or thousands of people get sick. This is an example of the type of case that can support a class action lawsuit.

Here is how it works. An attorney will be contacted by a client who was injured by the tainted food. The lawyer is then contacted by a couple of others who were also injured by the same food. The lawyer then discovers that hundreds of people in his or her state were injured by the same food and decides to file a class action lawsuit.

To do this, he or she will file a complaint with the named plaintiffs being the clients who had come to him. These plaintiffs will be called the "class representatives" because they will represent all of the injured people as the only ones with their names actually on the pleadings. Then, the lawyer must ask the judge to "certify the class." This means that the judge must consider whether it is in the best interests of everyone involved to allow the case to proceed as a class action.

> The factors that judges consider in deciding whether to certify a matter as a class action vary by jurisdiction but typically include such factors as: whether it would be possible or practical to name all of the injured persons separately; whether there is a close enough connection between each person's injuries and the cause of the injuries; whether the defenses used by the defendant are likely to be the same with regard to all those injured; and whether the named plaintiffs, the class representatives, can fairly and competently represent the interests of all members of the class.

If the judge certifies the case as a class action, the lawyer will then be required to contact everyone who is a potential member of the class. In some cases, a list can be compiled of everyone who could possibly have a claim—such as when the case involves a defect in a car, because all cars have to be titled.

In other cases, such as our food poisoning case, it is probably impossible to compile a list of everyone who was sickened by the food. So, the judge will require the lawyer to take other means of contacting the people who were injured. This might include publication in newspapers, magazines, television and radio advertisements or other means.

The lawyer will be required to inform those people who are potential class members—those who were injured by the tainted food—that a class action lawsuit has been filed and that each injured person has the right to participate in the class action or else take steps to "opt out" of the class. If they opt out of the class, they have the opportunity to bring a separate lawsuit on their own, for their injuries only.

> If someone fits into the class and does not opt out, she will be bound by the terms of whatever settlement or verdict is received by the class as a whole.

During the class action litigation, the named plaintiffs will make all the decisions typically made by clients about litigation which affect all members of the class and they have an obligation to act in the best interests of the class. However, in order to settle the case, the judge has to approve the settlement by determining whether it is fair and reasonable to the class members as a whole. That way, the named plain-

tiffs and lawyers cannot take advantage of the class members for their own personal benefit.

One thing that often confuses non-lawyers is the difference between a class action lawsuit and a multiple plaintiff lawsuit. If a lawsuit is filed with one hundred plaintiffs, the suit covers only those one hundred plaintiffs—and all one hundred plaintiffs are named—then it is *not* a class action.

Many people think that just because there are many plaintiffs to a lawsuit who were all injured by the same cause, that it is a class action lawsuit. This is not so. A lawsuit is only a class action when the actual lawsuit does not list the names of all of the plaintiffs but instead lists some plaintiffs by name as representatives of a class of persons similarly injured. If everyone's name is listed in the lawsuit individually, it is not a class action even if there are a thousand plaintiffs. That is simply a multi plaintiff lawsuit.

Class action lawsuits can be very useful in our society. Sometimes many people are harmed by the actions of a big company, but their injuries are too small to justify the costs for each of them to bring their own lawsuit. Without class action lawsuits, companies would get the message that they can harm people without recourse, as long as the harm is too small to make it worthwhile for plaintiffs to sue individually. In that situation, class action lawsuits step in and allow many claims to be combined into one big lawsuit that is economically worthwhile to bring.

Medical Malpractice

I mention medical malpractice only briefly because medical malpractice—although a type of personal injury—is so complicated that it would require its own book to explain completely.

Also, there are major differences in medical malpractice laws among the states.

Medical malpractice is, in its most simple form, negligence committed by a medical professional in the course of medical treatment. This can be a doctor, nurse, psychiatrist, psychologist or just about any other type of health care provider. In a medical malpractice action, the plaintiff sues a medical professional for injuries which were caused by the negligence of the medical professional during medical treatment.

As you might be aware, there is a lot of controversy in many states over medical malpractice. Doctors often complain that they have to pay too much for medical malpractice insurance. Insurance companies complain that there are too many lawsuits and that juries give too much money and that greedy lawyers file frivolous cases.

> As with any issue, there are many sides to the story and the situation is not as simple as the insurance companies or the doctors or the lawyers would like you to believe.

There are many complex factors which control the costs of malpractice insurance. Also, there are some bad lawyers who file bad cases. But for the most part, medical malpractice actions are legitimately filed by injured people who deserve reasonable compensation for their injuries.

Medical malpractice cases require the use of expensive experts. It is not unusual for the costs of a medical malpractice case to reach $20,000 to $100,000 or more. Because of this, to suggest that lawyers commonly file frivolous medical malpractice cases knowing that they will have to risk large amounts of money in costs does not make a much sense as some talking heads believe.

Intentional Injuries

Intentional torts are torts that are not caused by negligence. They are not accidents. Unlike negligence torts, where the perpetrator does not intend to cause personal injuries, with intentional torts the perpetrator *does* intend to cause personal injuries.

> The most common types of intentional torts causing personal injuries are assault, battery and intentional infliction of emotional distress.

Many people are unaware of the technical difference between assault and battery. Under the traditional definition, assault occurs when someone puts another in fear of imminent personal harm. With assault, there need not be any contact between the perpetrator and the

victim. For example, if someone raises a fist to threaten someone else and the threatened person believes that he is about to be hit, this is an assault.

Battery, on the other hand, is an unwanted harmful or offensive contact. So, if you hit someone who did not welcome the hitting, you have committed a battery. Not matter how hard—or softly—you hit that person. Also, the contact need not be harmful to constitute a battery, but need only be offensive.

> **If you pat your buddy on the back and he does not mind, this is not a battery. But, if you knock a tray out of a waiter's hand because he made you angry, this may not be harmful but it is offensive; and it may therefore be battery.**

Battery can occur in a host of other situations as well. For example, rape is a form of battery.

Another example of battery involves surgery. If a surgeon does not fully inform a patient about the risks of a surgery and the patient consents to the surgery based on intentionally false information given by the doctor, the doctor may have committed battery by doing the surgery if the patient would not have consented if he or she had known all of the true facts about the surgery.

For example, suppose a surgeon has developed a new type of surgical procedure to treat knees. The doctor has never done the procedure before but is eager to try it out because he or she is certain it will work very well. The doctor lies to the patient and tells the patient that the procedure is common, that he or she has performed it hundreds of times—and it has a very high success rate. In reality, the procedure has been criticized by other doctors and has never been performed by anyone. The patient agrees to the surgery based on the false information given by the doctor. The surgery causes the patient to lose complete use of her knee, whereas without the surgery, she would have been able to continue walking with a cane.

If the patient would not have agreed to have the surgery if she had known it had never been performed and/or that other doctors had criticized it, then the doctor has probably committed a battery.

Today, many states have gotten rid of the distinction between assault and battery in their criminal systems, tort systems or both. Instead, they use only one of the two terms, usually "assault," to refer

to both torts. So, in many states, an assault is called an assault whether it is technically either an assault or a battery.

> There is an important issue that you should be aware of with regard to intentional torts. Many insurance policies—automobile, homeowner and other types of liability insurance policies—exclude coverage for intentional acts. The idea is that insurance is meant to cover liability for accidents.

Of course, this means that victims of intentional acts are unlikely to receive any compensation for their injuries if the defendant does not have assets.

To overcome this problem, some states have government administered compensation funds for victims of crimes (most intentional torts are also crimes). These funds typically pay for the medical bills and lost wages of victims, but do not usually pay for pain and suffering, so they are only a partial replacement for the lack of insurance. It is sometimes possible to get around an intentional acts exclusion by alleging that the defendant's conduct was grossly negligent rather than intentional.

Liquor Liability

There are a few issues that you should understand with regard to a person's potential liability for serving liquor to someone who causes injuries to another. First, the laws in the states vary widely. The first distinction we need to make is between business establishments that sell or serve liquor and noncommercial people who serve liquor at a private party or in their homes to guests. I will call the first group "sellers" and the second group "hosts."

Some states allow sellers and hosts to be sued for personal injuries caused by someone whom they served if the alcohol was a factor in causing injuries to third parties. Some states allow suits against sellers but not hosts or vice versa.

Further, with regard to sellers, many states do not allow suits against hosts or sellers but will allow a suit against a seller if the seller serves someone who is underage and/or continues to serve someone who is of legal age but is clearly already intoxicated and that person causes personal injuries as a result of the intoxication.

For example, if a 19-year-old is negligently served alcohol at a bar and, as a result of intoxication, wrecks his car and hurts someone, the bar may be sued in some states. But it may *not* be negligent if the underage patron appears to be of legal age and has a fake ID that the bartender could not reasonably have known was fake.

Similarly, if a patron is clearly intoxicated and the bar continues to serve him or her, the bar may be sued in some states if the patron then causes injuries as a result of the increased intoxication.

In order to sue the bar, the injuries must be sustained as a result of actions by the defendant which are caused by the intoxication. Thus, if a bar serves a minor who wrecks because the wheel falls off his car and the evidence proves that there was nothing he could have done to prevent the accident whether he was drunk or sober, then the intoxication did not cause the accident and the bar would not be liable.

Another issue that sometimes comes up involves passengers who give alcohol or drugs to the driver. Some jurisdictions do not allow passengers to be sued for contributing to the intoxication of the driver. Some do. Some allow the passenger to be sued only if the passenger gives alcohol or drugs to the driver while they are traveling in the vehicle (in other words, not if they gave it to the driver before the journey in the vehicle began).

Negligent Entrustment

However, some states will allow suit to be brought against the owner of a car who allows someone to drive their car when they know or should know under the circumstances that the person is intoxicated. This is called "negligent entrustment."

If you were injured, you might sue the car owner for negligently entrusting an intoxicated person with the vehicle.

In a negligent entrustment case, it is irrelevant whether the owner is in the car or not at the time of the accident; the issue is whether the owner knew it was unsafe to let the person drive his vehicle and allowed it anyway.

> Negligent entrustment is not necessarily limited to situations involving alcohol. It might also be negligent to entrust a vehicle to a person you know is an extremely reckless driver.

Intentional Infliction of Emotional Distress

One can often sue another for emotional injuries caused by outrageous conduct. In addition to being called "intentional infliction of emotional distress," this tort is often called, in shorter form, the tort of "outrage." Generally, someone commits the tort of outrage or intentional infliction of emotional distress, when they do something which is so outrageous that it is viewed as totally unacceptable in society and that behavior causes emotional or psychological injury to someone else.

Here's a real example of this tort from a case I once read.

A lady had a miscarriage in a hospital. Later, after she had been released from the hospital, she returned to pick up some belongings that the hospital had put in storage for her when she was admitted. She waited at the nurses' desk while an employee of the hospital went to get her things. When the employee came back, she handed the woman a few personal items, as well as a glass jar filled with clear preservative liquid and the miscarried fetus.

This caused the woman to suffer severe emotional distress which was bad enough that she needed significant psychiatric treatment.

> In other words, her mental distress went beyond just being upset or sad. She suffered an extreme emotional or psychological, injury.

Understand the difference here. One cannot usually sue a store clerk for being rude or even calling you an unpleasant name. The behavior of the other person must reach the level of totally unacceptable and outrageous by society's standards *and* you must be so disturbed by it that you suffer an emotional injury—generally that it is so bad that you require psychological treatment. In other words, someone may commit outrageous conduct, but if it does not really harm you—you get over it—then you cannot reasonably sue them.

Toxic Torts

Toxic torts are similar to product liability. Toxic torts are injuries caused by the negligent release of toxins into the air or water.

For example, if there is an accident at a chemical factory and chemicals are released into the air or water and people are injured, this is a "toxic tort." The chemical company can be sued for its negligence in releasing the toxin and causing injuries, much like in a product liability case a car manufacturer can be sued for injuries caused by a car design that is unsafe. Also, a toxic tort does not have to involve a chemical company, but rather can be committed by anyone who negligently (or intentionally) releases toxins.

Food Poisoning

Injuries caused by food poisoning are also essentially another type of product liability.

If you are injured as a result of ingesting contaminated food or drink, then you may sue the manufacturer or distributor of the food (if packaged food) or the restaurant (if contaminated by the restaurant) or both (if a restaurant serves contaminated packaged food).

Often the big problem with food poisoning cases is proof. If several people get the same sickness and they only have one source of food in common, then a case can usually be proved by process of elimination. However, many food poisonings are isolated instances where only one person gets sick and the source cannot be found—perhaps it came from the one piece of chicken that did not get fully cooked, when all the rest did.

Further, because most people eat and drink several times per day, it can be very difficult or perhaps even impossible to establish evidence of the source of the contamination. So if you are in a restaurant and you are served something that does not seem right or does not taste right—or is an undercooked meat that should not be undercooked—such as chicken, do not eat it.

If you already started to eat it, make sure you keep a sample because if you get sick, you will want to have a sample for testing. Also demand that the restaurant preserve the remainder. And make sure you put what you kept in the refrigerator or freezer to preserve it.

> Keep in mind that issues will be raised about the authenticity of the sample you kept and whether it was properly preserved. However, having a sample that is challenged by the defendant is better than not keeping a sample at all.

If you are particularly concerned, consider taking a sample to your local health department.

Good Samaritan Statutes

So-called "Good Samaritan" statutes protect certain people from being sued for causing injuries in some situations—even though the injuries were negligently caused by them. The most common application of these laws involves the rendering of first aid in an emergency situation.

For example, if someone gives aid to someone who is choking or CPR to someone who has collapsed and causes injuries the process of rendering the aid, they cannot be sued for that injury, even if it was caused by negligence.

> The protection will usually only apply if the person performing the first aid is at least minimally qualified to perform the aid. For example, if someone has not had CPR training and tries to perform CPR anyway, he or she will probably *not* be covered by the Good Samaritan protection.

Also, in some states, the Good Samaritan law only applies to off-duty health care workers. In other words, only a doctor, nurse or the like would be protected by the law.

2 How to Choose a Personal Injury Lawyer

Personal injury lawyers, often called plaintiffs' lawyers, are those lawyers who represent people who are injured in accidents or suffer personal injuries caused by others. On the other side of the table are defense lawyers, hired to represent tortfeasors—the people who cause accidents. Many people assume that the term "defense lawyer" refers to a lawyer who represents criminals; typically, however, these are specifically called "criminal defense lawyers."

The lawyers that we usually refer to as "defense lawyers" represent civil defendants, the people being sued in civil lawsuits (*non*criminal), such as the at-fault driver (tortfeasor) in a car accident.

If you have ever looked in the lawyers/attorneys section of the yellow pages, you will note that there are often many lawyers with full-page advertisements. There are photos of accident scenes, ambulances or other fancy ads trying to draw you in with catchy slogans about "trust" and "getting money for you." These are the ads for personal injury lawyers. You will also often see ads for those same lawyers on billboards, on television, on the radio, plastered on buses and taxicabs and wherever else they think they might get your attention.

> **You will rarely see large or flashy ads for defense lawyers. In fact, you may never see any ads at all for defense lawyers, as they are usually hired by insurance companies and other corporations and therefore do not need to advertise very much, if at all, to the public.**

Another difference between defense lawyers and plaintiffs' lawyers is that more often than not, defense firms are larger than plaintiff firms. There are many defense firms in the U.S. with 500 or more lawyers and multiple offices throughout the country and even internationally. For example, the Chicago based firm Baker & McKenzie has over 3,000 lawyers located in offices throughout the world.

By contrast, in many places, a plaintiff firm with 10 lawyers is considered large. The majority of plaintiff firms are, in fact, solo practitioners—firms with only one lawyer.

One of the reasons that legal fees charged by plaintiffs' lawyers tend to seem somewhat high results from the tremendous amount of money that is spent on advertising, especially in the yellow pages. It is not unusual for even a small plaintiffs' law firm to spend many hundreds or even thousands of dollars per month on yellow pages advertising alone. This is in addition to costs for billboards, radio spots and television commercials. The fact is that many of your legal fee dollars go straight to the phone company and other advertising outlets.

On the other hand, there is often fierce competition among plaintiffs' lawyers; and the lawyers with the best (and often the *most*) advertising tend to get the most clients and best cases.

You may find that your lawyer and the defendant's lawyer often argue very strongly with each other about various issues in your case. Your lawyer might even say disparaging things to you about the behavior of the other lawyer. If you happen to go to court when your lawyer is arguing an issue with the judge, it might appear as though they might attack each other at any moment. What might surprise you is that often you will see your lawyer fight with the defendant's lawyer like gladiators over legal issues, but then catch them discussing where they are going for dinner or drinks later on.

> **Lawyers are trained to argue strongly in defense of their clients' positions. To do this well, lawyers must learn not to take the things said by the other lawyers personally. Often lawyers on opposite sides of a case are close friends. So even though they appear to be enemies in the courtroom, do not be surprised if they are very friendly afterward.**

Do You Need a Lawyer?

As a lawyer, my first (perhaps greedy) instinct when asked by a potential client whether they need a lawyer is "of course." However, this might be a little harsh, as I believe that sometimes people can safely settle some very small claims on their own.

> **A good rule of thumb for deciding whether to hire a lawyer is that if you have to go to a doctor more than a couple of times or if your doctor has prescribed physical therapy or chiropractic care or if your medical bills exceed a couple thousand dollars or you feel that you are permanently or seriously hurt, then you should definitely consult a lawyer.**

On the other hand, if you have an accident, you go to the doctor once or twice, you have some pain at first but it all goes away fairly quickly and your doctors are confident that you will not likely have any future problems, then you may not need a lawyer If you can get the insurance company to pay you for your bills and give you something reasonable left over for your pain and trouble. If you are unable to reach a reasonable settlement, hire a lawyer. Even if you choose not to hire a lawyer to represent you in your claim, because of the different laws of different states, particularly regarding time limitations for filing suits, you should at least contact a lawyer and discuss your claim, no matter how small you think it is.

Who knows, maybe you will find out that your claim is more complicated than you thought and that you really should have a lawyer represent you.

One of the most important things to remember about settling a claim for personal injuries is that you must not settle your claim too soon. Many people do not realize that once you settle your claim and sign a release from an insurance company, your claim is over and cannot be reopened. In other words, if the insurance company offers you a cash settlement a few days after the accident, you accept it and then find out you are going to need many costly surgeries that will not nearly be covered by the settlement—*too bad*. In some states, by law, an insurance company cannot ask a claimant to sign a release within a certain period of time after the accident and, if they do, the agreement may be cancelled by the claimant.

Check with an attorney or the insurance commissioner of your state to see if there is a waiting period in your state. However, if the insurance company has complied with laws and regulations regarding valid settlements and releases, once you settle, you cannot change your mind or reopen the claim or file a lawsuit unless you can prove that the insurance company committed an act of fraud that caused you to settle and sign the release. That is why it is very important not to settle a claim until you are absolutely convinced (as well as you can be with your doctor's advice) that you know what your injuries are and what care, if any, you will need in the future.

If your doctor says that you need to take some time to heal and then come back to see if you have any long term problems, do not blow off his or her advice and settle your claim until the doctor has released you (again, though, I cannot stress enough that you need to make sure you do not miss your legal deadline to file a lawsuit.

Insurance adjusters can be a lot like car salespeople. Have you ever been to a car dealership, found a car you liked and the salesperson tried to get you to buy it right away because "there were some people looking at it earlier and they are coming back in a couple of hours to buy it," or "I don't know if the price we're offering will be available after today."

Similarly, insurance adjusters will sometimes try to use sales techniques to try to get you to settle quickly. You cannot blame them. The sooner they settle your claim, the more likely it is that you will not hire a lawyer—or that they will get you to sign away your rights before you find out that you need back surgery. Either way, they save their employer lots of money.

So, if the adjuster tells you that their settlement offer is only available for one week or that you will get less money if you hire a lawyer or that it is not in your best interest to wait until your doctor releases you from care, *do not* believe them.

Insurance companies are generally required to make fair settlement offers when an accident is the fault of their insured. That requirement applies whether you settle today or six months from now (assuming your statute of limitations has not expired). In fact, if the adjuster's tactics are to the point that you feel intimidated, you should contact a lawyer or perhaps contact your state's insurance commis-

sioner to make a complaint. It makes sense that the adjuster would prefer that you not hire a lawyer; but, if he actually tells you that you shouldn't hire a lawyer, chances are you probably *should* hire a lawyer—because that adjuster may not be very scrupulous.

These tips are warnings about potential unscrupulous adjusters. Of course, not all adjusters are so bad. Just as there are many good car salespeople, there are many adjusters—perhaps even a majority—who play by the rules and act reasonably toward claimants. However, you have to be prepared, in case the one you are assigned is not.

> **You may settle your property damage claim, separately from your injury claim, within a few days or weeks after the accident. This includes settlement for the repairs to your car (or for the car's value if it is totaled), rental car fees, as well as damages to any property that was in the car.**

In most states, the amounts of money that an insurance company must pay you for a damaged or totaled car are specifically regulated by law. Therefore, it is less likely that you will be treated unfairly in a property damage settlement as compared to a bodily injury/pain and suffering settlement where fair settlements are more difficult to calculate.

Nevertheless, if you have *any* doubts about your property damage claim, it does not hurt to consult a local attorney to get his or her opinion as to whether you are being treated fairly (when a client hired me to handle their personal injury claim, I had them handle their own property damage claim but if the insurance company gave them a hard time, I normally handled it form them with little or no extra charge depending on the amount of time I spent on it—I never charged them my one-third percentage fee on the property damage portion of the claim).

Also, make sure that anything you are asked to sign only refers to property damage and not injuries, pain and suffering and the like (if there is any language at all that you do not understand, have a lawyer look at it). I have never seen an insurance adjuster try to pull a fast one in this way, but that does not mean it never happens, so be careful. Often, the insurance company will issue a check for property damage and not even bother with having you sign anything because property damage settlements are usually fairly straightforward.

If you have any doubts about any issue, whether it relates to injuries, property damage or any other aspect, call a lawyer. It is rare that a personal injury lawyer charges for an initial phone consultation or an initial in-person consultation. To be certain, you can always take the easy step of calling and asking in advance whether there is a consultation fee.

How to Choose a Lawyer

So, you have made the decision to hire a lawyer to handle your claim. Now, how do you pick one? Below you will find several methods for locating and choosing an attorney.

> Although I will present these methods in a certain order, I do not recommend any one of them over another except that the first, regarding the advice of a friend or relative, is often the most comfortable method. All of these methods have their pluses and minuses and you should consider each one separately and decide which you feel best about.

Probably the most comfortable way to choose a lawyer, in my opinion, is to base your decision on the advice of a friend or someone you trust. That way, when you contact the lawyer, you can mention that you were referred by your friend and that might help facilitate a more comfortable relationship. You will also have the benefit of learning both the things your friend liked about the lawyer as well as their criticisms.

You may find that if your friend used the lawyer for an issue not related to personal injury, the lawyer might not handle cases such as yours. In that situation, the lawyer will probably refer you to someone he or she knows and trusts or at least someone who practices the type of law that you need assistance with. Otherwise, you will need to get another referral from a friend or use one of the other methods for choosing a lawyer described below.

The Advertisement

If you cannot find someone you know and trust to recommend a lawyer, you might begin your search using lawyer advertisements.

This, however, can be tricky, since advertising often does not tell you much about the true personality, abilities and customer service practices of the lawyer. Your first instinct may be to choose the lawyer with the most advertising, thinking that they must make the most money in order to pay for the advertising...and therefore must be the best. While it is true that they must make a lot of money to pay for the advertising—and they may in fact be good lawyers—you may also face the drawback that they charge higher fees and are also often very busy, which means you could get less personal attention and find that your phone calls do not get returned in a timely manner.

Or, you may find that when you get to the law firm's office, you are assigned to one of the associates (if there are many lawyers in the firm) and never meet a lawyer that was in the advertisements or in the firm's name. That may not necessarily be a bad thing, as the associates are sometimes more likely to give you more time and personal attention than an owner or partner of the firm.

Also, although an associate may be less experienced than an owner or partner, they are usually, to some degree, supervised by an owner or a partner and are associated with the firm name, which may (or may not) be respected by insurance companies and other lawyers.

If you choose a lawyer with less advertising, you may get more attention and possibly pay a smaller fee; but, on the other hand, the lawyer may not have the capital to finance a good case for you properly (including expert doctor fees, vocational reports and the like) and you may also find that the lawyer is less experienced and taken less seriously by insurance companies and defense lawyers.

You will also want to consider what fees the lawyer—with a big firm or small—charges. The key is to evaluate the lawyer based on many factors, rather than to base your decision on any one factor (unless that one factor is especially important to you).

So how do you narrow down possible choices based on advertising? I am afraid that this may come down ultimately to intuition and personal preferences—much like buying a washing machine. Look at all the ads and use your common sense to choose the ones with ads that most suit your personality. Which ads do you feel good about? Is the ad tasteful? Does the slogan draw you in or turn you off? Does the

firm have a Web site that you can use to explore the firm and its lawyers further? Do they have a toll free number? Do they have a convenient location with free parking? Is personal injury the first listed area of practice or is it somewhere down on the list?

Consider these factors in order to help you narrow down a list of lawyers to contact. Then use the advice and the checklists in the Appendices at the back of the book to help make your final decision.

Internet Sites

In addition to the yellow pages and other local advertisements, another useful way to find a lawyer is to use an internet search directory. Over the past 10 years, numerous lawyer directories have popped up all over the internet. At the end of this chapter, there is a list of addresses for some of these Web sites. I will focus on two of these in a bit more detail. First, take a look at www.martindale.com. This search directory is provided by Martindale-Hubbell. For many years, well before the internet was available, lawyers often had volumes of giant Martindale-Hubbell lawyer directories in book form on their shelves. Some still do. Fortunately, the internet has opened up the opportunity for the public to use this product as well.

All lawyers are permitted to place a free basic listing in the directory and some choose to place a more detailed listing for a fee. Keep in mind that not all lawyers choose to be listed in the directory, but when I want to locate or learn more about a lawyer, this is the first place that I look because many lawyers have detailed listings. Some of the biographical information commonly listed on the site includes where and when the lawyer went to school, honors, what states he or she is licensed in, what organizations he or she belongs to and so on.

Although martindale.com may contain more listings than some other sites, it might not be the most useful for someone specifically trying to locate a plaintiffs' lawyer. It will take non-lawyers some worthwhile time and patience to find the kind of lawyer they are looking for on this site because it lists every type of lawyer—including plaintiffs' lawyers, defense lawyers, real estate lawyers, law professors, judges, etc.

By contrast, another Web site that I recommend is provided by ATLA, the Association of Trial Lawyers of America. This is an organization of plaintiffs' lawyers. (Insurance defense lawyers are not even permitted to join!) As such, almost all of the lawyers in the directory handle personal injury cases. Thus, it is easier to find a personal injury lawyer on this Web site, although the listings are sometimes less detailed than on martindale.com. To search for an ATLA member near you, go to www.atla.org and click on the "Find Lawyer" button. That will lead you to a search form to focus a search on your area.

Referral Services

Finally, to locate potential lawyers, you may want to contact your state's Bar Association, listed in the reference section at the end of this chapter, which may have a referral service. In some states, you can briefly describe your problem and a representative of the state Bar will give you local listings for lawyers who have indicated that they practice the type of law that you need.

Also, in many states, lawyers agree that if they receive a referral from the state Bar's referral service, they will meet initially with the potential client for a fixed, reduced fee. The fee does not usually apply to personal injury cases, where initial consultations are typically free anyway. The fixed fee applies more commonly to family law, criminal, real estate and other types of cases that do not typically involve a contingency fee arrangement.

One disadvantage of this method: the referral services usually only give you a couple of names, possibly chosen from their list randomly, even though there may be many possible choices in your area. Much like choosing a new shirt or a new car, the more choices you have, the more likely you will be to find the best selection for your personal tastes and comfort.

Your Final Choice

No matter which methods you use to find potential lawyers, I suggest that you take a piece of paper and list a few lawyers that you

want to explore in further detail. Then, once you have chosen some possible lawyers to contact, you must narrow your choice and actually hire one of them.

How should you go about making the final decision? First, you may want to check with your state Bar to make sure that the lawyer has not been disciplined for any serious breaches of legal ethics (contact information for each state Bar is provided in the Appendices section at the end of this book). Then, to organize the information you need to make an informed decision, make some copies of the checklist in the Appendices section—one for each lawyer you consider.

In order to begin gathering the information for your checklist, start by looking at the lawyer or law firm's Web site, if they have one (look for Web site addresses in yellow page ads or do an internet search). Usually, if a lawyer has a Web site, there will be a section containing biographical information and perhaps a photograph. At a minimum, these biographies usually indicate where and when the lawyer went to law school, what areas they practice in organizations they belong to and perhaps some other tidbits.

If the lawyer does *not* have a Web site (or just to get some further details), see if he or she has a listing on the aforementioned martindale.com or atla.org sites. These may provide a lot of useful information, if the attorney is listed.

The next step to getting the information you need will be to call the lawyer. One of the first details about the lawyer—which will be very important to you later—is how long it takes for you to get to speak with the lawyer and how friendly the staff is.

Did you get to talk to a lawyer right away? Did they call back that day? Next day? A week later? Never? The quicker you get to talk to them now may be a sign of how likely it is that you will be able to get in contact with them during the course of your case.

Keep in mind, though, that there are sometimes legitimate reasons why it takes awhile for a lawyer to return your call. No lawyer has time to call new potential clients while they are in trial or preparing for a trial that is scheduled to begin in the upcoming few days or when attending a deposition or mediation on behalf of another client. On the other hand, just because they respond quickly to your call does

not mean that they will be available later. Sometimes lawyers want to sign you up quickly and then will give you much less attention later on.

The best you can do is trust your intuition when you talk to them. Do they seem like they are trying to rush you off the phone? Do they talk down to you or treat you like they want to help you? The firm where I began my career had a policy of trying, if at all possible, to have a lawyer call back a potential client within two hours. If that was not possible, potential clients had to be called by the end of the day, even if it meant staying late.

> **I also encourage my clients to ask straightforward questions by e-mail. That saves a lot of time on pleasantries and small talk...and often gets them their answers even more quickly. So, ask lawyers you interview if they use e-mail and how often they check it and respond.**

The point is, a good lawyer *wants* to respond to a client's questions and make the client feel comfortable with the process. A good lawyer will do what is necessary to make that happen.

When you first talk to lawyers, you may find that they ask all of the questions. They want to know about the facts of the accident, your injuries, treatment and so on. You must answer their questions thoroughly—and it is good to have the information about your case handy when you call (names of other drivers and witnesses, names of insurance adjusters, names of doctors, dates of events and so on).

However, do not be afraid to interject and ask the questions that are on your checklist. If the lawyer seems to have a problem with you asking questions about their qualifications, this is probably a sign that you should not hire that lawyer.

A lawyer who is not comfortable with talking about his or her credentials or abilities is either very impatient or else has something to hide. Either way, you probably will not be happy with them in the long run. It should not bother a lawyer for a potential client to want to know where they went to school, how long they have been with the firm, whether they have ever been disciplined by the state Bar or sued for malpractice and other issues of this sort. By using the checklist, you should be able to ask enough questions in order to determine whether you are comfortable with the lawyer. Of course, you will also

need to discuss fees with each lawyer before making your final decision. If you find more than one lawyer that you are comfortable with, their fees might help you make your final choice.

Also keep in mind that just because a lawyer is new or inexperienced does not necessarily mean that you should cross them off your list. More experienced lawyers will often have a more established relationship with defense lawyers, judges and insurance adjusters. However, they might be less accessible and spend less time on your case. In contrast, newer lawyers may actually be more up to date on the law, spend more time talking with you and keep you better informed of what is happening in your case.

> **Newer lawyers may also have a more experienced lawyer supervising them if they are in a firm—and the firm name itself may command the respect of insurance companies and other lawyers regardless of the experience level of the firm's individual lawyers. So experience should certainly be a factor...but not the only factor.**

In addition, don't assume that a lawyer has to have gone to Harvard or Yale to win your case. In fact, it seems like most of the Ivy League lawyers are snatched up by big-city corporate *defense* firms.

Lawyers who went to less prestigious law schools may be just as capable of winning cases. To illustrate this, consider the following comparison between a friend of mine and...me. I was fortunate enough to have a very close friend who attended a top-tier law school, while I went to a state school. We've talked a lot about our opinions of the differences in our educations.

I paid about $4,000 per year for tuition; he paid more than $25,000 per year. Most of my professors saw themselves as teachers first, while many of his professors were writers, commentators and government consultants—leaving teaching assistants to teach the classes some of the time. My courses emphasized how to be a lawyer who tries cases, while most of his training was geared toward researching and writing. As a result, right out of school, I felt prepared to try my first case; he would probably be lost in a trial setting.

The point is that you should not dismiss a lawyer just because he went to a state school. He might be just as qualified (or *more* qualified) to handle a personal injury case as a former law review editor from an

Ivy League school. I am not knocking Ivy League schools. There can be distinct advantages for graduates of these institutions—not the least of which is a much bigger starting salary in a big law firm. My point is that what ultimately makes a trial lawyer good is not where he went to school—but rather a host of factors such as intelligence, knowledge, personality, tenacity and confidence.

Ultimately, there is no way—shy of psychic abilities—to know if you are choosing a good lawyer. What I have given you is a way of doing everything you can to evaluate a lawyer to the extent possible. By doing this, you increase your chances of hiring a lawyer who will represent you well and with whom you'll be comfortable.

In summary, the best choice is the lawyer who, after you have adequately researched their credentials and talked with them, makes you feel at ease, gives you the feeling that they are smart, confident and know what they are doing—and makes you feel comfortable that they will be accessible throughout the process. Remember, you are the customer. It is *they* who need to convince *you* to hire them…not the other way around.

Legal Insurance Plans

Although not as common as car insurance or health insurance, there are several legal insurance plans available on the market. In a typical legal insurance plan, the customer pays a fee (a premium), on a periodic basis in exchange for an insurance policy to protect them in the event of legal troubles.

Different plans have different terms and cover different potential legal issues such as paying a lawyer and legal fees in the event that you are sued for divorce or have child support or custody issues, are arrested and charged with a crime or other potential legal situations. The plans also commonly provide a certain amount of time during the policy period that the plan member can call a lawyer and ask questions free of charge. Sometimes as an enticement to join, new customers might also be offered an incentive such as having their will drafted as part of the plan. Although the policy might indicate that it also covers personal injury situations, what that often means is that in the

event that you suffer a personal injury, the insurance plan will give you the name of a personal injury lawyer in your area. The lawyer they refer you to then charges you a contingent fee on his or her usual basis.

> In fact, that lawyer may or may not even have a connection to the legal services plan. Although the plans often make deals with attorneys in family law and criminal matters to represent plan participants, the most connection that the plan sometimes has with personal injury lawyers is to have the lawyer on their referral list.

I do not have particular advice as to whether or not legal services plans are worthwhile. I believe that there are probably plans that are legitimate and worth their cost—and that truly provide the services that they are meant to provide.

However, I suspect that there are many plans that are less worthwhile and may not actually cover services that you are likely to need. My advice, if you are considering joining one of these plans, is to read the documentation and understand what the plan covers and doesn't cover. Also, research the legitimacy of the company by contacting your state Bar, state attorney general's office or Better Business Bureau to see if there have been any complaints made about it.

Attorney Fees

To help you decide among the lawyers on your narrowed-down list, it is best to start by comparing their fees. In order to make a thorough comparison, you will need to understand the concepts involved.

First, this section will explain the difference between attorney fees and costs—and that your responsibility for costs may or may not be contingent upon the outcome. Then, there is an explanation of how contingency fees work, including how they are calculated, what percentage they usually are and why they are not as high as they may seem to you at first. Next, there is advice on how, in some situations, you may be able to haggle for a reduced fee as well as give an explanation of how tiered contingency fees work. Finally, there is a brief outline of hiring a personal injury lawyer on an hourly fee basis rather than a contingency fee basis.

Fees vs. Costs

One of the factors in choosing a lawyer that deserves special attention is understanding the difference between attorney fees and costs. As you may have guessed by my use of both of the terms, "fees" and "costs" that they do not mean the same thing. This sometimes leads to confusion and causes clients to feel like they have been tricked.

You have probably heard lawyers boasting in their ads that they do not charge a fee unless you get money. You should be aware that although it may be true that they charge no fee for their time unless you win, you may be responsible for paying the costs of pursuing the claim regardless of the outcome.

The fee charged by a lawyer is the charge for their time. Costs, on the other hand, are those out of pocket expenses that the lawyer pays in the furtherance of your case and may expect, depending on the provisions of the fee agreement, to be reimbursed for. Costs include, among other things, charges for getting medical records, postage, copying, faxing, long distance charges, court filing fees, etc. Make sure that when you hire a lawyer to handle a personal injury case that you understand whether their contingency fee includes both fees and costs or whether instead the costs are separate from the fees...and exactly what you are responsible for paying, win or lose. (Some states have very specific rules that require lawyers to be very clear about this difference, but other states' rules are less stringent).

Common Costs in Personal Injury Cases

What follows is a list which includes many of the costs you might encounter in a personal injury case. Keep in mind that this list is not the entire list, as there may be costs for your particular case that are not common. For example, perhaps in your case liability is contested and you and your attorney believe that you need to pay an expert to disassemble and reassemble part of your car in the courtroom. This is not common, but it could happen. Also, keep in mind that the suggested cost range is typical, but may actually be more or less than what is listed based on what your lawyer charges, local market conditions, etc.

FILING/SERVICE FEES	Filing a lawsuit varies by state and perhaps even by county. Expect to pay anywhere from $50 to a couple hundred dollars for a personal injury case plus fees for serving the complaint and summons on the defendant(s).
EXPERT FEES	Vary considerably. Could be less than $50 per hour or more than $1000 per hour, depending on the type and availability of the expert. Remember, the expert's expenses (airfare, hotel, mileage, food, etc.) are usually in addition to his fee.
JURY FEES	Usually the loser pays these fees, usually a few hundred dollars.
MEDIATOR FEES	Usually anywhere from $75 per hour to over $200 per hour, plus expenses
POSTAGE	Usually the actual amount paid
PHONE CHARGES	Usually the actual amount incurred
RESEARCH SERVICE FEES	Some lawyers pass on the costs of Internet legal research services to their clients. This could be as little as a few dollars or as much as several hundred dollars depending on how much research is needed for your case. Lawyers often pay hundreds or even thousands of dollars per month for access to these services.

EXHIBIT PREPARATION	Client is usually charged the actual costs of any diagrams, anatomical models, video recreations, etc.
COPIES	Usually $.10 to $.50 per regular copy. Higher charges for color copies, blow-ups, copies of photographs, etc.
MILEAGE	Some lawyers charge a mileage fee to clients for travel related to their case. The lawyer might use the federal (IRS-approved) rate.
TRAVEL COSTS	If your lawyer incurs travel fees (hotels, airfare, rental cars, etc.) related to your case, he or she will probably charge them to you as a cost. Food costs while traveling related to your case are usually not charged to you.

Some lawyers may indicate that their fee is contingent on the outcome of the case and that they do not get paid a fee unless you win. But they may ask you to pay them a retainer up front for costs.

In my experience, this is not common—and is not a good sign. There could be several reasons (all troubling) that a lawyer wants you to pay for costs up front or insists that you pay for every cost as it is accrued. First, the lawyer may think for one reason or another that your case has a bigger chance of losing than most of his or her cases. He or she might be willing to take a chance on your case and invest time, but not money for costs. Usually, if this is the case, the lawyer will tell you up front that this is why you will have to pay for the costs. It might then be a good idea to consult with at least one other attorney before agreeing to do so, because another attorney might not see your case as being so risky—and might agree to advance the costs.

Of course, if you have never hired an attorney before, it is *always* good to consult with more than one attorney before you make your final decision.

Other reasons that the attorney might want you to pay the costs are that the attorney simply does not have the money or credit to pay the costs—or that the attorney does not have much experience doing personal injury cases and does not yet understand that it is the usual practice for the lawyer to advance the costs.

This does not necessarily mean that you should not hire the lawyer, but make sure you carefully consider a couple of things.

First, if the attorney cannot afford to pay the costs, you should ask yourself why. Most attorneys, even if they cannot afford the costs themselves, have access to credit that can be used for expenses. Second, make sure you are confident that the attorney knows what he or she is doing. Sometimes attorneys who mostly do divorce cases will take a personal injury case based on excitement from the belief that they can make a lot of money with little work.

A lot of lawyers who do not do personal injury cases sometimes have a misconception that personal injury cases are *easy*. What they do not realize is that there are a lot of complicated steps to handling a personal injury case properly. A lawyer who does them regularly often has a smooth system in place to handle each step of the case—almost like an assembly line. To an outsider, it may look easy; but, from the inside, a personal injury lawyer must at every moment be planning and strategizing every step of the case—such as the collection and organization of medical records, knowing what experts are needed and then finding them, getting reports from doctors, analyzing wage losses organizing proof of future medical bills, tracking down defendants, dealing with insurance companies, planning for trial and hundreds of other little details.

> **There have been many occasions when clients have come to me and said that they had hired a lawyer to do the title search for them when they bought their house to handle their car accident case. Six months later, the lawyer told them that they should take their case to another lawyer who primarily does personal injury work.**

I once had a client come to me who fired his lawyer because the lawyer was in over his head and wanted to settle the case for $10,000. The lawyer did not regularly practice personal injury law but thought that he could settle this personal injury case quickly and for lots of

money. The defendant was a big corporation that had a team of lawyers who were inundating the lawyer with reports from expensive, well credentialed experts that said the case was a loser for the plaintiff. The inexperienced lawyer did not know what to do and fell for the tactics of the defense lawyers and wanted to get out of the case quickly with something, because he feared he would get nothing if the case continued. In addition, the defense lawyers threatened that they would try to convince a judge to make the lawyer pay the defendant's legal expenses of the case, which were more than $100,000 (this was very unlikely, but the lawyer fell for it).

After spending a few hours with the file, I realized that the defendants were putting on a very elaborate and scary bluff and I called it. We settled several months later for an amount that my client was quite happy with.

> The lesson here is to make sure that your lawyer knows how to handle the type of case that you have or at least that he or she spends the time and effort to learn or works with another lawyer who does have related experience (at no extra cost to you, of course).

On the other hand, do not assume that someone who does mostly family law or criminal law cannot properly handle a personal injury case. It may be that they have experience in personal injury matters but prefer other types of work and take a limited number of personal injury cases. You should ask questions. Find out what experience they have and what types of cases they have handled in the past.

Understanding Contingency Fees

Most personal injury lawyers do not charge an hourly fee for their time. Hourly charges usually apply to criminal cases, divorce cases and others—but not personal injury cases. Normally, an attorney in a personal injury case will charge the client a percentage of the settlement or judgment that is attained, if any, at the end of the case. This is called a "contingency fee" or "contingent fee"—it is contingent upon the ultimate outcome of the case. If the case gets nothing, obviously any percentage of nothing is nothing. That is why there is no fee unless you win.

That leads to the obvious question of what percentage constitutes a proper contingency fee. Personal injury law can be very competitive, depending on where you live, and as such you may find that there are sometimes various fees charged by different lawyers to try to get your business. However, the most common contingency fee is probably still the traditional one-third contingency fee. In that arrangement, the lawyer's fee is one third of the settlement or verdict. Firms with a lot of advertising typically will charge a one-third contingency fee. In recent times, some firms have even increased their fees to forty percent or even more in some situations.

On the other hand, some lawyers who do not advertise as much or practice in locations with more competition may charge lower fees, such as 25 percent or even less. This may sound enticing, but keep in mind that a lower fee may mean a less experienced lawyer with less capital to fund your case and so even a higher percentage fee may be better in the long run if the more expensive lawyer gets you a higher settlement or verdict.

Also, cheaper lawyers often get more clients, are consequently busier and therefore may have less time to talk to you if you have a question or return your phone calls promptly. That is not to say that cheaper cannot be better, just remember that in many cases, you get what you pay for.

You should also be sure you understand at the outset whether the lawyer's percentage is calculated from the total settlement or whether costs are deducted before the calculation is made. In most cases, the percentage is calculated based on the total settlement and then the costs are taken off after attorney fees are deducted.

For example, suppose that your attorney charges the common one third contingency fee and deducts the fee before costs, as is usually the case. Suppose further that you get a settlement of $90,000, have costs of $5,000 and have to pay $5,000 in outstanding medical bills. The calculations would be as follows:

$90,000		Settlement
minus	$30,000	One third contingency fee
minus	$5,000	Costs to be reimbursed to your attorney
minus	$5,000	To be paid to your doctors (assuming you wish for the attorney to take care of paying these bills out of your settlement rather than tendering payment yourself—or if you authorized your attorney to do so)

Equals $50,000 Total amount of the settlement that you will
 receive

I have also frequently encountered confused clients who thought, despite my careful explanation and detailed fee agreement, that my contingency fee was calculated based on the amount of the settlement that remains after medical bills are deducted.

In other words, they thought I only got a percentage of the amount recovered for pain and suffering. I never understood why this misconception was so common and continued even after I instituted a policy of carefully explaining in the very beginning that this is not the case. So, if you believe this is the arrangement with your lawyer, make sure that you understand exactly how your lawyer's fee is calculated.

Haggling for Reduced Fees

You should keep in mind that because there is a lot of competition, there may be some room for haggling. If you have an easy case, such as a case where the other party is clearly at fault and your injuries are not particularly serious, you may be able to negotiate a lower contingency fee.

If you threaten to go elsewhere to check other lawyers' prices if the lawyer does not lower the fee, that lawyer has to decide whether he or she wants to risk losing your business or whether he or she can still make good money for little effort if you truly have an easy case. Keep in mind that some lawyers, especially more experienced ones, may be insulted by a request for a lower fee. This should not stop you from trying, but be respectful and professional in the manner that you go about making your request or they may simply ask you to leave.

The best way to get a reduced fee, in my opinion, is to explain to the lawyer that you know your case is easy because liability is clear and your injuries are straightforward (if this is really the case). You might also threaten to handle the case yourself if they do not reduce their fee. Try something like: "gosh, your fee is awfully high, maybe because my case is so straightforward I should try to settle it myself first before I hire a lawyer."

I remember offering fee reductions a couple of times based on that threat by a client, but only because their case clearly appeared to be straightforward and simple.

I want to make sure that you understand what I mean by "easy case" and what that means to lawyers, because almost every client believes that they have an easy case even if it is actually full of difficult issues. There are certain factors that must exist for a case to be easy. First, there must be no significant question as to liability.

> **Remember: You may think that the other driver was totally at fault—and in fact that may be true. However, that does not necessarily mean the other driver will not claim that you were at fault. Sometimes people view facts differently. Sometimes the other driver will lie. In any event, do not automatically assume that you will not have to put in effort to prove that the other driver is to blame.**

On the other hand, in some cases it will be pretty clear that the other driver is at fault. For example, if you are sitting at a red light or stop sign and someone rear ends your car, there is probably little blame that they can place on you. They might try, but in that situation, liability is fairly clear.

Also, if you were a passenger, rather than the driver, then there is really no question of liability (unless, for example, you are suing the driver of the car you were in and you knowingly and voluntarily got into the car with them knowing they were intoxicated or otherwise not fit to drive). For me, the first and one of the most important factors (but not the only factor) for determining whether liability will be an issue is who, if anyone, is listed on the police accident report as being at fault in the opinion of the investigating officer(s). However, just because the other driver is listed as being at fault does not *necessarily* mean that liability will be easy to prove. On the other hand, if my client is listed as being at fault, I know for certain that liability is going to be an issue.

I am often surprised when a client assumes that liability will not be an issue when the accident involves an intersection, one of the cars ran a red light and there are no disinterested witnesses. I will tell the client that the other driver may claim that he or she had the green light and that the client's was red. Despite this advanced warning, the

client is often surprised when we file a claim and the other driver says he or she had the green light. Unless there is a witness with no connection to any of the parties to the accident or the other driver admits to the police that he or she ran the red light, liability will not be clear in that situation.

> **If you tell a lawyer that liability is clear and he explains to you why he believes it is not clear, step back from the situation, imagine for a moment that it is not your case and consider whether what the lawyer says makes sense.**

Assuming that liability is clear, the next factor of an easy case is that damages must be clear. Essentially, that means that to have what is considered an easy case regarding damages, you must be healed to the extent that you can possibly heal—and there must be no issue regarding future medical bills or pain. In other words, suppose you were in a minor accident but had a small fracture to your arm, which was your only injury. You had treatment and some physical therapy but the arm totally healed, you have no additional pain or problems and your doctor believes that you will have no additional problems and require no additional treatment in the future. In that case, your damages are fairly clear and easy to calculate.

On the other hand, suppose you were in an accident and had whiplash. You have had ongoing treatment and two surgeries but the pain just does not seem to get better. Your doctors cannot say whether your pain will last forever or heal at some point because they cannot figure out exactly what is wrong. In that case, your damages are far from clear (previous injuries, if any, can also add to this uncertainty). Most damages situations will fall somewhere in between these two examples.

However, if they are not simple like the first example, they are not the type of damages that would fall under what I would classify as clear. Thus, unless both liability and damages are clear, you do not have what I would consider to be an easy case.

Instead of reducing their contingency fee percentage overall, some lawyers charge a contingency fee that depends on how far your case goes before reaching a conclusion. In other words, if the case settles before a lawsuit is filed, the contingency fee is lower than if the case goes all the way to trial or beyond.

A sample of this sort of multitiered contingency fee arrangement might look something like this:

- 25 percent if the case settles before a lawsuit is filed

- 33 percent if the case settles during trial or if the case goes all the way to a jury verdict

- 40 percent if the case goes to trial, either side appeals and the case must be tried a second time

These percentages are meant only to illustrate how this type of arrangement works. Unlike the common, overall contingency fee that has traditionally been one-third, there is no traditional or more common set of percentages that are used in this type of tiered fee arrangement that are more common than any others, at least not that I am aware of.

This type of arrangement may work to your advantage by offering a lower fee if your case ends sooner rather than later. On the other hand, the fees might be scaled so that if you go to trial you pay more than the traditional one third, in which case it might be better to take your chances with a one third arrangement regardless of how far the case goes. Of course, it can be difficult to predict at the outset how far your case will go.

Paying Hourly Fees

If you have a lot of available cash and you do not want to pay a lawyer a percentage of what you get, most lawyers will agree to take your case on an hourly basis. Keep in mind, though, that a typical personal injury lawyer may charge you anywhere from $125 to $250 per hour for their time, plus expenses. In some more rural areas or with some lesser experienced lawyers, you might pay as little as $85 per hour or less—and for some highly experienced and well known lawyers you might pay up to $500 or more per hour. The fees could easily reach $10,000 to $20,000 or more. As you might imagine, most people cannot afford to pay that kind of money; and most lawyers want a large retainer up front when they take a case on an hourly fee basis. Furthermore, every time the retainer runs low, the client has to replenish it with more money.

Also, it is important that you understand that hourly fees have to be paid as the lawyer does the work, you cannot wait until the case is over to pay in hopes that you get a settlement or verdict and can use

that money to pay the lawyer. This is why contingency fee arrangements are so attractive. The client does not have to put up a lot of money, and usually does not have to put up any money, in order to pursue a case.

The Theory Behind Contingency Fees

Many clients have asked me over the years why contingency fees are, in their perception, so high. They realize that most lawyers charge one-third of the recovery as their fee, but they believe this is very high and wonder why. Furthermore, clients often get particularly upset when they perceive that their attorney took a third of their money even if the case did not have to go to trial and even if the attorney did not spend very many hours on their case. I will outline for you the explanation that I have always given to those clients—and which has usually made them feel much better about the amount of the fee.

> **When you hire an attorney on a contingency fee basis, that attorney is taking a gamble on your case. During the course of litigation, the case may turn out to be easier than he or she initially thought. On the other hand, it might turn out to be much harder. Some cases will settle, some will go to trial and some will even be appealed and perhaps tried multiple times. Thus, when an attorney signs you up, he or she really has very little idea as to whether your case will take five hours of work or 500 hours of work. He or she also knows that the case may make lots of money or it could get nothing—in which case he or she has invested significant time and gets no money for that time. Also, not only will the attorney not get paid for his or her time if the case loses, but he or she will also lose the costs invested in it—potentially thousands of dollars—because many clients cannot afford to reimburse these expenses (even if they are contractually obligated to do so).**

Over the course of a year, an attorney will have some cases that make lots of money with little work, some cases with lots of work that make no money...and the rest will fall somewhere in between. When you walk into the office, neither you nor the attorney know where your case will fit on this spectrum. Therefore, you are agreeing to pay a third of the money you get regardless of how much work is involved

on the theory that if your case takes little time, that your case will help to finance other cases that lose. On the other hand, if your case loses, it was then financed by other cases that took very little time.

> Clients are, in effect, pooling their resources together, sort of like buying an insurance policy, to help offset the inability to know whether their case will ultimately be an easy one or a tough one. In the end, the personal injury attorney will win some, lose some and hopefully average a reasonable income after overhead is paid.

In order to make sure you understand exactly what you are being charged and what you are responsible for, use the checklists at the back of this book when you are consulting with an attorney about his or her fees and costs—and ask lots of questions. Remember that you have the right to spend as much time asking questions as you need to in order to understand. Your attorney is busy, so be courteous and reasonable; but make sure you ask enough questions in order to feel comfortable.

The Fee Agreement

Now that you have decided which attorney you want to hire, it is customary to sign a contract with that attorney. This contract is commonly called a "fee agreement." Attorneys' fee agreements vary quite a bit and different states have different rules as to what must be contained and what may not be contained in them, but there are some provisions that you are likely to find in all or most of them.

The fees and costs section of the agreement will spell out under what circumstances the attorney is entitled to receive a fee and, of course, how much. In the typical contingency fee arrangement, the fee agreement will indicate what percentage the lawyer is entitled to receive of the settlement or verdict. As discussed previously, if the fee arrangement is a tiered contingency fee, the percentage will be smaller or larger depending on whether the case settles without trial or goes all the way through a trial and the appeals process or somewhere in between. A thorough agreement will also spell out in detail how the percentage fee is calculated. For example, the agreement should spell out whether the fee is calculated from the entire amount of the settle-

ment or whether it is calculated on the amount after costs are deducted.

In addition to the fee arrangement, there should be a provision to indicate how costs of the case are to be charged. The fee agreement should clearly indicate whether the attorney or the client is required to front the costs of the case, such as paying for copies of medical records, filing fees, expert fees and other costs.

If the attorney fronts the costs of litigation, as is usually the case, the agreement should also clearly indicate whether the client is required to pay the attorney back for the costs expended on the case if the case happens to lose and there is no money recovered. Read this section of the fee agreement very carefully and ask the lawyer as many questions as you need to in order to fully understand it.

Fees on Structured Settlements

The concept of structured settlements starts with the idea that insurance companies believe that they can invest money better than you can.

A structured settlement is a settlement wherein the defendant, usually through their insurance company, agrees to pay the plaintiff money over time. For example, as a settlement in a case where a plaintiff has significant permanent injuries, the plaintiff might receive payment of $5,000 per month for 20 years. The total payments over those twenty years, if added, come to $1.2 million.

The idea is that the insurance company believes that it can invest, say, $600,000 at the time of the settlement and that their investments will be so good that over those 20 years, they can make all of the payments to the plaintiff and even possibly make additional money for themselves. In other words, they think that they can make a $1.2 million settlement and it will cost them $600,000 or less. The good part for the plaintiff is that the payments are guaranteed. If the insurance company's investments do not pay as well as they expected, it is their loss. The plaintiff gets their money no matter what. Only the insurance company takes any gamble on the investments. Of course,

you will want to make sure that the money is being held by a reputable company and otherwise protected if the company goes bankrupt at some point after the settlement.

> Structured settlements are very uncommon with smaller personal injury claims, particularly involving adults. Structured settlements are normally used where there is a child who has significant damages and will not receive any money until age 18 anyway or an adult (or child) who will have a lifetime disability and/or need a lifetime of care.

Many fee agreements provide that if a case is settled pursuant to a structured settlement wherein the client will be paid several payments over a period of time, the attorney receives one-third of the value of the settlement at the time the settlement is made rather than getting the attorney fee over time.

Let me explain. As you might imagine, lawyers do not usually want to receive their fees over a period of time, such as 20 years in our previous example. Thus, normally there will be an initial up front payment by the insurance company to the lawyer amounting to their contingent fee calculated on the amount of money being invested up front by the insurance company.

Suppose that, like in our previous example, the value of the million dollar settlement at the time of the settlement is $600,000 and as such the attorney will be entitled to one-third of $600,000 at the time of settlement, which is $200,000. Because the plaintiff is only getting $50,000 per year for 20 years, he or she would not have the money to pay the fee at the time of settlement. So, when negotiating a structured settlement, the parties will typically include as part of the settlement a certain amount of money to be paid to the attorney as attorney fees at the time of settlement in addition to the guaranteed payments to be paid over time to the plaintiff.

So, for example, the insurance company may agree to settle for a payment at the time of settlement of $900,000. One third of that money, $300,000 will be immediately paid to the plaintiff's attorney. The remaining $600,000 will be invested by the insurance company and the plaintiff will receive one million dollars over 20 years at the rate of $50,000 per year.

So, attorneys generally want to be paid at the time of settlement; but there is a small but growing number of attorneys who are also structuring their attorney fees. In other words, the settlement is set up so that the attorney gets paid fees at the same time intervals as the client. For example, the structured settlement terms might provide that the client will receive $50,000 per year for 20 years and that the attorney will receive $25,000 per year for 20 years. Thus, using our previous example, the attorney would not get a $300,000 fee at the time of settlement, but instead will receive a total of $500,000 spread out in equal payments over 20 years.

There are two reasons why attorneys might choose to do this. First, if the fee is all received in the same year, it might result in the income from the fee being taxed at a higher rate. Structuring the fee will result in smaller amounts of income per year from that settlement rather than a big income addition all in one year. Second, some attorneys might believe that the overall amount that they will receive over the 20 years is higher and more secure than getting the $300,000 and investing it themselves. It is guaranteed that the structured fee will be paid and how much it will grow over those 20 years.

Although rare, sometimes the law provides that the defendant has to pay the plaintiff's attorney fees if the defendant loses the case. For example, sometimes bad faith cases, where the insurance company acts unreasonably or maliciously during the claims process, result in attorney fees having to be paid by the insurance company. Attorneys sometimes will include a provision in their fee agreement that if attorney fees are collected from the defendant, that the amount of attorney fees collected becomes part of the total amount recovered—and the contingency fee percentage is calculated from the total amount collected, including those fees.

To understand this, let us use an example. Suppose you go to trial and collect $500,000 for your claim and the judge also awards $100,000 in attorney fees to be paid by the defendant. Your instinct may be that the attorney gets one third of the $500,000 and that the $100,000 is used to pay for a portion of that. But the fee agreement may provide that the attorney will get one third of $600,000, the total amount collected including the attorney fees. You might want to

see if your state allows the attorney to calculate fees in this way if you are in a situation where attorney fees may be awarded and the fee agreement is set up in this way. I am not saying this is improper if not prohibited by state law—just make sure that you understand that this is an area where clients are commonly confused and surprised when it comes time to calculate fees.

Dropping Your Case

Often an attorney will put a section in the fee agreement that gives him or her the right to drop your case—to stop representing you any further if he or she determines at some point that your case is not economically worth pursuing. This is also commonly called "withdrawing" from your case. For example, if after taking your case the lawyer determines that the facts make it appear that you were probably at fault instead of the other driver or that your doctors say that all of your medical problems were preexisting (that you had them all before the accident anyway) the lawyer may not want to, nor should he or she be expected to, spend his or her time and money on a case that is likely to make little or no money.

There are two things to keep in mind here. First, if a lawsuit has been filed, an attorney usually cannot stop representing you without asking permission from the judge. Second, your state may have regulations that limit the ability of a lawyer to drop your case except under certain circumstances, regardless of whether a lawsuit has been filed.

Some other provisions you might find in a fee agreement include a document retention policy, which outlines how long the attorney will store your case files after the case is over; a provision indicating that other attorneys and staff in the firm have the right to work on your case; that the attorney may discuss your case with other attorneys for purposes of strategy without violating attorney-client confidentiality; that the attorney has the right to withhold money from your settlement to pay for subrogation liens and for your medical bills.

Engagement Letters

Some lawyers—either by personal policy or by state requirement—send their clients engagements letters. Sometimes these letters are sent instead of having the client sign a fee agreement, but in most personal injury cases, the engagement letter is in addition to the fee agreement. A typical engagement letter will outline, in simple terms, what the

lawyer has agreed to do on behalf of the client, what the fees are and who is responsible for the costs. The letter may also summarize other parts of the fee agreement in simpler terms. This is just a way of taking some confusion out of the often complex legal wording of fee agreements. (See a sample engagement letter in the Appendices.)

Statement of Client Rights

Some states have additional requirements when a lawyer begins a new relationship with an attorney. For example, some states require that the client be provided with a written copy of their legal rights as clients. This is a set of rights provided to clients by law and is often drafted by the state so that every client gets the same document with the same wording. These statements of client rights often include information about the state's rules regarding certain types of attorney fees; rules regarding when an attorney may and may not cease to represent a client; rules regarding confidentiality of information you provide to your attorney; rules preventing attorneys from discriminating against clients; and other similar rules.

In New York, for example, a lawyer does not need to provide each client with a statement of rights, but the following statement of client rights must be on display in each lawyer's office:

1) You are entitled to be treated with courtesy and consideration at all times by your lawyer and the other lawyers and personnel in your lawyer's office.

2) You are entitled to an attorney capable of handling your legal matter competently and diligently, in accordance with the highest standards of the profession. If you are not satisfied with how your matter is being handled, you have the right to withdraw from the attorney-client relationship at any time (court approval may be required in some matters and your attorney may have a claim against you for the value of the services rendered to you up to the point of discharge.)

3) You are entitled to your lawyer's independent professional judgment and undivided loyalty uncompromised by conflicts of interest.

4) You are entitled to be charged a reasonable fee and to have your lawyer explain at the outset how the fee will be com-

puted and the manner and frequency of billing. You are entitled to request and receive a written itemized bill from your attorney at reasonable intervals. You may refuse to enter into any fee arrangement that you find unsatisfactory.

5) You are entitled to have your questions and concerns addressed in a prompt manner and to have your telephone calls returned promptly.

6) You are entitled to be kept informed as to the status of your matter and to request and receive copies of papers. You are entitled to sufficient information to allow you to participate meaningfully in the development of your matter.

7) You are entitled to have your legitimate objectives respected by your attorney including whether or not to settle your matter (court approval of a settlement is required in some matters).

8) You have right to privacy in your dealings with your lawyer and to have your secrets and confidences preserved to the extent permitted by law.

9) You are entitled to have your attorney conduct himself or herself ethically in accordance with the Code of Professional Responsibility.

10) You may not be refused representation on the basis of race, creed, color, religion, sex, sexual orientation, age, national origin or disability.

You now should have a better understanding of how attorney fees and costs work—as well as how to choose a personal injury lawyer.

Nothing can completely eliminate the inherently unpleasant nature of a personal injury claim; but, now that you have hired a lawyer, the remaining chapters of this book will help you to have a better idea of what is going to happen throughout the process—so that you will feel a little bit less in the dark.

Insurance Claims in Personal Injury Cases

3

When you've been in an accident, you need to know the basics of how insurance works. Both your insurance and the insurance of the other driver in the accident.

Although there are variations based on the insurance law in each state, there are certain basic categories of coverages in a typical automobile insurance policy (your state may have additional types of coverages as well that may not be listed here). These types of coverages commonly include general liability coverage (bodily injury and property damage), uninsured motorist coverage, underinsured motorist coverage, comprehensive coverage, collision coverage and med-pay/ PIP coverage.

General Liability Coverage

This type of coverage provides coverage to you, the policyholder, someone driving your car with permission (in a state where the insurance follows the car) and anyone else who is an insured under the terms of your policy for liability to others caused by negligently driving your car. (And, sometimes, it may cover you while driving someone else's car).

General liability coverage includes coverage for bodily injury liability (injuries caused to others in an accident that is your fault) and coverage for property damage liability (damages caused to another person's car or other property damaged in an accident that is your

fault). This coverage only applies if you or someone else covered by your policy is at fault for an accident. Also, it is important to realize that this particular coverage only pays others that are harmed by you or another insured under your policy.

> If someone else is at fault and hurts you, their general liability policy pays for your damages and if they do not have insurance or enough insurance, your uninsured or underinsured coverage, if you have it, pays for your additional damages.

Again, your liability policy does not pay you—only others to whom you or another insured under your policy negligently cause damages.

Uninsured Motorist Coverage

Put simply, this is coverage that you can buy that pays you if someone else injures you, they are at fault and they have NO insurance. Believe it or not, despite being required by law in almost every state, some people drive cars without any insurance at all and sometimes they cause accidents. In that case, if you have uninsured motorist coverage, it will pay you, up to your uninsured coverage limits, for your medical bills, lost wages, pain and suffering, property damage and the like.

If the defendant was uninsured or underinsured, your state law will probably provide that you have to serve the complaint on your own insurance company so that they are aware that they may have to potentially pay an uninsured or underinsured motorist coverage claim. Also, if the defendant is uninsured, he or she might not have an attorney or otherwise answer the complaint. In that case your insurance company will probably hire an attorney to represent the defendant. Thus, the law may require you to officially put your insurance company on notice of the lawsuit by serving them with the complaint so that they can take the necessary steps to protect their interests.

> In this situation, in a sense, your own insurance company becomes your adversary. That is why you should only give them an interview in the beginning of your claim with your attorney present.

This is coverage that you can buy that pays you if someone else injures you, they are at fault and they do not have *enough* insurance to pay the full amount of your claim.

For example: John Smith causes an automobile accident and you are injured. You have $15,000 in medical expenses and your pain and suffering is worth, say, another $15,000. Your total bodily injury claim is thus worth $30,000. Suppose further that John Smith only has $20,000 in insurance coverage. In that case, John Smith's insurance company would pay you $20,000 and your insurance company would pay you $10,000 from your underinsured motorist coverage, assuming you have purchased it and your limits are at least $10,000 (the difference between your claim and John Smith's policy limits).

Also, underinsured motorist coverage is only available if the tortfeasor's insurance company has paid you the tortfeasor's policy limits. Underinsured coverage is designed to pay when the tortfeasor does not have enough insurance to pay your claim, so logically it only kicks in if the tortfeasor's policy has paid its maximum and it was not enough to pay the full value of your claim.

Under and Up to States: Beware

With regard to underinsured motorist coverage, some states are what are called "under and up to" states. In an under and up to state you may only collect underinsured motorist coverage from your own policy to the extent that your coverage is greater than the coverage of the tortfeasor.

To make this easier to understand, let me give an example. Suppose that another driver, we will call him "driver A," is 100 percent at fault for an accident with you. Suppose further that your claim is worth $100,000. Driver A has $20,000 in liability insurance and you have $50,000 in underinsured motorist coverage. You can collect the $20,000 in coverage from Driver A and $30,000 from your underinsured coverage.

As you can see, you can only collect your underinsured coverage to the extent that it is greater than the tortfeasor's (driver A's) liability insurance (your underinsured coverage, $50,000, minus the tortfeasor's

coverage, $20,000, equals $30,000 difference). Thus, for your $100,000 claim you will have a total of $50,000 in available insurance coverage. Unfortunately, unless driver A has a lot of money or assets, you are likely only going to receive half the value of your claim. The lesson: buy adequate underinsured motorist coverage.

Comprehensive Coverage

Comprehensive coverage pays for damages to your car that are not directly related to your operation, negligent or not negligent, of your car. This pays for damages caused by such things as a tree falling on your car, a flood washing it away or hail making lots of dings.

This is just a sampling of some of the types of things covered. Read your policy or talk to your insurance agent or attorney to find out whether you have this coverage and what things are covered and not covered under it.

Collision Coverage

This is coverage that pays for damages to your car when you are at fault for an accident. We have learned that your general liability coverage pays for injuries and property damage to others when you are at fault and your uninsured and underinsured motorist coverage pays for injuries and property damage to you when someone else is at fault but has no insurance or not enough insurance. Collision coverage pays for property damage only, to your car, when you are at fault.

> **If you finance or lease a car, the bank or lessor typically requires that you carry minimum amounts of liability insurance as well as comprehensive and collision insurance coverage.**

Finance companies want to make sure that if the car they loaned you the money to purchase is damaged, that there is coverage to fix or pay for it no matter who is at fault for the accident. And, if they have to repossess the car because the loan payments are not made, they want to ensure that the car is in good shape so that it can be sold for full value and cover the loan balance.

80

Med-Pay/PIP

Med-pay, short for medical payments insurance, which in some states is called PIP, short for personal injury protection, is coverage that pays for the medical bills incurred by someone covered by your policy (and sometimes pedestrians injured by your car) regardless of who is at fault. So if you are in an accident and it is entirely someone else's fault, your med-pay/PIP coverage will still pay for the medical bills (and in some policies lost wages) of insureds under your policy— which for purposes of med-pay covers just about any driver or passenger in your car—caused by the accident, even though you were not at fault. For that matter, it pays the medical bills even of someone who is at fault. In other words, fault is irrelevant and as such it is referred to as a type of "no-fault" coverage.

If a covered driver or passenger in your car is injured in an accident in your car, they are covered. Keep in mind that this coverage only pays medical bills, although some policies pay lost wages as well. It does not pay for pain and suffering.

There are a few additional things to know about med-pay/PIP. First, in some states the coverage is optional and in some states you are required to purchase a minimum amount of it. Second, in some states, if the accident is the fault of someone else, it will still pay for your medical bills, however, if you make a claim against the at fault driver and collect for your medical bills, you may have to repay your insurance company for what they paid out in med-pay/PIP.

Med-pay is commonly found in auto insurance policies but is also included in most property insurance policies. Med-pay in property insurance policies pays for medical bills incurred for injuries suffered by someone on property covered by the policy. It is similar to med-pay coverage for car accidents but is instead applicable to injuries on property, rather than in a car. So if someone slips and falls on covered property, the medical bills are paid by the med-pay coverage.

Again, in terms of medical coverage, fault is irrelevant. Thus, if you are hurt on property—such as a slip and fall—even if it was your own fault, you should see if the landowner/shopowner/lessor has med-pay. Also, if you are hurt on your own property you should see if you

have med-pay under your own policy that will cover your medical bills.

One other issue worth mentioning is that there may be situations when someone is entitled to make a claim against someone's policy for both med-pay *and* general liability coverage. When two cars are involved in an accident, the victim(s) from one car will have a claim for general liability coverage against all negligent drivers. The people in each car will only have med-pay claims against their own policies or the policy of the car they were in.

> **Keep in mind, though, that there may be passengers in the car with the negligent driver. They will not only have a claim against the driver of the car they were in for general liability, but also a claim against the med-pay coverage of the car they were in.**

Finally, although some states have allowed attorneys to keep a percentage of med-pay payments as part of their contingency fee, I have never done so. I just do not feel that it is right to take a full contingent fee for collecting money that was there for the client for the mere asking. Now if the insurance company refuses to pay, then a fee is warranted for having to fight for the money—or the attorney might charge an administrative fee for the paperwork involved—but to take the customary one-third of med-pay/PIP payments is usually not appropriate...in my opinion.

What Is "Full Coverage?"

When talking about their car insurance, people often say with great confidence that they have "full coverage" on their vehicle. Unfortunately, I am not sure that many people really know what this means. It seems that people believe that, if they have "full coverage," they have purchased every possible type of coverage that is available—which is not always the case. Worse yet, some believe it means that the amount of insurance covering them is unlimited...or at least higher than it really is.

First of all, "full coverage" is not really a legal term, in that you will not commonly hear lawyers using the term. Furthermore, often different insurance companies and insurance agents define "full cover-

age" differently. People typically categorize themselves as having one of only two possible levels of coverage, full coverage or liability only. Thus, at the very least, saying that you have full coverage means that not only do you have insurance covering you for your liability against others, but you have insurance that covers damage to your vehicle for accidents that were not the fault of someone else (trees falling on the car, accidents that are your fault, etc.).

So any definition of "full coverage" is usually going to include those two types of coverages. However, having full coverage may or may not include other types of insurance coverages that may be available. It may or may not include medical payments/PIP coverage, uninsured and underinsured motorist coverage and so on.

Furthermore, you might have every type of coverage offered—full coverage in the broadest sense of the term—but what are the limits of each of those coverages? Your full coverage might not be as helpful as you think if you have all possible types of coverages but very low limits of each type.

My advice is that if you believe that you have "full coverage" it might be a good idea to look over your policy and declarations pages and talk to your insurance agent so that you know what coverages actually make up your "full coverage" and what the limits are of each type of coverage.

Often when I tell clients that we are going to make a claim against their insurance policy for med-pay, uninsured motorist coverage, underinsured motorist coverage or any other coverage for that matter, they become very concerned that the claim will result in cancellation or nonrenewal of their policy or an increase in their future insurance premiums. This is a common issue that many people worry about when the prospect of making a claim on their own insurance policy arises. Unfortunately, the answer depends on the practices of each insurance company combined with any applicable state laws. Thus, it may be that two people could make the same type of claim on their policy for similar amounts of money and one results in a rate increase or nonrenewal and the other does not result in either because they have different insurance companies.

If you are in an accident that is your fault and a claim is made against your liability insurance, you can almost certainly expect your

next premium to be higher. On the opposite end of the spectrum, if you make a claim on your uninsured or underinsured motorist coverage where the fault is clearly the fault of someone else, I think that it would be immoral and just plain mean for your insurance company to raise your rates.

This does not mean they will not do it, but I think that is very improper. Claims for collision or comprehensive coverage will vary. If a tree falls on your car, I think it would be wrong to suffer a rate increase. On the other hand, if you run into a tree, you can probably expect an increase.

If you are concerned about a potential rate increase for making a claim, talk to your insurance agent and ask them to find out what types of claims result in rate increases under your policy. However, there are couple things to keep in mind. If you have a small claim—perhaps a few hundred dollars to fix a dent caused by a piece of debris hitting your car on the road—it might not be a good idea to make a claim on your policy if it will result in a rate increase. Instead, pay for the repairs out of your pocket if possible. It may be cheaper in the long run.

On the other hand, if you are seriously injured by an uninsured or underinsured driver which will result in payment to you from your policy of many thousands or tens of thousands of dollars, you should not avoid the claim because your rates might go up a couple hundred dollars per year. That would be like turning down a big prize in a sweepstakes because you have to pay a third of it in taxes.

Insurance Cancellation

As for cancellation or nonrenewal of a policy, the laws are sometimes more strict than with rate increases.

Cancellation of a policy happens while the policy is in effect, while nonrenewal is the refusal of the insurance company to renew a policy upon its expiration. First, all states have rules requiring that an insurance company give an insured a minimum amount of notice before a cancellation or nonrenewal occurs. That way, the insured has some time to seek a new policy. Second, each state takes one of three general approaches to the circumstances under which an insurance company may cancel or refuse to renew an automobile insurance policy.

The state might have no restrictions other than notice; limit reasons for cancellation but not nonrenewal; or limit reasons for both

cancellation and nonrenewal, although the reasons might be different for cancellation than for nonrenewal.

In the first approach, the state law allows an insurance company to cancel or refuse to renew a policy for any legitimate reason, other than things such as age, race, gender discrimination or the like. In that case, the insurance company only needs to provide the amount of notice required by law.

In the second approach, the state law allows nonrenewal of a policy for any legitimate reason that is non-discriminatory, but limits the reasons for which an insurer may cancel a policy during the term of the policy. For example oregon law provides as follows:

> 742.562 Grounds for cancellation of policies; notice required; applicability. (1) A notice of cancellation of a policy shall be effective only if it is based on one or more of the following reasons:
>
> (a) Nonpayment of premium.
>
> (b) Fraud or material misrepresentation affecting the policy or in the presentation of a claim thereunder or violation of any of the terms or conditions of the policy.
>
> (c) The named insured or any operator either resident in the same household or who customarily operates an automobile insured under the policy has had driving privileges suspended or revoked pursuant to law during the policy period or, if the policy is a renewal, during its policy period or the 180 days immediately preceding its effective date. An insurer may not cancel a policy for the reason that the driving privileges of the named insured or operator were suspended pursuant to ORS 809.280 (7) or (9) if the suspension was based on a nondriving offense.
>
> (2) This section shall not apply to any policy or coverage which has been in effect less than 60 days at the time notice of cancellation is mailed or delivered by the insurer unless it is a renewal policy.
>
> (3) This section shall not apply to nonrenewal. [Formerly 743.905; 1991 c.8607a]

Thus, if the policy has been in effect for 60 days for more, the policy can only be cancelled for one of the listed reasons.

Some states take a third approach and limit the reasons for which an insurer can cancel or refuse to renew a policy. For example, in addition to limiting the reasons for which an insurance company can can-

cel an automobile insurance policy (see West Virginia Code 33-6A-1) West Virginia law also limits reasons for nonrenewal of policies that have been in effect for at least two years as follows (and I only cite the pertinent parts of the statute here):

> 33-6A-4. Advance notice of nonrenewal required; assigned risk policies; reasons for nonrenewal; hearing and review after nonrenewal. (a) No insurer shall fail to renew an outstanding automobile liability or physical damage insurance policy unless the nonrenewal is preceded by at least forty-five days advance notice to the named insured of the insurer's election not to renew the policy....
>
> (b) An insurer may not fail to renew an outstanding automobile liability or physical damage insurance policy which has been in existence for two consecutive years or longer except for the following reasons:
>
> (1) The named insured fails to make payments of premium for the policy or any installment of the premium when due; (2) The policy is obtained through material misrepresentation; (3) The insured violates any of the material terms and conditions of the policy; (4) The named insured or any other operator, either residing in the same household or who customarily operates an automobile insured under the policy: (A) Has had his or her operator's license suspended or revoked during the policy period; or (B) Is or becomes subject to a physical or mental condition that prevents the insured from operating a motor vehicle and the individual cannot produce a certificate from a physician testifying to his or her ability to operate a motor vehicle; (5) The named insured or any other operator, either residing in the same household or who customarily operates an automobile insured under the policy, is convicted of or forfeits bail during the policy period for any of the following reasons: (A) Any felony or assault involving the use of a motor vehicle; (B) Negligent homicide arising out of the operation of a motor vehicle; (C) Operating a motor vehicle while under the influence of intoxicating liquor or of any narcotic drug; (D) Leaving the scene of a motor vehicle accident in which the insured is involved without reporting it as required by law; (E) Theft of a motor vehicle or the unlawful taking of a motor vehicle; or (F) Making false statements in an application for a motor vehicle operator's license; (6) The named insured or any other operator, either residing in the same household or who customarily operates an automobile insured under the policy, is convicted of or forfeits bail during the policy period for two or more moving traffic violations committed within a period of twelve months, each of which results in three or more points being assessed on the driver's record by the division of motor vehicles, whether or

not the insurer renewed the policy without knowledge of all of the violations: Provided, That an insurer that makes an election pursuant to section four-b of this article to issue all nonrenewal notices pursuant to this section, may nonrenew an automobile liability or physical damage insurance policy if the named insured or any other operator, either residing in the same household or who customarily operates an automobile insured under the policy is convicted of or forfeits bail during the policy period for two or more moving traffic violations committed within a period of twenty-four months, each of which occurs on or after the first day of July, two thousand four and after the date that the insurer makes an election pursuant to section four-b of this article and results in three or more points being assessed on the driver's record by the division of motor vehicles, whether or not the insurer renewed the policy without knowledge of all of the violations. Notice of any nonrenewal made pursuant to this subdivision shall be mailed to the named insured either during the current policy period or during the first full policy period following the date that the second moving traffic violation is recorded by the division of motor vehicles; (7) The named insured or any other operator either residing in the same household or who customarily operates an automobile insured under the policy has had a second at-fault motor vehicle accident within a period of twelve months, whether or not the insurer renewed the policy without knowledge of all of the accidents: Provided, That an insurer that makes an election pursuant to section four-b of this article to issue all nonrenewal notices pursuant to this section, may nonrenew an automobile liability or physical damage insurance policy under this subsection if the named insured or any other operator either residing in the same household or who customarily operates an automobile insured under such policy has had two at-fault motor vehicle accidents within a period of thirty-six months, each of which occurs after the first day of July, two thousand four and after the date that the insurer makes an election pursuant to section four-b of this article and results in a claim paid by the insurer for each accident, whether or not the insurer renewed the policy without knowledge of all of the accidents. Notice of any nonrenewal made pursuant to this subsection shall be mailed to the named insured either during the current policy period or during the first full policy period following the date of the second accident; or (8) The insurer ceases writing automobile liability or physical damage insurance policies throughout the state after submission to and approval by the commissioner of a withdrawal plan or discontinues operations within the state pursuant to a withdrawal plan approved by the commissioner. (c) An insurer that makes an election pursuant to section four-b of this article to issue all nonrenewal notices pursuant to this

section shall not fail to renew an automobile liability or physical damage insurance policy when an operator other than the named insured has violated the provisions of subdivision (6) or (7), subsection (b) of this section, if the named insured, by restrictive endorsement, specifically excludes the operator who violated the provision. An insurer issuing a nonrenewal notice informing the named insured that the policy will be nonrenewed for the reason that an operator has violated the provisions of subdivision (6) or (7), subsection (b) of this section, shall at that time inform the named insured of his or her option to specifically exclude the operator by restrictive endorsement and shall further inform the named insured that upon obtaining the restrictive endorsement, the insurer will renew the policy or rescind the nonrenewal absent the existence of any other basis for nonrenewal set forth in this section.

If your insurance company attempts to cancel, refuses to renew or significantly raises your rates, it might be worthwhile to talk to a lawyer or a representative of your state's insurance regulator's office to find out whether the insurance company's attempt to take such an action is permitted by state law.

Deductibles and Declarations Pages

Deductibles, which can theoretically apply to any of the types of coverages listed above (although each state may have regulations concerning deductibles with regard to each type of coverage), set a minimum amount of damages that must be incurred before the policy will begin to pay. In other words, suppose your comprehensive coverage has a $500 deductible. That means that the policy will not pay the first $500 in damages.

So, if a tree falls on your car and causes $800 in damage, your policy would pay you $300 to $800 minus the $500 deductible. Deductibles are usually offered in order to help reduce policy premiums. The higher the deductible, the lower the premium. Some states even require deductibles for some types of coverages.

There are three main sets of documents that are normally involved with automobile insurance: the policy, endorsements and the declarations page. Let us examine each one individually.

- THE POLICY. When you purchase automobile insurance, you should be provided with a written copy of your insurance policy. This is a comprehensive document that covers all of the details of the coverages included, such as general

liability, uninsured, underinsured, med-pay, comprehensive, collision and so on. It will carefully spell out the definition of an "insured" (who is covered by the policy), under what conditions the company will pay for a claim, under what circumstances it will not pay (exclusions) and many other details. Keep in mind that the policy usually contains the details of all possible coverages available from the insurance company, even ones that you *did not purchase*. As you will see, it is your declarations page that outlines what coverages you actually have and at what limits. If you have never read your insurance policies, take some time now to read them. You might be surprised at some of the provisions contained in them.

- COMMON EXCLUSIONS. Insurance policies always include exclusions—things that the policy does not cover. Some exclusions are covered specifically in other parts of this book, such as exclusion of liability coverage for dog bites, liability between spouses, liability for intentional acts. There are also some other exclusions that are commonly found in automobile and homeowner insurance policies which may be applicable in personal injury cases. Coverage is typically excluded for damages caused by a car that is being driven without the owner's permission. Thus, if someone steals a car and injures someone, the car's liability policy will not provide coverage. Similarly, coverage is often excluded for the liability of someone driving, with or without permission, who does not have a valid driver's license.

In addition, in a regular, individual, non-commercial, automobile policy. coverage is usually excluded if the vehicle is being used for a given list of purposes. Some of those purposes include using the vehicle for business purposes, as a taxi, as a commercial delivery vehicle, as a rental vehicle, for any unlawful purpose and so on.

So liability coverage is not provided in a case where a thief steals the car and causes an accident which injures others—it will provide coverage, if purchased, for damages to the stolen car itself. Similarly, a non-commercial homeowner policy will often exclude coverage when the property is being used for business or commercial purposes. Separate commercial policies must be purchased to provide coverage in business/commercial situations. Finally, most policies will exclude cov-

erage for incidents resulting from acts of terrorism, acts of war and so on.

- ENDORSEMENTS. In addition to the comprehensive policy document, you will also usually receive a set of additional documents called "endorsements." You see, often an insurance company will produce a primary policy that they give to insureds in many states, even though the coverages may have differences in different states. To cover these differences, they also provide "endorsements" which either add conditions and provisions to the main policy, take away conditions and provisions from the main policy or make changes to the conditions and provisions of the main policy. For example, suppose that you are given a main policy that indicates that you must report a claim within 90 days in order to be able to collect a certain part of your coverage. But, in your state, the law does not allow such a 90-day time limit; the limit has to be at least 120 days. Then you would receive an endorsement that provides that the policy for residents of your state is modified so that you must report a claim within 120 days, rather than the 90 days stated in the main policy. Furthermore, although the main policy might not be updated by the insurance company for several years, you might receive additional endorsements every time you pay a new premium. So, before you assume that the information in your main policy is applicable, make certain by checking for endorsements that could apply to your policy.

- DECLARATIONS PAGE. The policy and the endorsements spell out the details of all insurance coverages offered by the insurance company. The declarations page spells out exactly which of those coverages you have and at what limits. The declarations page will vary in content somewhat by state. However, in general this is usually the document that makes up your detailed bill from the insurance company. The declarations page will usually contain your name, a description of each vehicle covered, the types of coverages that apply to each vehicle covered, the limits of each coverage, amounts of deductibles and perhaps a list of endorsements and discounts or surcharges applied. In addi-

tion, it will usually detail the price or premium as it is called with regard to insurance policies, that each coverage costs.

What If the Driver Is Not the Owner?

This question is often phrased as "does the insurance follow the *car* or does it follow the *driver?*" This issue is important when there is an accident in determining which insurance policy will pay for the liability of the driver who is at fault if the driver is not driving his or her own car. Different states have different laws regarding whether the policy follows the car or the driver. Also, every insurance policy is different and has different limitations on who and what is covered under different circumstances.

In a state where the policy follows the car, the primary coverage will be from the policy held by the owner of the car. So, if Friend is driving Owner's car—with permission—and Friend has an accident that is his fault, the primary policy that will cover the liability is Owner's policy. However, if the policy on the car does not provide enough coverage to pay all claims, then the driver's policy (if there is one) may kick in and pay the additional claims up to its limits of coverage. This is called "excess coverage."

Suppose Friend is driving Owner's car and has an accident with Victim and the accident is Friend's fault. Victim's damages are $200,000. If Owner's policy limits are $100,000 and Friend also has a policy that covers excess liability, then Owner's policy will pay its limits of $100,000 and then Friend's policy will pay the other $100,000 as excess coverage.

On the other hand, in a state where the policy follows the driver, in an accident the primary policy will be the policy held by the driver, assuming he or she has one. Thus, in our example, in a state where the insurance follows the driver, Friend's policy would primarily cover Friend's liability. Then, depending on the law and the insurance policies, Owner's policy may provide excess coverage if Friend's policy is insufficient to cover all of the claims.

Liability for Acts of Another Driver...Beware

There are three positions that states take with regard to the liability of the owner of the car for accidents caused by others using the car

with the owner's permission. In many states, a driver cannot be held personally liable (beyond their insurance policy) to pay for the fault of a driver using the owner's car with permission. In some states, the owner can be held personally liable only if the owner was negligent in letting the driver use the car, such as the owner knew the driver was drunk or otherwise not reasonably fit to drive. This is called negligent entrustment; I discussed it in some detail in the previous chapter.

> **Beware, though, that in some states, a driver can be held personally liable for the negligence of someone using his or her car with permission no matter what. In those states, if Owner loans his or her car to Friend and Friend negligently causes an accident in which the damages go beyond the insurance coverage available, not only can the injured party go after the personal assets of Friend, but also the personal assets of Owner.**

You should check with an attorney or insurance agent to find out whether your state imposes liability on owners for the acts of others using your car with permission. This could be a very important factor in deciding whether to loan your car to someone.

As an added wrinkle to all of this, some states do not impose personal liability upon an owner except under a family use law.

Under family use laws, if an owner's car is being used by a member of the vehicle owner's family (the law will indicate how close of a family member the person must be in order for the law to apply), the law presumes that the car is being used for the overall benefit of the family and as such makes the owner personally liable for accidents committed by the family member.

There are many issues that crop up in family use laws that are handled differently in different states. For example, does the family member have to live with the owner for the doctrine to apply? Does the law apply to children only if they are under the age of majority? Does it apply to children who are using a car owned by the parent while away at college? Is a parent liable for the fault of a child if the car is titled in the name of the child? In addition, some states have scaled back the law so that the owner family member is liable only to the extent that they have insurance, which makes it irrelevant if their policy primarily covered the car anyway. This is another situation where

you may want to consult an attorney or your insurance agent to find out your state's laws regarding the extent of family liability.

Coverage Minimums

The majority of states in the United States require their residents to have valid insurance coverage to cover liability in order to register and drive a car in that state (Some states do not require insurance if the driver can show proof that they have a minimum amount of assets equal to the minimum amount of insurance that is otherwise required). Obviously, as an aspect of this requirement, each state requires a minimum amount of such insurance. Furthermore, there may be different minimum requirements for each of the categories of general liability, uninsured motorist coverage and underinsured motorist coverage. Also, while all states that require drivers to have insurance require general liability insurance, not all of those states require drivers to have uninsured, underinsured and/or other coverages.

Whatever categories of coverages are required, the minimum requirements for each category are commonly set forth as a set of three numbers. For example, suppose that the minimum general liability coverage for State A is 20/40/10. These are expressed in thousands of dollars. So this requirement is actually 20,000/40,000/10,000 dollars. The first number usually represents the minimum amount of required general liability insurance to pay for liability for injuries to any one person in a single accident (the per-person limit). The second number usually represents the minimum amount of required general liability insurance to pay for injuries to all persons (combined) injured in a single accident (the per-accident limit). In other words, this is sort of like a minimum maximum. Do not worry, this will all make sense soon. The third number represents the minimum amount of required liability insurance to pay for property damage caused to another by the fault of the insured.

PER PERSON	PER ACCIDENT	PROPERTY DAMAGE
$20,000	$40,000	$10,000

An example should help all of this to make sense. Suppose that Joey has insurance in the amount of 20/40/10, which is his state's minimum. Joey is driving down the street one day and while playing with his radio negligently runs a stop sign and hits another car which

is being driven by Bob and in which Helen is a passenger. Bob is injured and his injury claim is worth $8,000. Helen is injured and her injury claim is worth $25,000. The repairs to Bob's car cost $12,000. How much will Joey's insurance pay to Bob and Helen? Joey's insurance will pay Bob $8,000 for his injuries and $10,000 for the damage to his car and will pay Helen $20,000. That means that Bob gets shorted $2,000 for the damage to his car and Helen gets shorted $5,000 for her injury claim.

Why? Joey's insurance pays a maximum of $20,000 *per person* up to a maximum of $40,000 *per accident* for personal injury claims and $10,000 maximum for property damage. Thus, the most that any single person can get from Joey's insurance for bodily injury is $20,000 and the most that everyone in the car combined (Bob and Helen, in this case) can get for bodily injuries is a total of $40,000.

The most available for property damage is $10,000. It does not matter that Helen's claim is worth more than the $20,000 maximum, the most she will get is the $20,000 per person maximum. Also, Bob cannot get more than the maximum $10,000 coverage for the property damage, even though the claim is for $12,000. Similarly, if there had been five people in the car, the most any single one of them could get is $20,000 and the most that all of them combined could get is $40,000.

So, if each of the five of them have $20,000 claims, none of them will likely get the full amount of their claim because—even though none of their individual claims exceeds the single person maximum of $20,000—their combined damages of $100,000 exceeds the $40,000 maximum per accident, so they will have to decide how to divide the $40,000 maximum among them. Since there is not enough coverage to pay all of the claims, the injured parties will have to either make a claim for their underinsured motorist coverage or if they do not have any, their only other option is to sue the tortfeasor (Joey) and hope that he has enough money or assets to pay the additional damages.

Single Limit Policies

Some states, either instead of or in addition to the three category limits explained above, may allow insurance companies to sell a policy with a minimum "single limits" amount. In other words, the insurance company sells the insured a policy which provides a certain amount of coverage which is not broken down into per person/per accident/

property damages limits. The single limit amount is the limit for bodily injury liability and/or property damage liability for an accident no matter how many people make claims as a result of an accident. In other words, suppose a policy is a single limits policy of $100,000. That $100,000 could be paid entirely for property damage or partly for property damages and partly for bodily injuries.

There could be one claim for bodily injuries for $99,000 and another for $1,000 without a per person limit affecting the first claim. In other words, it is very simple mathematically. There is $100,000— divide it however is fair. Which brings us to the biggest negative aspect of single limits policies.

Without the per person limits, it often makes it more difficult to come to a resolution of who gets how much. Suppose that there is $100,000 single limit, there are two people injured and each has a $200,000 claim. One has high medical bills but not a lot of pain and suffering and the other has low medical bills but a lot of pain and suffering. Should each get half? Should the one with more pain and suffering get more? Should the one with higher bills get more? This can itself lead to litigation about who gets how much.

Disputes over coverage limits are another good reason to purchase sufficient underinsured motorist coverage in order to be protected from having to be on the losing end of this argument with no other insurance coverage to turn to in order to pay the difference.

When You're Driving in Another State

Some states have higher minimum liability coverage requirements than other states. Because of this, insurance policies often provide (sometimes by law) that if you carry only minimum coverage for your state and you drive a car in a state with a higher minimum, that your policy will increase to the minimums of that other state if you incur liability while in that other state (usually only liability coverage minimums are increased, not uninsured, underinsured, comprehensive, collision and so on, unless otherwise provided in the policy or by law).

For example, suppose you live in State A and carry the minimum amount of insurance which in State A is 20/40/10. Suppose further

that one day you go for a drive in State B which has minimum requirements of 30/50/25. If you are in an accident in State B that is your fault, your insurance would cover you for State B's minimums of 30/50/25 for any liability you incur in State B. Check your policy or with your insurance agent to see if your policy provides this additional coverage and/or if your state requires it by law.

Umbrella Coverage

An umbrella is a type of insurance policy that supplements your other insurance policies. This is best explained by example. Suppose that you have an automobile policy with liability limits of $250,000 per accident and a homeowners policy that provides liability limits of $250,000 per incident.

Suppose that these are the highest limits offered under these policies, but you want more insurance because you do not believe that these limits are enough to protect you if you happen to be sued. In that case, you can purchase an umbrella policy. It is called an umbrella policy because it is an additional insurance policy which increases the limits of *both* your auto and homeowners liability insurance—it covers, like an umbrella, both of your other policies.

> **The umbrella coverage does not kick in unless you are sued for a matter covered under either your auto or homeowners policy and that policy does not provide enough coverage. Umbrellas are usually offered in increments of $1 million dollars. So, you might have a $1 million umbrella or a $2 million umbrella and so on—although other amounts might be offered by some insurance companies.**

Umbrellas work in one of two ways, they either add an additional amount of coverage to what you already have or serve to increase what you have to the umbrella's limits. So if you have $250,000 auto and homeowners policies, a $1 million umbrella will either increase your coverage under each to $1 million or increase each to $1,250,000, depending on how the policy works. Also note that many insurance companies will not sell you an umbrella unless you purchase the maximum limits offered on your underlying auto and homeowners policies. In other words, if the highest available coverage on the auto and

homeowners policies is $250,000, you cannot purchase $50,000 coverage on each of those policies and then a $1 million umbrella. You would have to purchase the $250,000 maximum coverage on each of the underlying policies in order to be entitled to purchase an umbrella. One of the reasons for this is because insurance companies know that claims exceeding the maximum limits they offer on underlying policies are comparatively rare.

Therefore, umbrellas are usually relatively inexpensive compared to the underlying policies because the insurance company knows it is unlikely that the coverage will ever be needed. So if you could purchase auto and homeowner policies with lower limits and supplement them with an inexpensive umbrella, the insurance company would lose money.

You should keep in mind if you are considering an umbrella that the umbrella does not necessarily have to be issued by the same insurance company as your underlying policies. As such, it may be beneficial to shop around and get quotes from several reputable insurance companies rather than automatically accepting the price offered by the company that issued your underlying policies. Also, it is possible that the company that issued your underlying policies does not sell umbrellas. In that case, you can look for an umbrella policy from another insurance company.

Because umbrellas provide significantly increased insurance coverage for a relatively low price, umbrellas are definitely worth discussing with your insurance agent.

Coverage in Another Country

Many people assume that their automobile insurance coverage covers them to drive their car, no matter where they drive it. They assume that if they drive it to Canada or Mexico or beyond that they are covered. Unfortunately, this might not be true. Most U.S. insurance policies cover drivers while driving in Canada. However, other than Canada, the policies of various insurance companies vary.

Some insurance companies cover drivers while driving in Mexico. Some companies will cover drivers while driving in parts of Mexico but not others. Other companies do not cover drivers while driving in Mexico at all. Furthermore, while most cover Canada and some cover Mexico, most do not cover driving in any other countries such as Europe or elsewhere. So before driving anywhere outside of the United

States, be sure to look at your policy and talk to your insurance agent about whether and the extent to which you are covered while driving in Canada, Mexico or other countries.

Claims Against Spouses or Family Members

Sometimes people get injured by their spouses. For example, a husband may drive negligently and cause an accident in which his wife is injured. There are two main questions that must be asked when a spouse is negligently (or intentionally) injured by another spouse—can the injured spouse sue the negligent spouse and will their insurance cover the claim.

In most, if not all, states the law permits one spouse to sue another spouse for personal injuries suffered because of the negligent or intentional torts of the other spouse. However, since most spouses own all of their assets together, it is usually a moot point for one spouse to get a judgment against the other spouse. Thus, the more pertinent question is whether the spouse's insurance policy will pay for liability of the other spouse. In some states, the law provides that an insurance company may not exclude liability coverage for a spouse negligently injuring another spouse (they may typically exclude coverage for intentional conduct)

In those states, a spouse may make a claim against the negligent spouse's insurance, even if the policy belongs to both of them jointly. In some states, however, there are no laws preventing insurance companies from excluding coverage for liability between spouses; in those states insurance companies may and often do, exclude that coverage.

Nevertheless, even if your state allows the insurance company to exclude the coverage, that does not necessarily mean that the policy excludes it. Check your policy and consult your attorney and/or insurance agent to find out whether your state allows coverage for spousal liability to be excluded from the policy and, if so, whether your policy excludes it.

Making an Insurance Claim

So how do personal injury insurance claims typically progress? Let us begin with a chart outlining the major steps of an insurance claim, then I will explain each step in more detail.

- Step 1: Setting Up a Claim

- Step 2: First Contact With An Adjuster

- Step 2B: Property Damage Claim

- Step 3: Gathering Of Information—You Get Treated for Your Injuries

- Step 4: You Reach Maximum Medical Improvement and a Demand Is Made *or* The Statute of Limitations Approaches and a Lawsuit is Filed

- Step 5: Settlement is Reached *or* A Lawsuit is Filed

Many lawyers follow the steps above in an attempt to settle claims before filing a lawsuit. However, some attorneys prefer to file a lawsuit earlier in the process—sometimes before making a settlement demand and sometimes before the plaintiff finishes healing.

Although the lawyer may do this merely as a matter of personal preference, there are two common strategic reasons for filing early. First and most common, is that in particularly busy jurisdictions the waiting time between filing a lawsuit and having a trial scheduled can be very long—as long as several years. In that situation, it might be beneficial to file a lawsuit as soon as possible in order to get in line for a trial date. Second, sometimes a lawyer will go ahead and file a lawsuit simply because he or she knows that the case has very little chance of settling.

This might be because the particular insurance company or adjuster has lacked interest in settling cases in the past or it might be that the case arose in a jurisdiction where insurance companies in general rarely settle cases. In those situations, the plaintiff's lawyer might see no point in waiting to file a lawsuit based on his or her past experiences in similar situations. If your lawyer files suit early in the case, as previously described, some of the following will not apply to you, although it will still be worthwhile to read, as many of the ideas and concepts might apply even after a lawsuit is filed.

Step 1: Setting Up a Claim

The first step in an insurance claim is setting up the claim. This is just a matter of giving basic information about the accident and the people involved in it to the insurance company. You or your attorney

will want to contact your insurance company as soon as possible after the accident, which is pretty straightforward and is geared mostly toward setting up a claim for medical payments/PIP coverage and letting them know that there was an accident in case a claim must later be made for uninsured or underinsured motorist coverage. Most insurance policies require that they be put on notice within a certain amount of time after an accident.

> Because the contact between you or your attorney and your insurance company is pretty straightforward, we will focus mainly on the claim you make with the *other* driver's insurance company

The first contact between you (or your attorney) and the other driver's insurance company will normally happen in one of two ways. Either an adjuster for the at-fault driver's (the tortfeasor's) insurance company will call you because the tortfeasor has already called his or her insurance company and let them know about the accident or, if you have not heard from the insurance company, your attorney will call them to report the accident and set up a claim file with them.

At this point, you are just setting up a claim, usually with the customer service department. An adjuster will subsequently be assigned to handle your claim.

Step 2: First Contact with an Adjuster

Once a claim is set up, the next step will involve the first contact with the insurance adjuster. The adjuster is an employee of or hired by the insurance company who will handle your claim on behalf of the insurance company. You will probably want to know a little bit about the person who will decide whether you are ultimately treated fairly in your claim, so let me tell you a little about what adjusters do.

First, adjusters handle many claim files. When people have insurance claims, they tend to focus on their own needs. This makes sense and is perfectly normal. However, when they consider the actions of the insurance adjuster, they often do not realize that the adjuster is probably handling hundreds of claims similar to theirs.

What is the significance of this? Let me elaborate. Adjusters have many responsibilities with regard to handling each claim. They have

to collect medical records, review medical records, collect medical bills, evaluate who is at fault and in what percentages, evaluate injuries, decide whether to request that claimants be sent for independent medical examinations, evaluate how much money, if any, to offer to settle a claim, deal with attorneys who are often angry because the adjuster made low settlement offers and deal with their bosses about how much they are spending on claims. All of these actions are done within the guidelines set by the insurance company regarding the processing and paying of claims.

What is the point of this explanation? My clients are often personally offended and emotionally distraught by the low offers that adjusters make or suggestions by an adjuster that a client had a preexisting medical condition that contributed to their injuries when in fact the client had no preexisting problems. They take it as the insurance adjuster picking them out and calling them a liar or failing to understand what the client "went through" because of the accident.

I agree that this behavior by insurance adjusters is frequently unfair, insulting and sometimes just plain mean. I also agree that it is perfectly natural to be angry about it. However, as I tell my clients, even though the low offers and suggestions of preexisting conditions are directed at you personally, you should try not to take them personally. I assure you that the adjuster is not singling you out. The adjuster has no idea who you are, has probably never seen you or even a picture of you and underneath their facade probably does not believe that you are lying and may even think that their own offer is unfair.

The reality is that they are just following the same procedures that they do with every claim. Their job is to identify possible preexisting conditions, medical anomalies and anything else that could reduce the amount of money the insurance company has to pay. If your doctor writes something in your record that could negatively affect your claim, the adjuster is trained and required to find it and use it against you. They are just doing their job.

Although I know it will not make you feel much better, it might make you feel a little bit better to know that practically *everybody* who makes a claim is treated equally fairly or unfairly by each insurance adjuster and insurance company.

During the first conversation with the tortfeasor's adjuster, the adjuster will ask for information about your identity, your address, your employment, information about your car, the accident and other information. The adjuster may also ask you to give a recorded interview over the phone wherein the adjuster will ask you questions and record your answers.

> **If you have contact with the adjuster before you have hired an attorney, you should probably tell the adjuster that you wish to contact an attorney for advice before you give an interview and answer questions other than about your name and contact info. If the adjuster criticizes or harasses you about this, it is probably all the more reason to contact an attorney before giving the interview or answering any detailed questions about the accident or your injuries.**

Not only is the insurance adjuster for the tortfeasor's insurance company going to want to take a recorded interview from you, but so is your own insurance company. Although you have no legal or contractual obligation to give an interview to the tortfeasor's adjuster (although refusing to do so makes it difficult to settle), you typically have a contractual obligation under your own policy to cooperate with your own insurance company, which includes giving them a recorded interview. However, you should understand that although technically your own insurance company should be on your side, that might not end up being the case at some point.

If it turns out that the tortfeasor is uninsured or underinsured and you make a claim for one of those coverages from your own policy, *your* insurance company could end up defending...the tortfeasor.

This apparent "betrayal" results because, in order to maintain the illusion with the jury that the defendant does not have insurance and in order to make sure that they only have to pay you as much money as if the defendant had his own (or had sufficient) insurance, your insurance company will probably hire an attorney to represent the defendant. It might help this make sense a little more to also understand that typically when you make a claim under your uninsured or underinsured coverage, you actually technically make the claim against the tortfeasor, but then your insurance pays whatever judgment you get against the tortfeasor. That is not to say that you will not settle.

Once you make a claim for your uninsured or underinsured coverage, your insurance company will want to try to negotiate a settlement for the claim just like you would negotiate with the tortfeasor or his or her insurance company if the tortfeasor had insurance (or enough insurance). But, whether you are negotiating a settlement or going to trial, your insurance company becomes—in a big way—your adversary for purposes of the claim. It might use your recorded interview against you if they can. Thus, because your recorded interview with your own insurance company might ultimately be used against you in an uninsured or underinsured claim, it is just as important that you have your attorney present when you give the interview.

You are usually contractually obligated to give your insurance company the interview, but that does not mean that you cannot insist on having your lawyer present. Also, once you tell the adjuster that you are represented by an attorney, they will typically not contact you any further but instead contact your lawyer directly.

Step 2B: Property Damage Claim

During the first contact, the adjuster may also want to make arrangements to have an estimator look at the damage to your car. This is normal and there is usually no reason not to allow these arrangements to be made. However, check with your attorney just to make sure, as some attorneys may want to participate in the property damage claim as well.

> **Remember: Even if your attorney does not participate in the property damage claim, do not answer any questions involving details of the accident or your injuries during the property damage claim process without your attorney being present.**

If liability is an issue, sometimes your own insurance company will pay to repair your car, if you have the appropriate coverage, since for many people their car is their primary means of transportation and people need repairs done quickly. Then, if liability is ultimately placed on the other driver, your insurance company will be paid back for the money it paid out. I suggest that you make sure, though, that if your insurance company does get paid back, that it does not continue to count the claim against you and therefore raise your premiums.

Step 3: Gathering Info and Seeking Treatment

Once your attorney has established a relationship with the ad-juster regarding your case, the next step, gathering of information, is basically a time to wait while you continue to receive medical treatment for your injuries, if they continue to pose problems. It is also the time to let your attorney collect medical records and invoices from your doctors.

Your claim will not be ready to be settled until one of two things happens:

1) Your injuries are totally healed and you are in the same condition that you were in prior to the accident or

2) You continue to have problems from your injuries, but you have gotten as much better as you are going to get according to your doctors (often called reaching "maximum degree of medical improvement") and your doctors indicate that the injuries are simply going to continue indefinitely or permanently.

Keep in mind, also, that if the statute of limitations approaches before either of these things happen (in other words, you are still being treated and your ultimate prognosis is not yet known), your attorney will have to file a lawsuit. This does not mean that you will not be able to settle your claim after the lawsuit is filed and before trial, but the suit has to be filed in order to preserve your rights.

While you are being treated, your attorney will order copies of your medical records using the medical records release forms that you will sign. Your attorney will also order copies of your medical bills in order to have a record of how much your treatment has cost.

Depending on his or her practices, your attorney will either provide these records and invoices to the insurance adjuster periodically as they are received or provide them all at once at the time a demand is made by the insurance company. Also during this time, your attorney may want you to have examinations or consultations with certain experts. These may include an interview with a vocational expert, a life care planner, an economist or a functional capacity evaluator. (See checklist of things to do while still being treated and questions to ask your attorney after you finish your treatment in the Appendices).

At some point, either while you are being treated, after you have made your demand or perhaps not until after a lawsuit is filed, the

insurance company for the other driver or his or her lawyer if a lawsuit has been commenced may request you to have one or more independent medical examinations.

First, I will explain what an independent medical examination (often referred to as an "IME") is and then I will explain why many plaintiffs' lawyers find the use of the term "independent" to refer to these exams to be very inappropriate.

An independent medical examination, as it is known in legal jargon, is a medical examination of the plaintiff performed by a doctor hired by the defendant's attorney or insurance company. The theory behind these exams is that there is a fear that the plaintiff's own doctor might be biased in favor of the plaintiff since the physician has a relationship, at least to some extent, with the plaintiff. In other words, even if the plaintiff and his or her doctor are not close friends, there is at least usually more of a connection between the doctor and the plaintiff than there is between the doctor and the defendant or the insurance company. As such, there is a fear that the doctor might be biased, whether intentionally or not, in favor of the plaintiff and tend to interpret medical problems more in favor of the plaintiff and therefore against the defendant.

> **An independent medical examination is intended to give a defendant the chance to hire a doctor who has never met or treated the plaintiff to examine the plaintiff and his or her medical records and offer his or her own medical opinion in order to see if it corresponds to that of the plaintiff's doctor.**

The exam itself typically consists of a visit by the plaintiff to the doctor who will examine the plaintiff's medical records either before or after the plaintiff's actual visit. The doctor will typically perform an examination of the plaintiff and may also wish to perform some tests, such as x-rays or an MRI. Alternatively, previous x-rays or MRI's might be loaned to the doctor or the plaintiff might be asked to take them to the exam for the doctor to view.

Most independent medical exams are fairly short (other than sitting in the waiting room beforehand) and there is usually very little conversation between the plaintiff and the doctor other than for the doctor to ask medical questions specific to the examination. It is usually considered inappropriate for the doctor and the plaintiff to discuss

issues related to the claim or lawsuit and there is no treatment relationship created as the result of the exam, although in theory the plaintiff could later seek treatment from that doctor if they both agree.

> Sometimes, if the doctor chosen by the other side to perform the examination is one that is particularly well known for being tough on plaintiffs, I will insist that my client take a tape recorder and record the examination. This is often met with objections and sometimes the judge has to be consulted (if the case is in litigation), but I at least give it a shot.

Also, I always give my client a form to fill out immediately after the examination that includes questions such as "what questions did the doctor ask you," "what were your answers," "what sorts of tests did the doctor perform," "how much time did the actual examination take," and so on (see the sample in appendices section). Check with your attorney before going to an independent medical examination to see what his or her practices are in this regard.

Depending on the situation, the defendant may wish to have more than one independent medical exam of the plaintiff performed. For example, the plaintiff might have several different kinds of injuries for which he or she has been treated by several different kinds of doctors. Perhaps the plaintiff has a bulging disk in his or her back for which treatment has been received from an orthopedic surgeon. In addition, the plaintiff might also have post traumatic stress disorder resulting from memories of the accident itself and for which treatment has been received from a psychiatrist. Perhaps a dental surgeon was also consulted to repair a jaw injured in the accident. And so on.

In that case, the defendant may wish to have an independent medical examination performed by several doctors—one corresponding to each of the types of doctors who has treated the plaintiff for ongoing injuries. So if your primary treating physicians included an orthopedic surgeon and a neurologist, it is common for the defendant to request independent medical exams from an orthopedic surgeon and a neurologist chosen and paid for by the defendant.

In addition, although not necessarily a medical exam *per se*, if you claim to have permanent loss of or reduction in your ability to work because of accident-related injuries, the defendant might also request that you be interviewed by a vocational expert that it choses.

Although the theory behind allowing independent medical exams makes sense, the manner in which they are carried out is often inconsistent with their intended purpose. Some plaintiffs' lawyers prefer to call these exams "defense medical exams" rather than "independent medical exams" because, they say, there is nothing independent about them.

> In my experience, there is often good reason for this feeling. Although not always the case, many times insurance adjusters and/or defense attorneys hire the same doctors over and over again to perform the exams on their behalf. Not surprisingly, these doctors almost never produce a report that is favorable to the plaintiff. In fact, the reports are often quite negative toward the plaintiff, often accusing them of inventing their pain for personal gain—they will often say that there is no objective basis for the pain or that the pain is likely to improve when litigation is over.

I have occasionally experienced situations where a doctor was hired by the defendant and produced a report favorable to the plaintiff. Of course in that situation I cannot say that I ever noticed them being hired again by the same insurance company or defense attorney. In my previous practice, there were a handful of doctors that I just knew would be chosen by every insurance adjuster and defense attorney and that their report would not support the opinions of the plaintiff's doctors. These doctors got quite a few referrals from adjusters and defense lawyers and made quite a bit of money examining plaintiffs and producing negative reports.

I'm not suggesting that these doctors are lying. Usually it is a matter of simply presenting the medical evidence in a way least favorable to the plaintiff or refusing to give the plaintiff the benefit of the doubt. For example, the doctor might indicate in a report that the plaintiff's pain is not consistent with any of the tests performed. This makes it seem like the doctor is suggesting that the pain is not real. The doctor may have left out, though, that the plaintiff's pain is consistent with the type of pain caused by similar auto accidents but typically does not show up in any test.

This might seem like a small distinction; but it can make a big difference to a jury.

Because these are licensed physicians who are qualified by the courts as experts, there is little the plaintiff can do to combat their negative exam reports. The best that plaintiffs can do is to point out to the jury that the legal work done by the doctor is primarily for defendants; that the defendant's doctor only saw the plaintiff one time for a brief amount of time as opposed to the plaintiff's treating physician who has a longer term relationship with the plaintiff; and that the defendant's doctor was hired by the defendant's lawyer and the plaintiff's treating physicians were attained by the plaintiff, not the plaintiff's lawyer.

> **The idea is to show the jury that the plaintiff's physician has little to gain from the plaintiff winning or losing and that the doctor hired by the defendant wants to continue to be hired by defendants and therefore has an incentive to lean toward discrediting plaintiffs if at all possible.**

Letters of Protection

Sometimes people who are injured by the fault of others do not have health insurance or med-pay/pip to pay their medical bills while they are being treated for their injuries. Furthermore, most of the time the other driver's insurance company will not pay claimants' medical bills as they are accrued. They are usually required to make only one settlement, for one amount, at the end of the claim and in exchange for a full release of the defendant.

They do not typically make settlement payments in increments or piecemeal. As such, if an injured person does not have insurance of his or her own to pay medical bills as treatment is received and they cannot afford to pay for the treatment out of their pocket, this can be a major, unfair hardship to an injured person.

> **In order to help these people, *some* doctors or hospitals will agree to provide ongoing treatment and/or hold off on collection of previous bills in exchange for a "letter of protection" (called by other names, such as "lien letters," in some places).**

A letter of protection is a letter sent by your attorney to the doctor or hospital that indicates that the attorney is trying to win a claim or lawsuit for you and that if the doctor agrees to provide treatment and/or hold off on collections until after the case is over, then the attorney will pay the doctor's bills out of the settlement money before giving any money to you. In other words, as you will learn below, when you settle your claim, the money is sent to the attorney who puts it in his or her bank trust account and distributes it from there.

The attorney is agreeing with the doctor by means of the letter of protection that if money is received in your case, that he or she will pay your medical bills out of that account from the settlement money before distributing any money to you. You see, the doctor is more comfortable if the attorney pays rather than you getting all of the money and paying the doctor yourself.

There are two very important things to keep in mind. First, the attorney is not agreeing to pay your medical bills personally. Rather, he or she is only agreeing that if the case results in receipt of money, that the doctor will get paid before you get paid. Second, the doctor is not agreeing to waive his or her bill if you lose. If the case loses and you get nothing, then the letter of protection is cancelled and you then owe the doctor the full amount of your bill—immediately. In that sense, by asking your attorney to provide a letter of protection for continuing treatment, you are, in a way, gambling that you will win the money to pay for that treatment. Of course, whether you ultimately win or not, your health and well-being should always be your primary concern. (See a sample letter of protection in the Appendices.)

It has been my experience that clients often seek treatment only for their pain and other obvious injuries resulting from an accident, but do not seek treatment for psychological injuries that result. However, there are also several psychological problems that can result from automobile accidents.

For example, prolonged pain can lead to depression, as can the negative financial effects of a motor vehicle accident. The inability to fully function, go to work, have sexual relations and participate in recreational activities can result in depression and anxiety problems.

Another frequent problem that arises is post-traumatic stress disorder. Automobile accident victims sometimes relive the accident in

their mind, react with fear to driving or riding in vehicles in some circumstances and so on.

For example, I once had a client whose car was hit by a tractor trailer. For more than a year after the accident, she would constantly scan the road ahead and behind and if a tractor trailer came within the vicinity of her car, she would pull off the road and wait until it had passed before continuing. It took significant therapy and even medication for her to begin to overcome this terrible fear.

> **Unfortunately, because psychological illnesses are so stigmatized in our society, people are often afraid to seek medical treatment or simply do not realize that treatment is warranted. Many people grow up being taught that if you are angry, sad or afraid, you should just deal with it and it will go away. However, this overlooks that these are often genuine illnesses that can benefit from treatment just like back pain.**

I am not a doctor and do not propose to tell you what kind of doctor or what kind of treatment you need. However, I do offer you the advice that if you think you might have a psychological injury or illness, go to your doctor and get a referral for appropriate care. There is absolutely no reason to feel embarrassed or ashamed about it and seeking treatment may be able to help fix any reduction in your quality of life caused by these symptoms.

Avoid Lapses in Treatment

One of the common things that insurance adjusters and defendants' attorneys will use against an injured plaintiff are gaps in medical treatment. Although gaps at any time in the treatment process will be used against you, the worst gaps are those that begin just after the accident.

If you receive treatment for pain for several months, then there is a gap in time where you do not receive any treatment for several months and then resume treatment, it will be suggested that the gap shows that you fully recovered and then re-started treatment either to increase your damages or else you must have suffered another injury that caused the need for additional treatment. The same is true when you have the accident and perhaps get some examinations but then do not

110

commence significant treatment for several months after the accident. It will be difficult to successfully argue that your pain and medical treatment was a result of the accident if your treatment did not begin near the time of the accident.

I realize that there might be legitimate reasons why you might not start for awhile or have gaps in treatment. Sometimes injuries take awhile before causing symptoms; sometimes injuries appear to be better but then take a turn for the worse. Also, injured victims often do not have insurance and money to pay for treatment. They are in pain and they need treatment, but they simply do not have the money to get it. It is unfair to punish an innocent injured victim for not getting treatment when he or she has no money to do so. Unfortunately, though, this happens often.

> **The best that the victim's lawyer can do in this situation is try to make the jury understand why there is a gap and, if possible, to try to make the defendant's lawyer look mean for using it against the victim—if it was lack of money that prevented treatment.**

I am not suggesting that you continue to get medical treatment if you do not have symptoms and have been released from treatment. However, if you still have symptoms, it is very helpful to your case if you continue to get regular and consistent treatment. If you cannot afford treatment, talk to your doctor about whether they would be willing to accept a letter of protection from your attorney. If not, perhaps you should seek a doctor who will. This has its own problems for your case, as outlined in the next section, but at least you will not have gaps in your treatment and you will be looking out for your health.

Do Not Go "Doctor Shopping"

There may be times, as mentioned in the previous section, when you have to change doctors. However, doing this too often can make it appear that you are shopping for a doctor who will give the best reports and testimony for your case. In other words, if you change doctors three times because the first three doctors say that your back pain was not caused by the accident and the fourth one does say it was caused by the accident, the jury will probably be very weary of believ-

ing your fourth doctor. This can be a frustrating situation. It is problematic if your current doctor refuses to participate in litigation or has opinions that do not support your case on some issues.

On the other hand, it is problematic to "shop" for a doctor that supports your position because then both you and the doctor look bad. If the situation arises that you cannot afford treatment or for some other reason you feel as though you want to change doctors, you should discuss the matter with your attorney so that he or she can take any steps that he or she feels are necessary in order to minimize negative effects that it might have on your case.

Step 4: Reach Maxmium Medical Improvement

If you totally heal or you reach the point that you are as healed as you are going to get, your attorney will then want to make a demand to the insurance company (or, as mentioned, if neither has happened but your statute of limitations is running out, a lawsuit must be filed).

Usually, to make a demand to the insurance adjuster, the attorney will outline the arguments about why the other driver was at fault, your injuries as shown in your medical records and also may provide reports obtained from your doctor which outline what your injuries were, what treatment you received and what problems you are likely to continue to have in the future and for how long (perhaps permanently). Based on the amount of your medical bills, the extent of your suffering and the extent of your potential future medical bills and future suffering, you and your attorney will decide how much to ask for from the insurance company.

Some lawyers will demand a specific dollar amount, while others will demand that the insurance company make the first offer. The written outline of this information and the amount demanded for settlement is usually sent in the form of a detailed letter and is called a demand letter.

A "demand package," as it is sometimes called, includes the demand letter, as well as your medical records, bills and other documentary and photographic evidence regarding the accident and your treatment—to the extent these documents were not previously sent to the adjuster. The demand package will be sent to the adjuster; and you will wait for a response.

Preserving Your Rights

If you and your attorney believe that your case is worth more than the maximum amount of insurance that the tortfeasor has, you will have to consider any other possible sources for collecting the remainder of your claim. In other words, if you and your attorney believe that your claim is worth $200,000 and the other driver only has $100,000 in insurance, you will need to consider any possible options for getting the extra $100,000. If you have underinsured motorist coverage, you will want to make a claim for any of that potential coverage available to pay the difference.

This raises another complicated process in some states. Many state laws and many underinsured motorist coverage policies require that in order to collect underinsured motorist coverage, you must give your insurance company the right to sue the tortfeasor and go after his or her personal assets.

> **Also, keep in mind that the tortfeasor's insurance company will usually only pay you money from the tortfeasor's policy in exchange for releasing the tortfeasor from any lawsuit or further liability. Thus, if you release the tortfeasor without getting permission from your underinsured carrier, you might lose the right to collect your underinsured coverage.**

Therefore, before releasing the tortfeasor in exchange for the limits of his or her policy, you must inform your underinsured carrier of your intentions and they must decide whether it is worth their effort to go after the tortfeasor.

Usually, they will give you permission to settle and release the other driver without losing your underinsured coverage because they figure the other driver does not have much to get or will just declare bankruptcy if they go after him or her.

On the other hand, if your underinsured carrier decides they want to go after the tortfeasor, they may have to pay you the amount that the tortfeasor's insurer was going to pay you and then they take the risk of how much they will ultimately get from the tortfeasor. Essentially, they pay you off and then "step into your shoes," so to speak, with regard to your claims against the tortfeasor. You might still have an obligation to testify if the insurance company pursues the tortfeasor

all the way to trial, but you will already have your settlement which you will not lose regardless of what happens at trial. The trial is mainly a function of the insurance company trying to get its money back from the tortfeasor if possible.

Step 5: Settle...or Sue

If you reached maximum medical improvement and had time to make a demand prior to your statute of limitations running out, then at some point the adjuster should respond to your demand. Remember, always keep the deadline for your case from the applicable statutes of limitations in mind and perhaps even remind your attorney when it gets close, just to be safe.

If the insurance company believes that their insured is at fault or primarily at fault, the adjuster will hopefully respond to your demand with a settlement offer.

One of the first things that I tell my clients before we even make the demand is that they should not get angry or upset about the amount of the first offer made by the tortfeasor's insurance company because it usually means very little. As part of the negotiation process, which is essentially a type of game, the plaintiff traditionally makes a demand for more than his or her case is likely to settle for and then the tortfeasor's insurance company will respond with an offer that is much less than the case is really worth.

This is just how the game is played. We start high, they start low and we try to meet somewhere in the middle at a fair settlement. So when the first offer is insultingly low, do not be insulted, it is just the first offer. I tell my clients that they should not start to get angry until at least the third round of negotiations, because it usually is not until at least that point that one starts to get an idea of what the tortfeasor's insurance company really thinks the claim is worth.

At some point during the negotiation process, your attorney will get a feeling, based on experience, that the insurance company has offered the most or close to the most, that they are ultimately going to offer. This is the most meaningful point in the negotiation process. At this point, you must decide, with the advice and help of your attor-

ney, whether to either accept the final offer being made by the insurance company or turn it down and file a lawsuit.

I often tell my clients in this situation that it is as though they are standing at the craps table in a casino holding chips equal to the amount being offered. They can either cash in those chips and go home or they can put those chips on the table and roll the dice, because, as you will learn throughout this book, having your case decided by a jury is truly a gamble. Your attorney can tell you all of the pros and cons of going to trial, all of the reasons to settle the case and all of the reasons to not settle the case, but you are the one who will have to take all of this information and make the decision.

Your attorney does not decide whether to accept a settlement, only you can do that.

Keep in mind that if you decide to turn down the offer and file a lawsuit, it does not mean that you will not eventually settle your case prior to trial. Negotiations typically continue as the litigation process goes forward and neither side ever wants to let a jury decide the case if there is any way of settling it on terms that both parties can live with. Thus, sometimes the insurance company's offer will increase as the litigation process unfolds. But not *always*.

If you do reach a settlement prior to filing a lawsuit, typically you will sign a release agreement (see the sample in the Appendices) wherein you agree not to take any further action toward the other driver involving the particular accident for which you brought the claim. In exchange, the insurance company will send a check. The check is typically sent in the name of you, your spouse—if applicable—and your attorney. Normally, all of you will sign the check, the attorney will deposit the check into a trust account and then pay himself or herself, your medical providers, any subrogation liens—and, finally, you— out of that account.

In most states, the trust account that the lawyer deposits the settlement funds into is a separate account used only to deposit and pay out clients' money. In many states these accounts are called IOLTA's, which stands for Interest On Lawyer Trust Accounts. The interest earned on the money in these account is paid to a special fund to pay for legal aid —free legal services for the poor. Thus, you will not typically receive any interest on the money in the account, although the money is usually in the account only for a very short time anyway.

Sometimes, if a client's money is going to be sitting in the account for more than a short time, the law requires the lawyer to open an

interest bearing account just for that client's money. The interest on that account then goes to the client.

If you reached a settlement, congratulations, you got your money and your case is over. If not, the next step is to file a lawsuit.

Paying Your Medical Bills and Liens

When your case is over and the check from the insurance company has come to your attorney, the question may arise as to whether your attorney will pay your outstanding medical bills out of the settlement moneys that have been deposited in his or her trust account or whether the money will be given to you and you will pay them. First, the attorney will generally pay subrogation liens out of the settlement and as we learned previously, he or she *must* pay medical providers to whom letters of protection had been issued. As for the other medical providers to whom no letters of protection had been issued, unless your contract with the attorney requires that the attorney make the payments out of his or her trust account, it will often be your decision.

> I usually tell my clients at that point that my taking care of making the payments is an extra service that I provide as part of my fee for handling the case. However, if the client wants to pay the bill himself or herself, that is fine too.

I prefer to make the payments if the client consents because doing so helps keep me on better terms with doctors. If doctors think that I am looking out for them, they are more likely to be cooperative in the litigation process and to accept letters of protection from me. This is a great benefit to my clients.

What Is Subrogation?

Subrogation is designed, in theory, to prevent a plaintiff from collecting more than once for the same element of damages. To prevent "double-dipping." This is best explained by example. Suppose that a plaintiff has an accident and has med-pay/PIP coverage on her own policy which pays the first $10,000 of her medical bills, which totaled $20,000. Then, she sues the driver who was at fault for the accident and gets money from the jury for pain and suffering, lost

wages, as well as the full $20,000 for her medical bills. At this point, the plaintiff has collected her medical bills, $20,000, from the defendant and has also had $10,000 of the bills paid by her own insurance company. As such, she has a net gain of $10,000 with regard to her medical bills (she has gotten $30,000 for $20,000 worth of bills). In most states, this is seen as unfair and the law gives the plaintiff's own insurance company the right to be paid back the $10,000 that it spent on her medical bills.

Understand that the plaintiff only has to pay back her own insurance company if she collects that money from the tortfeasor. Suppose the defendant had no money and no insurance, so the plaintiff was unable to collect any money in her claim or lawsuit. She would not have to pay back her insurance company. She only has to pay them back to the extent that she makes an overall gain by collecting from the party at fault.

Subrogation often applies in the same manner to health insurance as well. In some states, money paid by Workers' Compensation for wages and/or medical bills must be paid back from other insurance judgments or settlements.

Subrogation is becoming more complicated in practice because of modern no-fault laws. Traditionally, the plaintiff would collect all medical bills from the defendant and then pay back her own insurance company to the extent that they paid her bills. It was argued that the defendant, who was the wrongdoer, should not benefit from the plaintiff having purchased insurance by getting a credit for what the plaintiff's insurance paid. No-fault laws, however, are changing this.

In many states today, to the extent that the plaintiff's bills are paid by his or her own insurance, the liability of the defendant is reduced and the plaintiff does not have to pay back his or her own insurance company. Paradoxically, the defendant gets a credit for the plaintiff having purchased insurance protection for himself or herself. Thus, using our previous example, the defendant would only have to pay the plaintiff for $10,000 of the $20,000 in medical bills because the plaintiff's own insurance paid the first $10,000. In turn, the plaintiff does not have to repay anything to his or her own insurance company. In effect, the plaintiff has paid her hard earned dollars for a policy that ultimately financially benefits the wrongdoer.

As you might imagine, I have some moral concerns about the fairness of these systems, although I must admit that they can simplify the process to some extent. No-fault laws are being implemented in more and more states under the theory that ultimately they reduce lawsuits and therefore insurance costs. Whether this is true remains to be seen.

The Attorneys Fees and Costs Deduction

As an additional subrogation issue, many state laws provide that if a plaintiff pays a lawyer to collect money from the tortfeasor, the insurance company seeking subrogation must share in the attorney fees and costs. Suppose the plaintiff has $20,000 in medical bills which were all paid by her medical payments coverage. Suppose further that the plaintiff sues and collects the full $20,000 from the defendant. In that case, if the plaintiff has to pay her attorney one third of what she gets from the defendant, then that would mean paying the lawyer one third of the $20,000 in medical bills that are collected from the defendant. If the plaintiff were then required to pay back the full $20,000 to her insurance company that paid for her bills under her insurance policy, she would have a net loss ($20,000 minus one third equals $13,333.33. If she then must repay her insurance company the full $20,000 she has a net loss equal to the attorney fees of $6,666.66).

> As it is considered unfair to allow the plaintiff's insurance company to "ride the coattails" of the plaintiff and not pay anything for attorney fees and costs, the law often allows the plaintiff to reduce the amount of subrogation by the corresponding pro-rata percentage of attorney fees and costs that were paid. In our example, the plaintiff would subtract one third (assuming a one-third attorney fee which includes costs) of the amount of subrogation—and repay her insurance company $13,333.33 of the $20,000 that was paid.

If costs were not included in the attorney fee, the costs would be added to the attorney fee and then calculated to determine what percentage of the total settlement or verdict constituted attorney fees and costs. The plaintiff would then reduce the amount paid back to her insurance company by that percentage figure. For example, suppose

there was a settlement of $100,000, a one-third attorney fee and $10,000 in costs. The total fees and costs would come to $43,333.33 ($33,333.33 in fees plus $10,000 in costs), which is 43.3 percent of the $100,000 settlement. Therefore, any subrogation to the plaintiff's insurance company would be reduced by 43.3 percent.

Insurance and Bad Faith Law

You may or may not be surprised to find out that sometimes insurance companies do not act fairly toward people making claims. Common examples include accusing the person making the claim of being at fault for an accident when there is really no basis for making that assertion; waiting unreasonable amounts of time to pay claims; not offering reasonable amounts to settle claims; claiming that a particular event is not covered by a policy when it clearly and unquestionably is; failing to respond to phone calls and letters and so on. I think that the West Virginia Supreme Court explained the purpose of bad faith laws very well when it wrote:

> "when an insured purchases a contract of insurance, he buys insurance—not a lot of vexatious, time-consuming, expensive litigation with his insurer."

> Hayseeds v. State Farm Fire & Cas., 177 W.Va. 323, 352 S.E.2d 73 (1986).

Unfortunately, in most places, there is very little that a lowly little insurance claimant can do against a big, wealthy, powerful insurance company.

Most states have laws or regulations that prohibit insurance companies from being unreasonable. These laws are commonly referred to as "bad faith" laws. However, in many states these laws have little bite. The only thing a person can do if they are being treated unfairly by an insurance company is to make a complaint to the state government agency that regulates insurance and hope that it does something to try to get the insurance company to be reasonable and fair.

Unfortunately, many states do not have adequate resources to investigate all of these claims; so claimants have to fend for themselves.

In a few states, however, individuals can personally sue insurance companies for violating bad faith laws. In other words, people in these states can sue the insurance companies for committing acts of bad faith during the claims process. These laws provide that people can sue for money to compensate them for annoyance and inconvenience

caused by acts of bad faith and sometimes attorney fees incurred in bringing the lawsuit and potentially punitive damages if the conduct of the insurance company is considered bad enough.

Ask your attorney whether your state has these laws and if so, whether in his or her opinion they actually reduce unfair practices by insurance companies.

4 How Much Is Your Case *Worth?*

How much is your case worth? Good question! It is often a complicated process to determine how much a case is worth. First, if you do not understand what is meant by the term "damages," or you have forgotten or started reading this book with this chapter, take a moment to read the "Some Words You Need To Know" portion of the Introduction to this book.

The ultimate answer to the question "How much is my case worth?" is "Whatever the jury thinks it is worth." However, the context in which this question comes up is usually connected to the question how much to value a case for possible settlement purposes—in order to avoid having a jury determine the ultimate outcome.

> Whenever you make a legal claim against someone else (assuming that person has some form of insurance coverage), both you and the person's insurance company will want, if possible, to reach a settlement in the case. No one wants to go to trial and face the chaotic unknown of how much...or how *little*...a jury might award.

In order to settle a claim, though, the two sides must come to an agreement as to how much the case will settle for. You, the plaintiff, must determine the least you will accept and the defendant must determine the most they will pay. If these numbers overlap, the case can settle.

So how does each side determine how much it believes the case is worth? The process is complicated and involves many factors. Each side will make its own guess as to how much money a jury might award in a verdict—based on such factors as:

- the political leanings of potential jurors in the place where the jury trial will be held;

- the economic situation of the average potential juror in the place where the jury trial will be held;

- whether or not there is a question about who is at fault;

- whether either party is well known in the community where the case will be tried and

- many other facts which interplay.

Each side will also factor in how much it will cost in fees, time and other expenses to take the case all the way to trial. Only through experience and training can a lawyer interpret and analyze these factors. But I can help you get a quick sense of these forecasts by considering some of these factors in more detail.

> **This chapter will give you a functional understanding of how your lawyer will arrive at a recommended settlement range for your case.**

How much money a jury will arrive at in its verdict is a very difficult thing to predict.

Jurors are chosen at random from among the members of the community. As such, every jury is going to be made up of a different set of people with different beliefs, genders, occupations, races, economic situations, etc. On one day, a chosen jury might be totally different than a jury chosen the next day. One day the jury might be mostly liberal; the next, mostly conservative. One jury might be mostly men and another, mostly women; one jury might be mostly middle class and another, mostly poor. One jury might be mostly Catholic and another mostly Protestant and so on.

The best that one can do is to look for traits in the community as a whole from which the jury will be chosen. For example, is the community mostly Republican or mostly Democrat; mostly wealthy or mostly poor; blue collar or white collar; well-educated or mostly less

educated? A personal injury case might be worth more in a county where people make more money than in a county of poor folks where unemployment is high. On the other hand, if the wealthy county is politically conservative, the poorer county might be preferable—because politically conservative jurors tend to be more skeptical about injury claims.

> Remember, these are statistical stereotypes that do not always pan out. Juries often do not do what statistics say they "should." This unpredictability is one of the reasons that even personal-injury lawyers don't like going to trial.

Another important consideration is the strength of proof of the plaintiff's damages. In other words, is it clear how extensive the plaintiff's injuries are and is it also clear that those injuries were caused by the accident? A lost limb in an accident is much more clearly and easily linked to an accident than, say, lower back pain or so-called "soft tissue" injuries for which no cause can be found in medical tests—even when there is real, serious damage.

Does the plaintiff have any conditions that existed prior to the accident? If the plaintiff was in a wreck five years ago and complained of lower back pain and is in another wreck and now complains _again_ of lower back pain, a jury will have to decide how much of the current pain was from the prior accident.

The clearer the damages and the clearer the connection between the injuries and the accident, the easier it is to prove the case to a jury.

Keep in mind also that most of the proof regarding these issues must be based on opinions from doctors. As such, it is much more helpful if the plaintiff's doctor will give an opinion that the accident caused a certain injury than if he says he does not know. Doctors are frequently noncommittal on the causation of an injury from an accident. Furthermore, if the plaintiff's own doctor says an injury is not related to the accident, the judge will often not allow the claim for that injury to be presented to the jury.

Contributory Negligence

Another factor that must be considered when evaluating the settlement value of a case is whether the plaintiff was partly at fault for the

accident. Each state follows one of two main types of rules regarding the effects of the plaintiff's own partial fault in an accident: contributory negligence or comparative negligence.

In my opinion, contributory negligence is one of the most abysmal distinctions in the legal system of the United States.

In an outdated reflection of America's colonial past, a lot of U.S. law is based on English common law. And, back in *Olde England*, that common law contained a principle called "contributory negligence."

> **Under that principle, if a plaintiff was 1 percent or more at fault for his injury, he was not entitled to recover anything—zip, nada, nothing. For example: John was negligently run over by Bill's horse. But John had a glass of wine before the event and a jury finds that, because of the wine, John was 1 percent at fault for his own injuries; Bill was otherwise 99 percent at fault. Still, John would get *nothing* in a lawsuit.**

The contributory negligence rule was originally adopted in most of the states, back in the old days. However, in the 20ᵗʰ Century, most states eventually abandoned the rule in favor of the rival "comparative negligence" rule, which I explain in the next section.

Unfortunately, there are a few states that still cling to the rule of contributory negligence—despite its inherent unfairness and outdated reasoning. So beware, because in these states if you are found 1percent or more at fault yourself, you *cannot* collect damages from someone else. You get nothing.

(I should note that one way to sometimes get around this harsh rule is the last clear chance rule. Under that rule, if the defendant had the last clear chance to avoid an accident and did not, the plaintiff may still collect even if he or she was partly negligent.)

As of the time this book was written, the jurisdictions still having the contributory negligence rule were Alabama, North Carolina, Virginia, Maryland and the District of Columbia.

Comparative Negligence

Although the rule is a little complicated and there are several variations in the states, the comparative negligence rule basically holds that the amount of money that the jury gives to a plaintiff will simply

be reduced by their own percentage of fault. In other words, the jury is required to decide how much, if any, the defendant was at fault for the plaintiff's injuries and what percentage, if any, the plaintiff was at fault for his or her own injuries. Then, the amount that the jury gives will be reduced by the judge in an amount equal to the percentage of the plaintiff's own fault.

So, in our previous case of John and Bill, John would receive 99 percent of his damages (since he was 1 percent at fault, resulting in a reduction of his damages by 1 percent to 99 percent), rather than nothing—which he would get under the contributory negligence rule.

Also, some state laws provide that if a plaintiff is more than a certain percentage at fault for his or her own negligence, the plaintiff does not get anything. Each state follows one of three scenarios in that regard. First, some states are called "pure comparative fault" states. In those states, it does not matter whether the plaintiff is 1 percent at fault for his or her own injuries or 99 percent at fault, the defendant still has to pay, but in an amount reduced by the plaintiff's own level of fault. So, even if the plaintiff is 99 percent at fault for his or her own injuries—which the jury determines are $100,000—the plaintiff may still collect that 1 percent or $1,000 from the defendant.

The rest of the comparative negligence states follow one of two other systems. In one system, the plaintiff may collect money from the defendant only if the plaintiff's own level of fault is 49 percent or less. In other words, the defendant has to be more at fault than the plaintiff by at least 1 percent.

Plaintiff's Fault	Defendant's Fault	
50%	50%	Plaintiff Loses
49%	51%	Plaintiff Wins

In the other system, the law provides that if the plaintiff and defendant are equally at fault, the defendant has to pay, but if the plaintiff is more at fault, then the plaintiff loses. Said another way, the plaintiff only wins if his or her level of negligence is 50 percent or less.

Plaintiff's Fault	Defendant's Fault	
50%	50%	Plaintiff Wins
51%	49%	Plaintiff Loses

When evaluating the settlement range for a case, the attorney must therefore consider whether the plaintiff did anything in the accident for which the jury could assign partial fault. Was the plaintiff going to fast? Using a mobile phone at the time of the accident? Eating? Tired? If there is any possibility that some percentage of fault might be attributed to the plaintiff, this must be considered.

In a *contributory* negligence state, the attorney must determine whether the plaintiff's own potential negligence jeopardizes the case and, if so, how this affects the minimum for which the plaintiff should be willing to settle. In a *comparative* negligence state, the attorney must consider the extent to which the plaintiff's negligence may cause the jury's verdict to be reduced and factor that into the settlement.

Personal Injury Damages

The most significant consideration the lawyer has to make in determining settlement value is an analysis of the types of damages that the plaintiff can claim as a result of his or her injuries and the nature of the case.

There are several types of damages that a plaintiff may seek in a typical personal injury case. The damages for the actual losses and effects of the accident upon the injured plaintiff can be divided into two main categories—economic damages and non-economic damages, which are also sometimes called "special" damages and "general" damages, respectively. The economic and non-economic damages can each then be further divided into past and future damages. In other words, damages suffered up to the date of trial as a result of the accident (past) and damages that are expected to continue to accrue into the future as a result of the accident (future).

Economic/Special Damages

Economic damages or "special damages" as they are also often called, are those types of damages which have a clear dollar amount associated with them. The main types of economic damages in personal injury cases are medical bills, lost wages/lost profits, loss of earning capacity and property damage.

The main feature of economic damages which distinguishes them from non-economic damages is that they have a sum certain. In other words, we can point to a medical bill and show how much money was

lost. We can point to lost wages and say how much was lost. We can point to a damaged car and show how much it cost to fix or replace it.

Economic damages—such as with loss of earning capacity—might not always be easy to calculate; but they are based on calculable figures. We know about how much back surgery will cost. An economist can calculate approximately how much a person would have earned in their lifetime had they not been disabled by an injury.

Conversely, as we will see, non-economic damages are much harder to value. So, let us look at each of the types of economic damages.

Why You Should Buy a Safe Car

After many years of representing victims of auto accidents, as well as being married to an orthopedic surgeon, I have seen the full array of injuries that people suffer in these accidents. One way that these experiences have changed my frame of mind has been to make me realize the importance of crash protection ratings when purchasing a car.

> Some accidents are so severe that it does not really matter how safe the car is. However, in many accidents, the crash-worthiness of a car can mean the difference between minor and severe injuries or even the difference between life and death. I am not an engineer, nor am I an expert on auto safety—so I am not qualified to tell you how to evaluate a car's safety. However, I have learned that there are resources available from such experts that can at least give you an idea of how one car has compared to others in crash tests.

Check out www.safercars.gov for crash test results from the National Highway Transportation Safety Administration, an office of the Federal government. In addition, www.iihs.org lists crash test results from the Insurance Institute for Highway Safety, a non-governmental organization that conducts independent offset-crash, side-impact and other safety tests. Do some research before you buy.

Valuing Medical Bills

If the jury finds in your favor and gives you money to compensate you for your injuries, they will have to consider past and future dam-

ages separately and their verdict form will normally have separate entries for past and future damages. This is because the level of proof required for future damages is often greater than the level of proof required for past damages.

> **The plaintiff must normally prove any type of damages suffered up to the time of trial by a preponderance of the evidence. This means that he or she need only prove that it is more likely than not (any amount, even slightly, more than 50 percent) that the past damages were caused by the accident.**

With regard to medical bills, this involves presenting the medical bills along with evidence that the bills were incurred because of injuries caused by the accident.

With regard to any type of future damages (those that will continue after the trial but must be presented at the trial in order to be compensated), the plaintiff must prove that the injury was caused by the accident by a preponderance of the evidence, but must prove to a greater level of proof that the injury is likely to continue into the future or be permanent.

For example: Bill is in an accident that was not his fault and suffered a herniated disk in his spine. As a result of the herniation, Bill has had pain and suffering ever since the accident and it has not stopped. He has had physical therapy and a surgery which both helped, but he still has pain. As such, he will have to continue taking pain medication indefinitely and will require an additional surgery and subsequent physical therapy. To make a claim at trial for the future, continuing medical bills, Bill will have to:

1) prove by a preponderance of the evidence that the herniation was caused by the accident;

2) prove that the treatment up to trial was a result of the herniation; and

3) prove by a higher standard that he will need the future treatment.

Commonly, the higher standard for proving that future medical bills and pain and suffering will be incurred is to a level of reasonable certainty. Thus, Bill will have to prove that it is reasonably certain that he will require the additional treatment in the future. Furthermore,

the only way to make such proof is by the testimony of a doctor who is qualified to render such an opinion. In Bill's case, he might call an orthopedic surgeon to testify. Bill's attorney will ask the doctor to give an opinion that he or she believes to a reasonable degree of medical certainty within the field of orthopedic surgery that the future treatment will be required.

The defendant's attorney will probably call another doctor to testify that it is *not* reasonably certain from a medical standpoint that the treatment will be needed (or for that matter that the injury was caused by the accident). Then the jury will have to decide which of the competing experts they believe.

Once your doctors have provided opinions about what they believe your future medical treatment will be, you must then be able to properly tell the jury how much these bills will cost. Sometimes, your doctor and/or his or her staff will be able to provide you with a list of the costs of the medical treatment that you are reasonably certain to be required in the future. If your doctor is hesitant to do this or if your medical treatment will be extensive, your attorney may want to hire a life care planner to create a report.

Life Care Planners

A life care planner is someone who takes the information about your future medical needs, from medical procedures all the way down to band-aids and aspirins and calculates the prices of these needs, generated in the form of a report. Life care planners are often nurses or doctors who work either solely as life care planners or do so in addition to their regular jobs. As you might expect, life care planners who are nurses usually do not charge quite as much as life care planners who are medical doctors. Of course, those who are doctors are often permitted by the judge to give more detailed medical opinions at trial.

Another consideration regarding life care planners is whether they are certified. This may be important when it comes time to ask the judge to recognize a life care planner as an expert. Life care plans consist of the life care planner's opinions about how much future medical bills will be. Testimony regarding opinions may only be given by witnesses who are certified by the judge as an expert in their field.

Thus, the plaintiff's lawyer must convince the judge that the life care planner is an expert on the preparation of life care plans and the opinions contained therein, otherwise the judge will refuse to allow the life care planner to testify and also refuse to allow the use of the life care plan itself. This could be disastrous because the plaintiff might not then be able to prove the costs of future medical bills and might consequently lose out on those damages.

Therefore, the plaintiff's lawyer must make certain that he or she hires a life care planner with enough credentials to convince the judge that he or she is an expert in life care planning.

In this regard, it helps to hire a certified life care planner. Some states may have certification or licensing requirements and there are also some organizations that offer life care planning certification. Each state or organization has different requirements for certification that consist of various education requirements and/or examinations.

If your lawyer can establish that your life care planner is certified by one or more states or well known organizational bodies as a life care planner, it will make it much easier for the judge to rule that the life care planner is qualified as an expert.

Regardless of whether the future costs are provided by your doctors or through a life care plan, that information is then sent to an economist or accountant who calculates the "present value" of those costs. This means that, for example, if you are expected to incur $100,000 dollars in medical expenses in the future, the present value of that $100,000 will actually be a lesser amount. That is because money that you are given today can be placed in a savings account and will grow over time.

Thus, if you are expected to incur $100,000 in medical bills at regular intervals over twenty years, it may be that $50,000 paid today could be invested and the interest used to pay the $100,000 of expenses over that twenty years. In that scenario, the present value of the $100,000 future expenses would be $50,000. These calculations are extremely complicated and that is why it is often necessary to hire economists or accountants to make them.

Finally, understand that the higher standard of proof describe above typically applies to all future damages, not just medical bills. Thus, in

many states it must typically be proven by reasonable certainty that lost wages, lost profits, loss of earning capacity, pain and suffering, loss of consortium and so forth will continue in the future.

Lost Wages/Lost Profits

Lost wages are just what you would imagine—those wages that you lose because you are unable to go to work because of your injuries. These damages are relatively simple to prove. Once you prove that the accident caused your injuries and that your injuries prevented you from going to work, you simply have your employer or some other knowledgeable witness testify as to how much money you would have earned had you been able to go to work.

If you are self-employed or own your own business, proving your losses may be more difficult. You will have to show how much money you normally would have made in wages and/or profits had you been able to work. This can be done using accounting records, prior tax returns and so forth.

If your business is new, you may have difficulty proving how much you would have lost because you do not have records to show how much money you made in the past in order to estimate how much you would have made in the future. If that is the situation, your attorney may need to hire an economist or accountant to testify as an expert as to what your losses were. Furthermore, if your evidence is weak— meaning that you do not have solid evidence to show how much you would have made—the judge might even refuse to let you make the claim for those losses and grant summary judgment on that issue.

Loss of Earning Capacity

Loss of earning capacity is your ongoing loss of ability to perform your job at all or perform it as well as you did before the accident. This is only an issue if you have future or permanent injuries that affect your ability to work.

Suppose, for example, that you are a construction worker and you sustain a permanent injury that affects your ability to lift objects more

than 20 pounds. Obviously this will reduce your ability to perform the tasks of a construction worker. Or suppose that you are a teacher and are unable to either sit or stand for more than 15 minutes without extreme pain. Your ability to teach will be reduced.

> **The best way to present loss of earning capacity to a jury is by hiring experts to calculate the loss. A vocational expert may be consulted to evaluate your job skills as well as your medical information and provide an opinion as to what percentage your ability to perform your work has been reduced.**

It may be that your work abilities have been reduced by a percentage or it may be that you are totally disabled from a vocational standpoint—meaning there is no job that you can reasonably perform given your injuries.

How does a vocational expert figure out what percentage your ability to work, your earning capacity, has been reduced?

If your doctor has clearly indicated either by letter, report or in your medical records that you are totally disabled from performing any work, the vocational expert's job is much easier. You have a 100 percent loss of earning capacity. Stated another way, you are totally disabled from a vocational standpoint. The vocational expert, if one is even needed in that case, need only buttress the doctor's opinions by indicating that there are no jobs available for someone with your limitations and therefore agrees that you are totally disabled.

How does a vocational expert designate a percentage of loss of earning capacity that is between 1 and 99 percent?

The expert will need to know exactly what physical and mental limitations you have from a medical perspective and to what extent they physically limit you. This will be based on opinions from doctors in medical reports and medical records as well as interviews with you in which the expert asks a series of questions about what you can and cannot do. For example, the expert might ask how long you can sit or stand without discomfort. How much weight you can lift, how often you get headaches and so on.

A jury will be scrutinizing the truthfulness of your answers, so another useful tool that a vocational expert can use is called a functional capacity evaluation—often abbreviated FCE. A functional capacity evaluation is usually conduced by a physical therapist but might

also be conducted by a physician. The evaluation consists primarily of taking measurements of your ability to function physically. This might include such things as how much weight you can lift, how long you can sit comfortably, how long you can stand comfortably, how far you can walk without experiencing pain, how far you can bend or flex various parts of your body, how long you can function in certain situations without pain medication and other related evaluations.

These tests are used to determine the extent to which you are able to function physically compared to your previous levels of function, compared to the average person of your age and compared to the average person of your vocation in order to determine how much your abilities have been reduced or lost. This information can be extremely useful in determining the extent to which you are vocationally disabled—the extent of your loss of earning capacity.

Also, the information from the vocational expert is given to an economist or accountant who uses economic data and statistics to determine how much money you will lose in the future because of your reduced ability to work. If your abilities are expected to be reduced for a certain number of years, then the calculations are done for that number of years. If your reduction is believed to be permanent, then the calculations will be made using the date that you planned to retire or, if that cannot be proven, the average retirement age according to government statistics.

The final numbers that will be presented to the jury must then be reduced and presented in their present value.

There is one final tidbit that I want to mention on this topic. Although some lawyers might disagree, it has been my experience that jurors are more receptive to lost wage and loss of earning capacity claims when the plaintiff tried to go back to work.

I realize that in some situations injuries are so severe that going back to work is not an option—and in those cases I do not think that a jury will penalize the plaintiff for not trying to work. However, where the plaintiff's injuries are such that the plaintiff can still otherwise function in life, I think that it looks better if the plaintiff tried to go back to work but simply could not do it rather than not trying at all. My reasoning is that during cross examination, if the plaintiff testifies

that he or she is able to do grocery shopping, take the kids to soccer practice, go on vacation, do the laundry and dishes and so forth, it will be very tough for a jury to believe that the plaintiff cannot work.

On the other hand, I realize that working is often much different than slowly and carefully doing housework and so does a jury. So if the plaintiff can explain that he or she is able to do chores by doing them a little bit at a time or very slowly, but that he or she tried to go back to work but could not keep up without serious pain, a jury is more likely to believe that the plaintiff truly cannot work and is not simply trying to milk the lawsuit.

Legal Fees and Costs

Traditionally, the winning party in a lawsuit cannot collect his or her attorney fees and costs from the losing party. However, there are a few state and federal laws that permit recovery of attorney fees and costs for certain types of lawsuits.

Check with your attorney to find out whether it is possible to collect your attorney fees from the defendant(s) if you win.

Property Damage

Another category of economic damages is damages to property, including your car and property that was damaged in the car.

General Damages

Non-economic damages—also sometimes called "general" damages—are more mysterious than economic damages, in that there is no specific formula that we can use to help calculate them. Their amounts are left almost entirely to the imagination of the jury.

Non-economic damages include such things as pain and suffering, loss of enjoyment of life, mental anguish, scarring, loss of consortium and related damages which may have different names in different states. The jury cannot look to any formula or calculation or price book to see how much money they should give a plaintiff to compensate him or her for the pain and suffering experienced as a result of an accident. The jury is left totally to their own opinions, life experiences, judgments and intuitions in arriving at an amount. In fact, in many states, the plaintiff may not even suggest to the jury that a specific

amount should be given. In others, lawyers may suggest to the jury a specific amount to give.

Let us now look at some of the main types of non-economic damages in more detail.

Pain and Suffering

Unfortunately, when someone experiences a personal injury, they usually experience corresponding pain and suffering. Because pain and suffering can be one of the most unpleasant experiences in life, our society believes that when someone negligently causes pain and suffering to someone else, that the injured person should be compensated for having to endure that pain and suffering

> To some people, it may seem improper to try to place a monetary value on pain and suffering, but unfortunately that is the best that our system can do to try to make up for the pain. In other words, if we cannot take away the pain, the best we can do is pay someone for having to experience it.

Presenting evidence to the jury regarding pain and suffering is inherently difficult. You cannot take an x-ray of pain or hook someone up to a machine that measures pain. Also, every person experiences pain differently. Thus, the only way to show the jury how much pain the plaintiff has suffered is to have the plaintiff describe the pain to the jury. The plaintiff can describe not being able to get out of bed because of pain or crying for hours while huddled in a crouched ball shape in the corner because of it. They can talk about the medications that they have to take—which may or may not help very much.

Many of my female clients have compared their pain to childbirth. Anything that can help the jury visualize the extent of the pain helps. Those descriptions, together with the doctor's descriptions of the injuries, may give the jury an idea of what the plaintiff is going through.

Mental Anguish

As an extension of and somewhat incorporating pain and suffering is the concept of loss of enjoyment of life and mental anguish. In addition to the actual pain that an injured person suffers, the effects of

the pain and suffering and other limitations of the injury may affect the person's ability to enjoy life.

There are various things that most people would list if you asked them what it is that they enjoy about life. Some of those things might include playing sports, going on trips, getting together with friends, taking care of family, going dancing with a spouse and so on. Pain reduces a person's overall enjoyment of life. This is often another category of damages wherein a jury may compensate the plaintiff for this loss, although some courts simply combine it with the pain and suffering category.

In addition, when someone's enjoyment of life is reduced or as a result of pain itself, people often become depressed and otherwise suffer mental anguish. This is often compensable as well, either as part of loss of enjoyment of life or as a separate category of damages.

Scarring

Scarring usually will not be a separate category of damages. However, scarring can be a significant cause of someone's reduction in ability to enjoy life. Many people are sensitive about their personal appearance. Scarring, depending on how prominent and extensive, can be a potential cause of reduction in one's self-image and therefore reduce the ability to enjoy life and cause mental anguish. If you have scarring as a result of your injuries, you will want the jury to see your scarring—whether by showing them or by photographs—to let the jury know how it has negatively affected your life and self image.

> **I have had the most difficulty determining a reasonable settlement amount for scarring. Some juries do not see scarring as a particularly big deal and others see it as devastating. I also found that some insurance adjusters saw scars as warranting large settlements while others saw them as having very little settlement value.**

Loss of Consortium

When one of the spouses of a married couple is injured by the fault of another, the non-injured spouse tends to suffer as a result. As such, the non-injured spouse is entitled to sue the tortfeasor for loss of

consortium. Loss of consortium consists generally of the "three s's:" services, society and sex.

In other words, the non-injured spouse may receive compensation for the loss of services typically performed by the injured spouse, such as helping to take care of household chores, the society of the injured spouse, such as going out to dinner or dancing or to social events and, of course, the loss of sex occasioned by the injured spouse being unable to have sex because of the injuries. Again, the jury has to figure out how much compensation is appropriate to compensate for the inability to have sex with one's spouse.

Similarly, an injured person's children may have a claim against the defendant for loss of parental consortium which includes such things as loss of parental affections and recreation. A small child can be very negatively affected if their parent can no longer pick them up after having done so their whole life.

Note that if you hire someone to perform household services that the plaintiff is no longer able to do because of injuries, that would be an economic loss, rather than a non-economic loss.

Valuing Non-economic Damages

It is usually harder for a jury to decide how much money to give a plaintiff for non-economic damages—such as pain and suffering, loss of enjoyment of life, mental anguish and loss of consortium—than it is for them to decide how much to give for medical and wage losses.

With regard to medical and wage losses, the jury will be presented with very specific numbers that they can use to arrive at an amount of money. It usually has less concrete advice from the lawyers in determining non-economic damages because there is not a definite amount of money that the parties can point to. Since we cannot scientifically measure pain and suffering, it is difficult even to begin to match levels of pain and suffering to amounts of money—and even trying to do so can feel awkward.

The jury, for the most part, can only take what they have heard from the testimony and other evidence and do their best to give what they believe is fair. This is why one jury on one day might give a much different amount of money than a different jury on a different day. These amounts are based on the jurors' life experiences, biases, economic standings in life and other factors which may vary among different groups of six strangers.

One other point that you will want to be aware of is that some states allow the plaintiff's attorney to suggest an amount of money to the jury to give for non-economic damages or suggest to the jury that the suffering is worth so many dollars per day and that the plaintiff is expected to live a certain number more days (suggesting that the jury multiply to reach an amount). Other states absolutely forbid the attorney from making any suggestion to the jury of an amount that they should give for non-economic damages.

Further, some states do not allow the plaintiff's attorney to suggest that the jury put themselves in the shoes of the plaintiff or try to imagine how much they would deserve if they were going through the same ordeal. The theory is that juries should decide cases based on facts, not emotions.

Remember when you are considering settlement options that amounts given by the jury for non-economic damages are very hard to predict. The jury's final decision can easily be much more or much less than you or your attorney predicted.

Issues Involving Children

Can a child be negligent?

Sometimes torts are committed by children and sometimes children are injured by the torts of others. As such, there often arises the issue of whether a child can be negligent, either as the primary negligent person (the tortfeasor) or as comparatively or contributorily at fault for his or her own negligence.

In looking at this issue, one must first know what the term "child" refers to in the relevant jurisdiction. In most places, for legal purposes, a child is someone under the age of majority, which is usually eighteen years old. So in most places a "child" is any person who is between birth and eighteen years old. Note also that some jurisdictions refer to anyone under 18 years old as an "infant," despite our usual connotation of that term referring only to a baby.

Next, we must find out what the rules are regarding the liability of children in the pertinent jurisdiction, which will be either the place where the tort occurred or the place where the litigation occurs, depending on the rules of the court where the litigation occurs. In other

words, the court may use the child liability laws of the state where it is located or may use the child liability laws of the state where the tort occurred, if in a different state.

Back in the old days, following English common law, states often used the "rule of 7" with regard to child liability.

The rule of 7 used a three-tiered approach, with a different rule applying depending on whether the child was between birth and 7, between 7 and 14 or over 14.

Under this rule, a child under age 7 was conclusively presumed incapable of negligence. That means that under no circumstances, no matter how smart the child was or how bad the act was, could a child under 7 years of age be found negligent. A child from age 7 to 14 was presumed incapable of negligence, but could be found negligent if it was proved that he or she was more mature than the typical child of his or her age.

In other words, a child from 7 to 14 got the benefit of the doubt of presuming that he or she was not mature enough to be held negligent for his or her actions. However, if it could be shown that the child was particularly intelligent or particularly mature, then the presumption could be overcome and the child of those ages could potentially be found negligent. Finally, a child over the age of 14 could be found negligent with no restrictions, just like an adult.

Today, some states still use the rule of 7 to determine the potential liability of children. However, other states have different rules. In some states a tiered system is used which is similar to the rule of 7, but has different age cutoffs for each tier. Still other states take a more vague approach in which the standard of care of a child is determined by the behavior and maturity of the average child of the same age.

In other words, the judge or jury will consider what level of maturity and behavior should be expected from an average child of the same age of the child in question—and determine whether the conduct of the child at issue is beneath that expected level. If so, then the child may be found negligent.

So, the behavior of a five year old must conform to the level of maturity expected of a five year old. The behavior of a 12-year-old must conform to the level of maturity expected of a twelve year old and so on. If the average 12-year-old is mature enough to know better

than to throw rocks off an overpass onto a highway and a twelve year old commits such an act and causes injury, then that twelve year old could be found negligent for that act.

> **There is an additional wrinkle. In some states, if a child who otherwise could not be found negligent may be found negligent while participating in an abnormally dangerous or typically adult-oriented activity.**

For example, a child who negligently operates an automobile or a four-wheeler or is operating some other machine that is dangerous and/or typically reserved for operation by adults could be found negligent in the operation of that machine. Of course, liability might revert to an adult if the child was operating the machine upon the orders of an adult rather than for their own benefit or recreation.

Parental Liability for Children

Parents often wonder whether they can be sued for injuries caused to others by their children. As usual, the answer to that question is not simple and as with most other issues varies widely by state. First, be careful to distinguish the difference between a parent being liable for the acts of their children and a parent being liable for negligent supervision. In a negligent supervision claim, the parent is sued for the parent's negligence in failing to properly supervise the behavior of their children. This is different from a parent being liable for the child's negligent acts.

There are several approaches to this topic that your state might take:

1) a parent might be liable for the acts of their children but only if those acts are intentional or particularly reckless; and sometimes there is also a maximum amount of money that the parent can be held liable for;

2) a parent might be held completely liable for the acts of their children;

3) a parent might not be held liable for the acts of their children in any circumstances.

In some states, parents may not generally be liable for the negligent acts of their children except when the child is driving a car and sometimes only if the car is titled or registered in the parent's name. If you want to know whether you have potential liability for your child's actions, you will need to find out the rules in your state.

Suing on Behalf of an Injured Child

Children, which generally includes anyone under age 18, usually cannot bring lawsuits on their own behalf. As such, when a child is injured by the negligent or intentional acts of a third party, the issue arises of how a lawsuit can be brought against the wrongdoer for the child's injuries. In general, there are two options:

1) the child can usually wait until he or she is an adult and then sue;

2) some adult can bring a lawsuit against the wrongdoer on behalf of the child.

In most states, when a child is injured, the usual statute of limitations is put on hold and does not start to run until they are 18. So, if a child is in a car accident when she is 14, she would have until she was 20 to file a lawsuit based on that accident.

Beware, however, that in some states there is a maximum time limit to bring a lawsuit regardless of whether the victim is a child. So be careful. In a number of states, there is a limit not for all types of cases but for certain types of cases, particularly medical malpractice.

In other words, a child might not be restricted to the normal two- or three-year statute of limitations but must still bring their lawsuit within a maximum of 10 years (or the limitations period past their 18th birthday, whichever is earlier).

So, if a child is injured at age 8 and there is a two-year statute of limitations and a 10-year maximum, a lawsuit would have to be filed on behalf of the child within 10 years of the accident. On the other hand, if the child is injured at age 15 and there is a two-year statute of limitations and a 10-year maximum, the 10-year maximum will be irrelevant because the suit will still have to be filed within two years of the child's 18th birthday.

I cannot stress enough how important it is to make sure you find out the statute of limitations deadlines for your case so that you do not miss them.

The other typical option (which may be necessary if the statute of limitations runs before the child is 18) is for an adult to bring a lawsuit on behalf of the child. As you might imagine, this will usually be done by a parent, but does not necessarily have to be. The lawsuit may be brought by a parent, legal guardian, a person appointed by the judge to bring the lawsuit or any other person permitted by state law. If the child's name is Billy Smith and the adult bringing the lawsuit on his behalf is Joe Smith, then the listed name of the plaintiff will be something along the lines of "Joe Smith, as parent of Billy Smith, a minor" or something similar.

> **Note that if the case is by a child against his or her parent, such as when the child is a passenger and the parent was a negligent driver, the parent being sued cannot be the child's representative, as that would be a conflict.**

When an adult brings a lawsuit on behalf of a child, the court realizes that the child is having his or her interests represented by someone who might not necessarily have the best interests of the child in mind. As such, states typically have various safeguards in place to protect the interests of the child.

For example: In most states, if the parties reach a settlement, it will have to be approved by the judge. The judge will want to make sure that the settlement is fair for the child. This usually involves the judge appointing someone, usually a local attorney who has nothing to do with the case (sometimes called a guardian *ad litem*), to review the proposed settlement and report to the judge as to whether that attorney believes the settlement is fair, reasonable and in the best interests of the child.

If the judge then approves the settlement, the child cannot later try to bring another lawsuit when he or she reaches age 18. Furthermore, the judge has to make sure that the money from the settlement will be saved for or used for the benefit of the child. Often, state law will require that the money be placed in a bank account which is in the adult's name on behalf of the child, but which cannot be touched until the child is 18.

Commonly, the money must be placed in an interest bearing, insured account and cannot be placed in investments that have a risk of losing money. Also, in some states the bank must certify that it will

not release the funds to anyone, absent a court order, until the child is 18 and then release the money only to the child.

The laws regarding lawsuits by or on behalf of children are very complicated and very important. As such, you should consult an attorney regarding the specific rules applicable in your state and/or situation so that you do not wait too long to bring a lawsuit.

If Children Are Injured or Killed

If a child is killed because of a negligent act, the typical principles regarding wrongful death actions will apply.

However, what if a negligent act causes a child to die who is still in utero? The laws differ by state; but there are three general approaches taken. The first approach holds that although injuries to an unborn fetus may be actionable, there cannot be liability for the death of an unborn fetus.

The second approach holds that a defendant can be sued for negligence which causes the death of a viable fetus. The law considers a viable fetus to be one that is far enough along that it could probably live if removed from the womb. Often the law will define viability using some sort of time-frame.

For example, the law might state that a viable fetus is one that has progressed into the third trimester. Thus, if the fetus dies before viability, however it is defined, then there can be no lawsuit for wrongful death. But if the fetus is considered viable, there can be.

The third approach holds that a defendant can be sued for negligence which causes the death of a fetus, regardless of whether it is viable. In other words, if a defendant's negligence causes the death of an in-utero fetus, no matter how far along the pregnancy is, there can be a lawsuit for wrongful death of the fetus. Of course, no matter what approach a state takes, there are always exceptions which prevent suing a mother for the wrongful death of a fetus as the result of a lawful abortion.

As with many of the issues in this book, you will need to consult your attorney or your state's laws to find out what the rules are in your state regarding liability for the wrongful death of an unborn fetus.

Other Damages Issues

Some other issues that you and your attorney will have to consider when analyzing the settlement value of your case, if applicable, are damage caps and failure to wear your seatbelt. Let us look at some of these.

- **Damage caps** are limits on the amount of money that a plaintiff can collect either overall or for a certain category of damages. The most common damage caps, which you may have heard debates about in the news, involve caps on the amount of money that a plaintiff can receive for non-economic damages (pain and suffering) in medical malpractice cases.

 There are even a few situations in which caps have been placed on all damages from a case, including economic damages. That means that theoretically a plaintiff could be limited to receiving less money than he or she actually lost. Obviously, there is much debate over whether these caps are fair. At present, most states only apply caps in medical malpractice cases. However, legislation is changing every day, so you should check to see if there are any damage caps that might apply to your situation.

- All but one state has laws requiring the use of seatbelts by adults. So what if someone is injured in an accident and was **not wearing a seatbelt** even though it was legally required? Does that mean that they cannot sue for their injuries? There are several ways that states deal with this situation. In some states, the failure to use a seatbelt, even though mandatory by law, cannot be used against a plaintiff to prevent or reduce the plaintiff's verdict from a jury.

 Conversely, some states permit the failure to use a seatbelt to be considered by the jury as evidence that the plaintiff was comparatively negligent and potentially reduce the plaintiff's verdict. Somewhere in between these positions, some states provide by statute that if the plaintiff was not wearing a seatbelt, that the medical expenses portion of their verdict will be reduced by a certain percentage spelled out in the statute. For example, the West Virginia statute provides that if the plaintiff was not wearing a seatbelt,

that the amount they receive for medical expenses may be reduced by 5 percent:

> d) A violation of this section is not admissible as evidence of negligence or contributory negligence or comparative negligence in any civil action or proceeding for damages and shall not be admissible in mitigation of damages: Provided, That the court may, upon motion of the defendant, conduct an in camera hearing to determine whether an injured party's failure to wear a safety belt was a proximate cause of the injuries complained of. Upon such a finding by the court, the court may then, in a jury trial, by special interrogatory to the jury, determine (1) that the injured party failed to wear a safety belt and (2) that the failure to wear the safety belt constituted a failure to mitigate damages. The trier of fact may reduce the injured party's recovery for medical damages by an amount not to exceed five percent thereof. In the event the plaintiff stipulates to the reduction of five percent of medical damages, the court shall make the calculations and the issue of mitigation of damages for failure to wear a safety belt shall not be presented to the jury. In all cases, the actual computation of the dollar amount reduction shall be determined by the court.

Contrast this with the language from the Maryland statute, which prohibits failure to use a seatbelt to be used against a plaintiff:

> (1) Failure of an individual to use a seat belt in violation of this section may not:
> (I) Be considered evidence of negligence;
> (ii) Be considered evidence of contributory negligence;
> (iii) Limit liability of a party or an insurer; or
> (iv) Diminish recovery for damages arising out of the ownership, maintenance or operation of a motor vehicle.
> (2) Subject to the provisions of paragraph (3) of this subsection, a party, witness or counsel may not make reference to a seat belt during a trial of a civil action that involves property damage, personal injury or death if the damage, injury or death is not related to the design, manufacture, installation, supplying or repair of a seat belt.
> (3) (I) Nothing contained in this subsection may be construed to prohibit the right of a person to institute a civil action for damages against a dealer, manufacturer, distributor, factory branch or other appropriate entity arising out of an incident

that involves a defectively installed or defectively operating seat belt.

- What happens if **the defendant files for bankruptcy** at some point during your claim? If the defendant has insurance in effect at the time of the accident, the only effect that the defendant filing bankruptcy will have on your case is that you probably will not be able to get anything from the defendant if the defendant's insurance is insufficient to pay your claim. Otherwise, your claim should proceed as though the defendant had not filed bankruptcy, except that if a case is filed before or after the bankruptcy filing, there might be a little extra paperwork involved.

 If a defendant who does *not* have insurance files for bankruptcy, the situation will be a bit muddier. If you have already filed a lawsuit, everything comes to a grinding halt pending the results of the bankruptcy proceeding; if the defendant files for bankruptcy before your lawsuit is filed, everything will be put on hold immediately after you file. Your attorney will probably register you as a creditor of the defendant with the bankruptcy court. This lets the court know that, if the defendant has any assets to pay creditors, you wish to be on the list to be paid. There is one obvious problem, however: Since trial is on hold, you will not know how much the defendant's debt to you is going to be.

The rules allow your attorney to ask the bankruptcy court to unfreeze the litigation in order to go forward to trial and obtain a verdict to be used to establish the amount of the defendant's debt to you. However, unless there are going to be significant assets to divide among the creditors, the judge may deny your request. Also, the judge may not allow your case to proceed because the defendant would not be allowed to spend the money on trial expenses that could otherwise be used to pay creditors.

Suffice it to say that if the defendant files for bankruptcy and does not have any insurance, your attorney will probably want to evaluate whether there is any point in con-

tinuing with your claim and may advise you to drop it. It would be foolish to spend more to continue litigation against the defendant than you could possibly collect. Whatever assets are available from the defendant will be divided among the creditors and then all unpaid debts, including yours, will be cancelled.

Joint and Several Liability

Some complicated issues arise when more than one defendant is liable for injuries to a plaintiff, such as in a multi-car accident.

What happens if there are three defendants equally at fault and only two of them have insurance? Is each defendant only liable to the plaintiff for a percentage of the verdict equal to his or her percentage of fault? The traditional rule on these issues is the rule of joint and several liability.

The rule basically means that each defendant is liable to the plaintiff for 100 percent of the verdict, regardless of his or her percentage of fault. In other words, the plaintiff can collect the verdict from one defendant, all defendants or several defendants. The plaintiff cannot collect more than 100 percent of the verdict—but can divide up how he or she is paid by the defendants in any way he or she desires.

Obviously, the plaintiff will want to start with the defendant with the most insurance or greatest personal net worth... and go from there.

This brings us to the related concept of contribution. Whereas joint and several liability allows the plaintiff to collect the judgment from the defendants in any combination the plaintiff chooses, the law usually then allows a defendant who paid more than his or her share of the judgment to collect some of the money back from the other defendants. Let us use an example. Suppose the plaintiff sues Joe, Bob and Tom for injuries suffered in an automobile accident. The jury returns a verdict for plaintiff in the amount of $100,000 and finds the defendants liable in the following percentages:

Joe 50% at fault
Bob 25% at fault
Tom 25% at fault

The plaintiff then collects all of the $100,000 from Joe because he has a large insurance policy. Because Joe paid 100 percent of the judgment even though he was only 50 percent at fault, he can collect 25

percent from Bob and 25 percent from Tom. This is called seeking "contribution" from the other defendants. Further, unlike the plaintiff who may collect any or all of the judgment from each defendant regardless of their percentage of fault, a defendant may only get contribution from another defendant to the extent of the other defendant's percentage of fault. Thus, Joe could not collect the other 50 percent all from Bob or all from Tom. He can only get contribution from each other defendant to the extent of their percentage of fault, in this case 25 percent each.

The legal theory behind contribution is that, when there are multiple defendants at fault and not all of them have insurance or financial resources, someone has to lose out. Either the plaintiff has to collect less than the total judgment or else one or more defendant will have to pay more than his or her share (and contribution will be fruitless because the other defendants have no money). In the situation where someone has to lose out, it is preferable that the defendants lose out because they are guilty—at least to some extent. The plaintiff is the only innocent person in the equation.

Some states have either modified or abandoned the traditional rule of joint and several liability. The first thing to note is that in some states, changes to the traditional rule have been made to apply to all types of cases. In some other states, the rules have only changed with regard to certain types of cases—frequently medical malpractice. So what are the alternative rules that these states use. One version abandons the joint and several liability rule entirely and says that the plaintiff can only collect from a defendant to the extent of the defendant's level of negligence.

Thus, if a defendant is 25 percent at fault, the plaintiff can only collect 25 percent of the judgment from that defendant. In other words, under this rule, if one or more of the defendants does not have enough money to pay their share, the plaintiff loses out, rather than the other defendants.

Another version of the rule provides that the plaintiff can collect only the defendant's percentage of the judgment from those defendants under a certain level of negligence, but can collect under the traditional rule—in any manner the plaintiff wishes—from any defen-

dants who are over that level. For example, the law might provide that if a defendant is less than 50 percent negligent, then the plaintiff can only collect from that defendant a maximum equal to their percentage of negligence. However, if a defendant is 50 percent or more negligent, the plaintiff can collect all of the judgment from that defendant regardless of their percentage of fault. Let us consider a couple of examples of a 50 percent threshold to help it make more sense.

Example 1: Three Defendants
Joe 20% at fault
Bob 15% at fault
Tom 65% at fault

In this situation, the plaintiff could collect a maximum of 20 percent from Joe and 15 percent from Bob, but could choose to collect any amount, including 100 percent from Tom. Tom is the only one who is above the 50 percent threshold. Of course, if the plaintiff collected more than 65 percent from Tom, he could seek contribution from Joe and Bob.

Example 2: Three Defendants
Joe 30% at fault
Bob 30% at fault
Tom 40% at fault

Here, none of the defendants meet the 50 percent threshold. Therefore, the plaintiff will only be able to collect an amount from each defendant up to their percentage of fault.

Example 3: Two Defendants
Joe 50% at fault
Bob 50% at fault

Here, both meet the 50 percent threshold, so the plaintiff could collect any or all of the verdict from either Joe or Bob. Here, the situation would be just like the traditional joint and several liability rule.

Taxes on Personal Injury Awards

Because tax laws frequently change and because different states have different tax regulations, I will not attempt to outline what taxes are applicable to personal injury settlements and verdicts. However, there are some tax issues to keep in mind because you will want to

know when considering a possible settlement how much, if any, of the settlement will have to be paid in taxes. You will need to consider not only whether there will be federal taxes on your settlement, but also whether there will be state taxes as well. Depending on the laws at the time of your settlement or verdict and the state in which you live, there may be taxes on:

- the whole settlement or verdict,

- none of it,

- lost wages and punitive damages but not on medical bills and pain and suffering or

- taxes only on punitive damages.

You will want to find out in advance what parts will be taxed and how much the taxes will be—before considering whether to accept a particular settlement offer.

> Do not be surprised if your attorney will not answer tax questions for you. Many attorneys—myself included—do not feel qualified to give specific tax advice. Accountants are tax professionals, lawyers (except for tax lawyers) typically are not. Much like I would not perform surgery on a client's spine, I do not advise my clients about their taxes other than to explain basically that there are tax issues involved and suggest that if they are concerned they should talk to an accountant.

Wrongful Death Damages

When someone dies as the result of a tort, the lawsuit procedures are a little bit different than in other personal injury cases. A wrongful death case is usually brought by the executor or administrator of the estate of the deceased. That person makes all of the litigation decisions as though he or she were the plaintiff. In addition, he or she is responsible to the beneficiaries of the estate for making reasonable decisions. The decisions do not have to be perfect decisions or even the best decisions, but they have to be reasonable under the circumstances.

Another important difference often applicable to wrongful death cases is how the money is distributed. When a plaintiff dies before his

or her case is resolved, but does not die because of injuries related to the case, any money that is received normally becomes part of the estate. It is distributed to the beneficiaries according to the deceased's will—or to his or her legal beneficiaries if he or she had no will.

In wrongful death cases in most states, the money does not necessarily go to the same beneficiaries as listed in the will. Instead, most states have statutes indicating to whom the money is to be distributed. Most statutes provide that the money is to be distributed in varying proportions to the surviving spouse, if any; the surviving children, if any; and other relatives if there is no surviving spouse or children. In some states, there is also a provision providing for distribution to others who were economically dependant upon the deceased.

To illustrate, here is a sample of the distribution provisions from the Ohio wrongful death statute (note: this is only a portion of the complete statute):

> 2125.02. Persons entitled to recover; determination of damages; limitation of actions
>
> (A) (1) Except as provided in this division, a civil action for wrongful death shall be brought in the name of the personal representative of the decedent for the exclusive benefit of the surviving spouse, the children and the parents of the decedent, all of whom are rebuttably presumed to have suffered damages by reason of the wrongful death and for the exclusive benefit of the other next of kin of the decedent. A parent who abandoned a minor child who is the decedent shall not receive a benefit in a civil action for wrongful death brought under this division. (2) The jury or the court if the civil action for wrongful death is not tried to a jury, may award damages authorized by division (B) of this section, as it determines are proportioned to the injury and loss resulting to the beneficiaries described in division (A)(1) of this section by reason of the wrongful death and may award the reasonable funeral and burial expenses incurred as a result of the wrongful death.
>
> In its verdict, the jury or court shall set forth separately the amount, if any, awarded for the reasonable funeral and burial expenses incurred as a result of the wrongful death.

Understanding Punitive Damages

Another category of damages, punitive damages, is designed for just what it sounds like—to punish wrongdoers. Actually, by policy they are designed to *deter* rather than to punish. In other words, the

typical justification for punitive damages is to deter a defendant who has committed bad conduct in the past from committing similar bad conduct again in the future.

> **Punitive damages are also meant to deter others besides the defendant from committing acts similar to those of the defendant—for fear that they too will be sued and have to pay a large sum of money.**

Punitive damages are very tightly governed by the law and by courts. First, they are only possible in cases of intentional and in some cases grossly negligent or reckless conduct, as opposed to merely negligent conduct. Some examples may highlight the distinction. If you aim your car toward a person and run her over, it is *intentional*; if you simply are not paying attention or you are going too fast and you run them over, it is *negligent*. There can be punitive damages given for the intentional act, but not the merely negligent.

However, if you are drunk and you run someone over, even if it was not intentional, it is often considered grossly negligent and the law in some states might allow punitive damages.

Second, punitive damages can only be so high. The law often limits the amount that punitive damages can be, often based on a comparison to the actual damages calculated by the jury. In other words, if the jury gives someone $100,000 for their medical bills and pain and suffering, punitive damages can only be so many multiples of that amount before the judge may find that the punitive damages have gone too far. The limits vary by jurisdiction, but the limits may never exceed what would be allowable under the United States Constitution as interpreted by federal courts.

However, as I said before, punitive damages are designed mainly to deter, so in order to be effective, they must be enough that the defendant is upset or bothered by the amount he has to pay.

One additional issue that may be of interest to you is how the jury is instructed to determine punitive damages. First, as I have mentioned, the jury must determine whether the defendant's conduct was sufficiently bad so as to warrant the imposition of punitive damages. Then, in order to determine the amount of punitive damages to impose, the jury will consider a number of factors indicated to them by the judge. Although the factors will vary by court and state, some of

the common factors include the extent to which the conduct was wrongful, the wealth and/or typical profits of the defendant, the defendant's level of awareness of the wrongfulness of his/her/its conduct, whether and how long the defendant concealed the wrongful conduct and so on. The following is a sample statute regarding punitive damages.

The following New Jersey statute is an example of principles involving punitive damages:

> 2A:15-5.12. Award of punitive damages; determination a. Punitive damages may be awarded to the plaintiff only if the plaintiff proves, by clear and convincing evidence, that the harm suffered was the result of the defendant's acts or omissions and such acts or omissions were actuated by actual malice or accompanied by a wanton and willful disregard of persons who foreseeably might be harmed by those acts or omissions. This burden of proof may not be satisfied by proof of any degree of negligence including gross negligence.
>
> b. In determining whether punitive damages are to be awarded, the trier of fact shall consider all relevant evidence, including but not limited to, the following: (1) The likelihood, at the relevant time, that serious harm would arise from the defendant's conduct; (2) The defendant's awareness of reckless disregard of the likelihood that the serious harm at issue would arise from the defendant's conduct; (3) The conduct of the defendant upon learning that its initial conduct would likely cause harm; and (4) The duration of the conduct or any concealment of it by the defendant. c. If the trier of fact determines that punitive damages should be awarded, the trier of fact shall then determine the amount of those damages. In making that determination, the trier of fact shall consider all relevant evidence, including, but not limited to, the following:
>
> (1) All relevant evidence relating to the factors set forth in subsection b. of this section; (2) The profitability of the misconduct to the defendant; (3) When the misconduct was terminated; and (4) The financial condition of the defendant.

Tying It All Together to Reach an Estimated Value

Now that you have a basic understanding of the potential damages and related issues involved in a personal injury case and how a jury might go about determining your damages, you are probably wondering how you and your attorney will ultimately determine how

much you should be willing to settle for. There are too many factors involved to really give you the tools to be able to fully value your case using this book alone. You must have the advice of your attorney who knows the local laws and what the juries are like, as well as what insurance adjusters tend to pay in your area.

However, this book should give you a basic, general idea of how a case might be valued so that you can understand your lawyer's analysis and have realistic expectations about your case. To do this I will give you a fictional set of facts involving a car accident and explain how I would value it for settlement purposes.

> Facts: Bill is driving his 2001 sedan on a highway in State A. The speed limit is 50 mph; Bill is traveling between 50 and 55 mph. At an intersection, Joe drives his 1995 pickup into the path of Bill's car. Bill slams on his anti-lock brakes but there is not enough room to stop. Bill hits Joe's truck. Upon impact, Bill is thrown forward and, although his airbag significantly limits his movement, his head and neck are jerked forward and back. Bill immediately feels pain in his neck and he can barely move it. The police and an ambulance come to the scene and Bill is transported to a local hospital. Joe is not hurt in the accident. The police officer determines that Joe is at fault for the accident—even though Joe swears that Bill was speeding and that the speeding contributed to the accident. Joe says Bill was going at least 70 miles per hour. At the hospital, Bill is x-rayed, which shows no broken bones and Bill is sent home with some pain medication. Although Bill's pain improves a little bit over the next two weeks, he still has significant pain. He sees an orthopedic doctor who sends him for physical therapy. After three months of physical therapy, Bill recovers except for an occasional stiffness once or twice a month that does not really cause him much discomfort.

Bill hires me to make a claim against Joe and his insurance company. Joe's economic losses are as follows:

Ambulance:	$ 750.00
Emergency Room:	$ 900.00
Orthopedic Doctor:	$1,350.00
Physical Therapy:	$3,000.00
Total:	$6,000.00

Because Bill has, for the most part, healed and does not have significant continuing damages, I must analyze the value of his claim

from the time of the accident to the time I make the claim. In other words, there are no future damages to claim. (Again, this assumes that Bill's doctor indicates that Bill has fully recovered and will not have any significant future problems.)

Assuming that Bill has no lost wages, Bill has $6,000 in economic damages, plus his pain and suffering and annoyance and inconvenience caused by his injuries. For the moment, we will set aside the issue that Joe claims Bill was speeding. So, assuming that Joe is entirely at fault, I will estimate a value range for Bill's claim of between $18,000 and $24,000.

> I arrive at this number because, in a simple case—where there is no issue about who was at fault and there is no issue about future losses—a reasonable baseline to start at would be an amount three to four times the amount of the economic losses.

More complicated factors may then come into play to move this range either up or down. In Bill's case, if there are witnesses to the accident who are not related to or friends with Bill or Joe and they say that Bill was not speeding, then fault really should not be much of an issue—despite Joe's claim that Bill was speeding.

On the other hand, if there are no witnesses or there are witnesses who say they think that Bill was speeding, then fault will be an issue and the settlement value might fall toward the lower part of the range— or even below the range—depending on what percentage of comparative negligence a jury might assign to Bill.

Other factors that could lead to additional comparative negligence against Bill could cause the range to be lowered even more. For example: Were Bill's brakes not properly maintained? Was Bill using a mobile phone at the time of the accident? And so on.

Factors that might cause me to *raise* the settlement value range of Bill's case would include: if Joe was drunk when the accident happened, if Bill will incur future medical bills and/or future pain and suffering because of his injuries or if Bill is unable to fully perform his job because of his injuries.

I will also evaluate the settlement range up or down depending on how I think Bill and Joe will appear to a jury. Will the jury like them? Does Bill's personality evoke sympathy? Is Joe a jerk or a nice guy? These all affect the potential settlement range.

> One important piece of advice that I can give is that you should not set your sights too high based on what you see on television or in the media. The huge jury verdicts that you hear about on the news are probably on the news because they are unusually high. Juries have quite a bit of leeway in the amounts of money they award. As such, there are occasionally really huge verdicts. What you do not hear about are the juries who give plaintiffs little or nothing because these cases are not covered in the news.

There are lots of cases being tried every day. How many do you hear about on the news? I hate it when I tell a client with $5,000 in damages that their case is worth $15,000 to $20,000—only to have them tell me that they heard about a case on the news in which the plaintiff got $1 million in a similar situation...or that their aunt had a similar case and she got $100,000. I have to explain that, if those people *actually* got those amounts, there was something very different about their cases. They either had bigger damages, permanent injuries, lived in a place with more liberal juries, etc.

Still, any good attorney should know what settlement range is in your best interest to accept.

> Remember, your attorney is usually working on a contingency fee basis. That means that the more money you get, the more money he or she gets.

Your attorney has every reason to maximize the amount of money you get while minimizing the potential of getting less. This is the best incentive to giving you reasonable advice about the value of your case for potential settlement purposes given the possible risks and benefits of going to trial.

As a final note, make sure that when you are evaluating your settlement, that your attorney explains to you how much of the settlement you are going to get after fees, costs, medical bills and all other expenses are paid. It does you no good to consider a $100,000 settlement if you do not know how much of that money you will receive after everything is paid. Use the settlement evaluation worksheet in the appendices to help make your own estimate.

Focus Groups

Sometimes, it is particularly difficult to estimate the value of a case. Maybe it is hard to guess how a jury will view liability—or perhaps the amount a jury might pay a client for having to live with a scar on his or her cheek is just too abstract to predict. Although there is of course no way to know what a particular jury chosen for a case on a particular day will do, it can often be helpful to present the case to a focus group.

A focus group is like a mock trial. A group of people, usually totally unfamiliar to the case, the lawyers and the parties are paid to participate as mock jurors. They can be hired at random at a local gathering spot, by placing an ad in the local newspaper or even chosen from among court provided lists of people who served as jurors previously and are no longer on jury duty. The case is presented to them and they render a verdict.

> There are various ways that focus groups are carried out and cases are presented to them in various levels of detail. Perhaps the attorney simply explains the case to them and they offer their opinions. Or, a small trial might be put on for the mock jurors with someone hired to play the part of the defendant and defense attorney. Other focus group procedures will fall somewhere between these two levels of comparability to a real trial.

Besides the sheer amount of money that the mock jurors arrive at, there is much additional useful data that focus groups can offer. Often the focus group session is recorded and if the plaintiff testifies, it is an opportunity for the plaintiff and his or her attorney to review and gage how well he or she will testify in court.

In addition, a discussion with the mock jurors after the session can reveal much useful information. The jurors can tell the lawyer what they did and did not like about the lawyer's arguments, the lawyer's appearance, the plaintiff's testimony, the plaintiff's appearance, the documentary evidence and so forth. They can reveal what arguments they were persuaded by and which ones they did not believe.

Sometimes, the mock jurors will even raise arguments or issues during their deliberations that the lawyers never thought of. The fact

is, lawyers are so trained to think like lawyers that sometimes they miss things that non-lawyers latch onto. As such, in that situation a focus group can be particularly valuable.

5 The Mechanics of Personal Injury Lawsuits

We have considered the broad issues of what to do immediately after an accident, how to find a good lawyer if you have been injured and how to put a value on your claims. Now, we come to the chapter that deals with the details of actually filing a lawsuit and going to trial. This is a long chapter—so, I will outline it briefly at the start.

If you are unable to reach a settlement with an individual or insurance company, a lawsuit will have to be filed and your case will have to be tried.

I will begin this discussion with a look at statutes of limitations. This may be the most important topic in the entire book.

> You must—must—file a lawsuit within the time limits provided by the applicable statutes of limitations or you lose all of your rights to seek compensation for your injuries. You cannot file a lawsuit, cannot make an insurance claim—nothing. Once that deadline passes, you lose all those rights.

Then I will explore the litigation process, from the commencement of the lawsuit through trial—as well as some related issues that will help you to better understand the process. The first section regarding commencement of the lawsuit explores the drafting of a complaint, filing the complaint, serving it and answers served by the defendant. The subsequent section deals with discovery, wherein parties exchange information and documents pertinent to the issues of the

case. This includes written discovery tools, such as interrogatories, requests for production of documents and requests for admissions, as well as depositions, which involved asking questions orally of a party or witness and recording the answers using a court reporter.

Following the discovery section, I will discuss mediation and offers of judgment, two tools designed to encourage the settlement of lawsuits prior to trial, are covered. The next section covers trial itself, beginning with preliminary issues such as burden of proof, which is the level of proof required in order to win your case, preparing for trial, getting to know the courtroom and courtroom etiquette.

The chapter ends by covering some additional related topics including an explanation of hearsay, which many people misunderstand, privileges, which prevent and/or allow people not to testify in some circumstances and issues regarding actual collection of money when you win your case.

Statutes of Limitations

What is a statute of limitations?

It is, quite simply, a limit on the amount of time that you have to file a lawsuit. If you do not file before the expiration of that timeframe, you lose the right to bring any claim or lawsuit, forever. Furthermore, there are *no excuses* and *no exceptions*. If the attorney's car breaks down on the way to the courthouse and the case does not get filed, that is too bad. The case cannot then be filed.

Errors involving statutes of limitations are responsible for many lawyer malpractice cases in the United States.

> When a lawyer forgets or waits until the last minute and something goes wrong and he or she does not get the case filed on time, he or she has almost certainly committed malpractice. Because of this, I always try to file cases at least a week before the deadline—just to be safe.

Statutes of limitations vary from state to state and from one type of case to another. Common time limits for personal injury cases are two years or three years. In other words, although statutes of limitations range from less than two years to more than three years, two-year and three-year limitations periods are common among the states.

Again, I want to stress that these times vary, so you need to check to see what the limitations period is where your case will be filed. In this chapter, for purposes of explanation only, we will use a two-year time limit.

If the statute of limitations for personal injury lawsuits in your state is two years, you must file your lawsuit within two years of the date that the personal injury occurred. The time period is usually measured from the day that the personal injury occurred or in some jurisdictions the following day (unless the discovery rule or another exception applies).

So, if you are in a car accident on March 10, 2001 and there is a two year statute of limitations in your state, you have until March 10, 2003 (or possibly March 11, 2003, depending on the rules) to file a lawsuit—or you lose the right to bring a lawsuit forever. If the last day of the time limits falls on a weekend or holiday in which the courts are closed, then the final day is usually the next day in which the courts are open. However, to be safe, make sure your state does not then make the limit the day before the holiday or weekend.

While statutes of limitation do not directly control insurance claims, they do *indirectly* control claims. An insurance claim against a tortfeasor is directly linked to your ability to sue that party. Thus, if the statute of limitations deadline passes, you cannot file a lawsuit and consequently you also cannot bring an insurance claim or any other claim for your injuries.

Your right to compensation for your injuries expires when the statute of limitations period runs out.

The Discovery Rule

In many states, there is an exception to statutes of limitations which is called the "discovery rule." Under the discovery rule, if for some reason at the time a personal injury occurred you did not know that a personal injury occurred—despite the exercise of reasonable diligence—then you have until two years (or whatever the statute of limi-

tations period is) from the date that you discovered—or reasonably should have discovered—that the personal injury occurred in which to file a lawsuit.

This may seem a little strange. How could you not know that you were in a car wreck? The discovery rule, although it could theoretically apply in any type of case—and is more often applicable to medical malpractice personal injury cases.

> For example: You have a surgery and the statute of limitations in your state for medical malpractice cases is two years. Three years after the surgery you get a bad infection and find out that the doctor left a sponge inside of you when the surgery was performed. You would then have two years from the date you discovered the sponge in order to bring the lawsuit.

Keep in mind also that in many states the discovery rule has a maximum amount of time in which it can apply. For example, a state might have a two-year statute of limitations and also have the discovery rule, but have a 10-year maximum limit in which to bring a lawsuit. In other words, you may be able to go beyond the initial two years with the discovery rule, but you can never go beyond the 10-year maximum. This can be particularly important when considering statutes of limitations for injured children.

The policy behind all of these time limits and extensions in certain circumstances is to allow injured people enough time within which to discover the injury and file a lawsuit, while at the same time limiting the amount of time that a possible defendant has the threat of a lawsuit hanging over his or her head.

There are various other exceptions to statutes of limitations, that again vary by state. The most common ones include infancy and incapacity. In most states, if a minor, legally called an "infant" (all the way to age 18) is harmed, they have until a certain amount of time after their 18th birthday to file a lawsuit (unless there is a maximum overall time limit that will expire earlier).

Keep in mind that someone can sue on a minor's behalf prior to her 18th birthday—but, if nobody does, the minor has the right to bring suit up to a certain amount of time after she turns 18.

The same holds true for people in jail or who are mentally incompetent, either someone must bring suit on their behalf or else they

may wait until the disability or incarceration ends (again, often subject to a maximum amount of time to bring the lawsuit).

Filing a Lawsuit

In law school, future lawyers are taught how to draft a complaint, the document which is filed with the court which spells out who is being sued and why. That is pretty much the end of the teaching regarding how to file a lawsuit. New lawyers are often left to figure out on their own what other documents must accompany a complaint, how much it costs to file, how to serve the complaint on the defendant and all the other little details.

Because I am a lawyer who files a lot of lawsuits, I had to learn very quickly. In the following sections are the typical steps involved in filing a lawsuit.

The first thing that your attorney must do in order to commence a lawsuit is to draft a complaint. As you read this, you may refer to the sample complaint in the appendices section. The complaint will contain your name and the names of any others with whom you are bringing the lawsuit, listed as plaintiff(s) and the name of the people or entities (corporations, governments) that you are suing, listed as defendant(s). These names are listed at the top of the first page of the complaint and along with the name of the court where the document is being filed, comprise what we call the "style" or "caption" of the case. Most case styles are some variation of the following:

IN THE CIRCUIT COURT OF YOUR COUNTY, YOUR
STATE
JOHN JONES AND JANE JONES,) husband and wife)
Plaintiffs,)
) Civil Action No.: 01-01-2005 vs.)
)
)
) WILLIAM JOHNSON)
Defendant)
COMPLAINT

Below the style is the body of the complaint.

The body contains several categories of information, including a statement of jurisdiction (some attorneys do not include this expressly) the facts, the cause or causes of action, a list of damages and demand for relief, jury demand if a jury is requested and the signature and

identifying information of the attorney. In some states, the plaintiff(s) must also sign and include what is called a "verification," which is a document in which the plaintiff swears, (typically by signing under oath in front of a notary public) that to the best of their knowledge and belief, the information contained in the complaint is true—the complaint is then called a "verified complaint."

Let us look at each of these categories in a little more detail.

The statement of jurisdiction simply spells out that the court where the case is being filed has the legal right to hear the case and why. Thus, this portion of the complaint must contain the facts which give the particular court the right to hear the case. Let me give an example to help clarify this. In a car accident case, in most states, the plaintiff victim can sue the defendant primarily in one of two places—either where the accident took place or where the defendant lives. So the complaint might state that the court has jurisdiction over the case because the accident which gives rise to the causes of action in the complaint happened within the geographical territory of the court. Or it might state that the court has jurisdiction over the case because the defendant resides within the geographical bounds of the court.

The purpose behind this is to prevent a court, perhaps with a popular judge, from being swamped with cases from far outside the geographical area that the court was designed to cover.

> **For example: Suppose that there is a really popular judge in Vermont who is known for commonly making rulings in favor of plaintiffs. If there were no restrictions on who could file in her court, then plaintiffs from far away with less sympathetic judges would file cases in her court. In other words, plaintiffs in nearby New York or New Hampshire might start filing their cases in Vermont even if none of the parties lived in Vermont and the accident did not happen in Vermont.**

Keep in mind that lawyers do not always directly state in the complaint why the court has jurisdiction. However, as long as the facts stated in the complaint show that there is jurisdiction, that is usually enough. For example, if jurisdiction is based on the accident having happened in the state, it is enough that the complaint spells out that the accident happened in the state. There does not necessarily have to be a statement that says "jurisdiction is proper in this court

because the accident occurred within this state." In other words, jurisdiction is implied by the facts.

This brings us to the facts and causes of action sections. In most states, the plaintiff need only state the minimum of facts necessary to establish their cause or causes of action and that the court has the right to hear the case, as mentioned in the previous paragraph. That means that for each element of the cause or causes of action, the plaintiff must allege basic facts to indicate that the element is met.

So, in the case of a car accident, we must show breach of duty, causation, injury and remedy. The complaint need only state that there was an accident (and it must state when and where in order to establish that the case was filed on time and that the court has jurisdiction), that the accident was caused by a breach of duty by (or simply state that it was caused by the negligence of) the defendant, that the plaintiff was injured and a demand for relief (money).

This would be a good time to look over the sample complaint in the appendices. You will see by reviewing the sample complaint that these facts may be stated very, very simply and still be acceptable. This is called "notice pleading," meaning that your complaint only has to provide just enough information for the defendant to understand why he or she is being sued (just enough so that they have notice).

The following is the notice pleading rule from the Federal Rules of Civil Procedure:

Rule 8. General Rules of Pleading

(a) CLAIMS FOR RELIEF. A pleading which sets forth a claim for relief, whether an original claim, counterclaim, cross-claim or third-party claim, shall contain (1) a short and plain statement of the grounds upon which the court's jurisdiction depends, unless the court already has jurisdiction and the claim needs no new grounds of jurisdiction to support it, (2) a short and plain statement of the claim showing that the pleader is entitled to relief and (3) a demand for judgment for the relief the pleader seeks. Relief in the alternative or of several different types may be demanded.

The causes of action section essentially becomes intermingled with the facts section because allegation of the facts alone, as long as they cover the elements of the causes of action, are sufficient. In other words, you need only list the facts of a negligence cause of action, you do not have to list each element specifically and say why it is met. However, it is often proper to lay out in detail the cause of action if it is not obvi-

ous or usual. For example, sometimes a cause of action will result from the defendant violating a statute. If this is the case, it is prudent to make reference to the statute in the cause of action, explain that the defendant violated the statute and why the plaintiff should be allowed to recover damages as a result of the defendant violating it. A few states require more detail than others or require that certain causes of action contain more detail than others.

Next, the complaint must contain a list of damages and demand for relief. This will include an outline of the damages suffered—which you could consider to be part of the facts section as well—and a demand for money to compensate for those damages. Different lawyers use different levels of detail with regard to their damages and demand for relief.

> A simple version might simply say something like "as a result of the accident which was caused by the negligence of the defendant, the plaintiff has suffered past, present and future medical expenses, lost wages, loss of earning capacity, pain and suffering, mental anguish and loss of ability to enjoy life" as an outline of damages and "Wherefore, the plaintiff demands judgment against the defendant in an amount to be determined by the jury to compensate the plaintiff for her aforementioned damages."

There is often debate among lawyers about whether to request a specific amount of money in the complaint. Although different states and different courts have differing rules about whether the complaint can—or must—have a demand for a specific amount of money, it is often up to the lawyer to choose whether to request a certain amount.

In other words, the lawyer might simply ask for "a reasonable amount to compensate the plaintiff for her damages," or he might ask for "$1 million to compensate the plaintiff for her damages." Others might break it down further and ask for specific amounts for different categories. The complaint might ask for $50,000 for past medical bills, $100,000 for future medical bills, $300,000 for past lost wages, $1.2 million for future lost wages and $2 million for past, present and future pain and suffering and loss of ability to enjoy life.

There are many arguments on both sides of this issue. It is commonly argued that it is good to ask for a specific amount of money

because it lets the other side know that you are serious and how much money you believe you deserve.

On the other hand, it is also argued that it is bad to ask for a specific dollar amount because it might make you look greedy to the jury and inflates the plaintiff's expectations when it comes time to try to settle the case. In other words, it is difficult to file a complaint asking for a million dollars and then by the time mediation occurs try to make the plaintiff understand why the case should be settled for $100,000 or less. The plaintiff is left baffled about why the value of the case suddenly went from $1 million to one-tenth that amount.

> **Personally, I never include a specific amount in the complaint unless I am in a court where the law or rules require me to do so. I believe that because most of the damages are ultimately up to the jury to decide anyway, it simply impedes the process to ask for an amount in the complaint.**

Also, it is difficult to know how much to ask for. If you ask for too much, you look greedy; if you ask for too little, the jury might give you less than the case is worth—and the defendant may be less likely to negotiate if they believe that the plaintiff's expectations are too high. It just seems easier to me on every level to let the value of the case unfold on its own throughout the course of litigation as it becomes more clear whether there are liability issues, what the doctors will ultimately say about injuries, the total medical bills, what the plaintiff's long term lost wages will be and so on.

If you and your attorney wish to have a jury trial, rather than having the judge determine the entire case (for plaintiffs, jury trials are almost always preferred) then after the body of the complaint there will be a statement indicating that the plaintiff wants a jury. It might read something like "The plaintiff demands a trial by jury on all issues."

Finally, the lawyer puts his or her contact information at the end of the complaint and signs it.

The client may also need to sign a verification, thereby swearing that to the best of the plaintiff's knowledge, the facts in the complaint are accurate.

Filing the Complaint in the Proper Court

This is a good place for an explanation of the various types of courts. My description here is very much a simplification—but it should serve as a basic primer.

Each state has various groups of courts that fall into two broad categories: trial courts or appellate courts. The trial courts are "lower" courts and the appellate courts are the "higher" courts.

Even within these main categories, courts are rigidly organized. At the very bottom of the legal food chain are city courts, town courts and other municipal courts. Just above those are magistrate courts, justices of the peace and other courts that operate on a county level. Then there are the main trial courts, called by different names—such as county circuit court or district court—but operated by the state.

> Fans of the television franchise *Law & Order* deserve a special explanation here. New York is a little unusual in the naming of its courts. In most states, the supreme court is the state's highest court (much like the highest court in the U.S. is the U.S. Supreme Court). However, in New York, the trial courts are called the supreme courts and the higher appellate court is called the Court of Appeals.

The lowest courts, the town and city courts, usually hear cases such as traffic tickets or other violations of city law. The higher level trial courts hear various types of cases, usually based on how much the case is worth. In other words, some lower courts might hear cases with a maximum at issue of some small amount—usually less than $5,000 or $10,000. The highest level of trial court generally has no monetary restrictions and can hear pretty much any kind of case with few limitations. These are often called courts of general jurisdiction.

Appellate courts hear appeals from lower courts. Some states have only one appellate court and it is the highest court in the state, others have two or more levels of appellate courts. After the lower appellate court has ruled, the losing party may then appeal that decision to the higher appellate court, if any, to review the decision of the lower appellate court.

It is impossible for me to give you a very complete explanation of the different levels and types of courts because there is so much varia-

tion among the states. Just know that there are different levels and types of courts that hear different types of cases.

Below is a general outline showing the various levels of state courts:

Highest Appellate Court (Often called Supreme Court)
^ ^ ^
Lower Appellate Courts—If Any
^ ^ ^
Highest Level Trial Court
^ ^ ^
Lower Level and Local Trial Courts

Following similar fashion, the levels of federal courts are:

United States Supreme Court
^ ^ ^
United States Circuit Courts of Appeals
^ ^ ^
United States District Courts (the main trial courts)
^ ^ ^
United States Magistrate Courts

There are sometimes other types of courts within the state and federal systems, such as bankruptcy courts, social security courts, workers compensation courts and so on. However, these are called "administrative" courts and are distinct from the main court systems.

In a personal injury case, there might be more than one court in which the case could legally be filed. Most states' rules provide that a case can be filed in the jurisdiction where the personal injury occurred or where the defendant (or any defendant if there are many) lives.

Suppose that Joe, who is a resident of Virginia, negligently collides his car into Bill's car in the state of New York. Bill is a resident of Vermont. Bill will have the option of suing Joe in one of two states: He can sue Joe in New York, where the accident occurred or in Virginia, where Joe lives. Bill does not have the option of suing Joe in Vermont.

Once you have picked a state, you will have to file in the particular county where the injury occurred or where the defendant lives.

> If you file in federal court, rather than state court, you will still make the same kind of decision about where to file. You will have to file in either the federal court district (they are set up by districts usually encompassing several counties) where the injury occurred or where the defendant lives.

If the defendant is a corporation, perhaps in a product liability action, there is a special rule. Corporations are said to reside in two places, the state in which they are incorporated and the state in which they primarily conduct business. Of course, if both of these occur in one state, there will only be one state of residence for the corporation. A corporate defendant can be sued where the injury occurred, but only if the corporation does business there or where the corporation resides (where it is incorporated or its principal place of business).

Let us consider an example of suing a corporate defendant. Suppose that Chipsmaker Corporation manufacturers potato chips and sells them in all of the 50 states and the District of Columbia. Chipsmaker Corporation is incorporated in Delaware and has its principal place of business in Pennsylvania. A batch of contaminated chips is sent to North Dakota where five people become very sick and have to spend significant time in the hospital. Each has permanent damages to their stomachs as a result of eating the contaminated chips. Where can the plaintiffs sue Chipsmaker? First, because Chipsmaker does business in North Dakota—selling their chips there—and because the injuries occurred in North Dakota, Chipsmaker can be sued in North Dakota. (The suit may have to be filed in a county where the injury occurred within North Dakota.)

There are two other states in which Chipsmaker could be sued as well. Since a corporate entity resides where it is incorporated and where it has its principal place of business, Chipsmaker could be sued in Delaware (where it is incorporated) or Pennsylvania (where it has its principal place of business).

There are a couple of wrinkles that need to be mentioned. First, if you sue in a state other than where the injury occurred, the court will usually apply the law of the state where the injury occurred, even if it is different from the law where the case is being tried. So if Bill sues Joe in Virginia, the Virginia court will apply the law of New York, where the accident occurred, to the case. The Virginia court will use Virginia procedural rules, but New York auto accident laws. One ad-

ditional twist in the same regard, though, is that the court will not apply a part of the other state's law that is against its public policy. For example, some states that have the comparative negligence rule have refused to apply the law of contributory negligence even if the accident occurred in a state that has the contributory negligence rule. However, these public policy issues are rare.

> **Actually, it is rare to have a case in a state other than where the accident occurred; but it sometimes happens, so you should be aware of it.**

The second wrinkle is that, in some instances, a state will apply its own law to an accident that occurred in another state if the plaintiff and defendant are both residents of the state where the case is brought. For example, if an accident occurs in Maryland but both the plaintiff and the defendant are residents of West Virginia, the case may be brought in West Virginia—because the defendant resides in West Virginia—and in that situation, the court may apply the law of West Virginia, rather than Maryland, because all of the parties involved are West Virginia residents.

Now that you know your options regarding where the case can be filed, how does your lawyer choose which one to go with? This is a matter of strategy and convenience and often involves the demographics of jurors or the reputation of the judge in each potential court regarding ruling more often in favor of plaintiffs or defendants.

Again, this is just an introduction to the rules involving where a case can be filed in common situations. There are many more complicated rules on this subject, many involving U.S. Constitutional issues.

State Court vs. Federal Court

Although most cases will be filed in state courts, sometimes a case may be filed in federal court. Without getting into a detailed explanation of the various levels of federal courts, which is generally similar to the explanation of the various levels of state courts, above, know that the primary trial courts in the federal system are the District Courts. In order to file a civil lawsuit in a federal court, one of two conditions must be met. Either there must be a federal law issue involved in the

case or else there must be diversity of citizenship between the parties and an amount in controversy of greater than $75,000.

If a federal law makes up a basis of your lawsuit, then you may usually file in federal court. For example, if you file a lawsuit against a police officer for violating your constitutional civil rights, then the suit may be brought in federal court.

Keep in mind that cases with federal questions may be filed in state court *or* federal court—with some exceptions (which may *only* be filed in federal court).

Also, a lawsuit may be filed in federal court if it involves what lawyers call "complete diversity." For complete diversity to apply, two conditions must be met.

First, every party on one side of the case must be from a different state than every party on the other side of the case. In other words, write down all of the plaintiffs on one side of a piece of paper, along with the state where they reside; and write down all of the defendants on the other side, along with the state where *they* live. If any state is listed on both sides, there is no complete diversity; if *no* state is listed on both sides, then there *is* complete diversity. It doesn't matter if two plaintiffs are from the same state or two defendants are from the same state—the comparison is made only between plaintiffs and defendants.

> **For purposes of determining diversity, a corporation is from two states according to the law—the state where it is incorporated and the state where it primarily does business —so you may have two listed for each defendant.**

The second requirement for complete diversity is that the amount at issue in the case (called the "amount in controversy") must have the possibility of being greater than $75,000. In a car accident case, if there is significant pain and suffering, there is a possibility of a jury giving more than $75,000. On the other hand, if the case were only about property damage and the damage was at most $10,000, then you could not have diversity jurisdiction.

The purpose of diversity jurisdiction is to prevent "home cooking." In other words, where a plaintiff files a lawsuit against an out of state party in his or her hometown, where the lawyers and judges know each other, there may be an unfair bias of the judge in favor of the local person. The theory is that federal courts, which are fewer in

number than state courts and where the judges are appointed by the president, will have less of this type of bias. As such, in addition to the plaintiff being able to file in federal court in the above circumstances, the defendant has the right to "remove" a case from a state court and into a federal court if either of the above requirements are satisfied.

If your case is filed in federal court because there is a federal law at issue, the federal court will apply the procedural rules of the federal courts and the federal law to your case. However, if your case is in federal court because there is diversity of citizenship, the court will apply the procedural rules of the federal courts to your case, but will apply state law from the state where the accident occurred with regard to your causes of action.

How Does the Lawyer File the Complaint?

When the complaint has been written ("drafted" in lawyer language), it must be filed with the court. This generally involves taking one or more copies to the courthouse and visiting the clerk of the court (or your state's equivalent). The clerk will typically take the complaint and stamp it with the time and date that it was filed (to prove that you filed it on time), enter the information about the parties and lawyer into their computer system, assign the case to a judge and whatever else their practices dictate.

Some clerks will also at this point prepare a "summons," which is a document that is attached to the copy served upon each defendant and indicates to the defendant that they must file an answer and how long they have to do so—some places require the plaintiff's attorney to prepare the summons (see a sample summons in the Appendices section). The clerk will also collect a filing fee.

Now it is done. Your lawsuit is filed and the proverbial "ball" is now rolling. You are officially a plaintiff.

Serving Notice of the Complaint

Serving the complaint is a very important part of the process—which must be done correctly and timely. The sections below cover the general procedure for serving defendants, issues involved in serving out of state defendants and procedures for serving corporations.

Once the complaint has been filed, the plaintiff has a maximum number of days, as provided by law, in which to properly serve the

defendant(s) with a copy of the complaint and summons. Different states provide different manners in which a defendant can be properly served with a complaint. The most common and old fashioned way to serve a defendant is by "personal service."

By this method, someone—not a party to the case—hand delivers a copy of the complaint and summons to the defendant and then usually files a paper with the court indicating when and where the service was completed. This is often done by process servers (yes, there are people who make a living doing this—perhaps you saw the movie *Serving Sara*) or local sheriff's deputies; but sometimes a lawyer will have an assistant do it, if permitted by law.

> Some courts also allow defendants within the state to be served by certified mail instead of personal service. If you use this method, however, you must hope that the defendant signs for the parcel, otherwise service will not be proper and you will have to re-serve the defendant by another means.

If the defendant has disappeared and—despite making reasonable efforts—you have not been able to locate him or her, the judge may allow you to serve the defendant by an alternative means.

Some of those alternatives include attaching the complaint and summons to the door of the defendant's last known address, publishing notice of the lawsuit in newspapers where the defendant was last known to have lived or some other means approved by the judge that is designed to try to give the defendant notice of the lawsuit.

Request to Waive—The Federal Method

The federal courts have developed an alternative method for service of the complaint and summons which has recently begun to catch on and be adopted in some states. Under the federal rules of procedure, the plaintiff may send the defendant a complaint and summons by mail along with a request that the defendant waive the requirement of service by traditional means. Included with the summons and complaint is a notification that the defendant must return the request for waiver of service with his or her agreement to waive service within 30 days (or 60 days if outside of the U.S.). Otherwise, the defendant must pay all expenses incurred by the plaintiff in serving by tradi-

tional methods. In other words, if the defendant does not waive the requirement of traditional service, then the defendant has not been effectively served and has not waived that requirement, so the plaintiff has to carry it out by traditional means.

> **If the defendant makes the plaintiff serve by traditional, more expensive means by not agreeing to waive that requirement, the judge will make the defendant pay for that service.**

If the defendant agrees to the waiver and returns the request indicating his or her waiver, then he or she must file an answer within 60 days from the date the plaintiff sent the request for waiver (90 days if outside of the U.S.).

Serving Out-of-State Defendants

What if the defendant lives in a different state than where the lawsuit was filed? For this situation, states have what are called "long-arm statutes" which correspond to the state's "long- arm jurisdiction." Long-arm jurisdiction is, at its most basic level, the right of a state's courts to conduct a trial against a resident of another state.

> **This is a complicated subject and often an entire semester of law school is spent on this subject. Basically, for purposes of this book, understand that if a person from state A commits a tort in state B, then a lawsuit can generally be brought against that person in state B.**

In order to conduct a trial in one state against a citizen of another state, there must be so-called "minimum contacts" between the defendant and the state where he or she is to be tried. One of the main connections relevant to personal injury cases is that, if a person commits an act of negligence which causes injury in a state, he or she has minimum contact (by virtue of committing the negligent act).

Typically, service under long-arm jurisdiction is completed by a state agency office, such as the secretary of state. In other words, the plaintiff delivers the complaint to the state agency and the state agency

mails the complaint, usually by certified mail, to the resident of the other state. Service is then complete upon receipt by the defendant resident of the other state.

Alternatively, if the defendant happens to be in the state where you filed the lawsuit for some reason, you may serve him or her in person at that time, unless the only reason that he or she is there is to attend a legal proceeding. In that case, personal service must be made in the state where the lawsuit was filed, not the state where the defendant lives. This is called "tagging" the defendant.

Serving Corporations

Another common situation which should be mentioned involves service upon a business, particularly a corporation. When you sue a corporation, most states provide several options for service. You may typically serve the president or other officer of the corporation.

Alternatively, in most states, corporations are required to register the name of an agent for service of process with the secretary of state or other state office which governs corporations. The plaintiff's attorney then delivers the complaint to the secretary of state or similar office which forwards the complaint to the registered agent for service of process. For timing purposes, which are important for calculating service of process deadlines for the plaintiff and deadlines to answer for the defendant, service is usually complete when the state office receives it rather than when the defendant corporation receives it.

> Serving a non-incorporated business is generally done by serving one of the owners or managers of the business. States have differing rules about what agents of a business are sufficient for service upon the business.

The Answer

Once you have served the complaint and summons upon the defendant(s), they must file an answer in response to the complaint. In most states, the defendant typically has anywhere from 20 to 30 days in which to file an answer. (See a sample answer in the Appendices.)

The answer is the defendant's response to your complaint. In the answer, the defendant either admits or denies the allegations made by the plaintiff. In addition, the defendant will also include in the answer any counterclaims or cross claims as well as certain defenses being raised against the plaintiff.

Assuming the defendant files an answer, it will usually deny most of the allegations and request that the judge dismiss the action. If your attorney sends you a copy of the answer in the mail and does not explain in advance the meaning of what is said in the answer, you may be concerned when you read it.

The answer often denies everything that you claimed in your complaint, accuses you of being at fault for your own injuries, suggests that you made everything up, that all of your problems existed prior to the accident—and that you are really the one to blame for the accident. This is usual, typical, boilerplate language for an answer and it does not mean very much.

The lawyer for the defendant may not think that you are necessarily lying, but it is his or her duty to defend the defendant zealously. Before admitting anything, the defendant's attorney will want to do some discovery and find out all the facts. It would be a mistake, for example, for the attorney to admit that the defendant was at fault because of running a stop sign only to find out later that the plaintiff was drunk and could have otherwise avoided the accident. As such, the defendant's lawyer wants to be very careful.

Along these same lines, there are certain defenses, called affirmative defenses, that must be listed in the answer or else they cannot be made later. Because the defense lawyer does not necessarily know whether a defense will apply at the time the answer is being written, often any of the defenses that might possibly apply are listed in the answer, just in case. The affirmative defenses listed in Rule 8(c) of the Federal Rules of Civil Procedure include:

> accord and satisfaction, arbitration and award, assumption of risk, contributory negligence, discharge in bankruptcy, duress, estoppel, failure of consideration, fraud, illegality, injury by fellow servant, laches, license, payment, release, res judicata, statute of frauds, statute of limitations, waiver and any other matter constituting an avoidance or affirmative defense.

Because the answer is really more designed just to get the ball rolling and because the defendant's lawyer may be working on a short deadline and have no idea what the case is really about, they commonly deny just about everything related to negligence and fault. So do not worry too much about what the answer says until you have had a chance to thoroughly discuss it with your lawyer.

Default Judgments

If the defendant fails to file an answer and the complaint was properly served, the plaintiff automatically wins the case by asking the judge to grant a "Default Judgment." Much like a person might default on a loan by not paying it, a defendant defaults on a lawsuit by not answering it. A judgment is then entered against the defendant in default much like a foreclosure would be entered against a debtor in default.

Counterclaims and Cross Claims

Sometimes, if a defendant believes that you are to blame for the accident or at least partly to blame, they will file, as part of their answer, a "counterclaim." This means that you sued them and they are suing you back.

There are two common situations in which this happens. First, you sue someone and they think you are really the one at fault, not them. For example, you say they ran the red light and so they are at fault and they say you ran the red light and so you are at fault.

The second situation is where you had a passenger in your car when you had the accident, you and the passenger both sue the defendant, the defendant believes you are partly to blame and the defendant sues you to make you pay for part of your passenger's claim.

Consider the following example: John and Suzie are in a car being driven by John. Bill is driving another car and pulls out in front of John and Suzie and there is a crash. John and Suzie sue Bill and Bill claims that John is partly at fault because he was speeding. Bill consequently files a counterclaim against John (Suzie is a passenger so she has no potential fault for passenger liability—that is not to say passengers can never be liable, but such circumstances are rare).

Now, suppose that the jury finds Bill 90 percent at fault, John 10 percent at fault and gives John and Suzie each $20,000. John would

receive 90 percent of his $20,000 or $18,000. Suzie would receive $18,000 from Bill and the other $2,000 from John.

> **Suzie gets 100 percent of her verdict because she has no fault. Keep in mind that Suzie has the right to sue both Bill and John from the beginning if she and her attorney believe that John was partly at fault for the accident.**

A Second Attorney?

If a counterclaim is filed against you in response to the lawsuit you file, you are then potentially at risk of a judgment being entered against you for some amount of money. In other words, there is never certainty that you will not be a loser in the case.

Assuming that you have car insurance that covered you at the time of the accident, that insurance policy should pay for any judgment that might be entered against you. However, because your insurance company has the potential of having to pay, they also have the right and the obligation to defend you in the counterclaim. To that end, the insurance company will hire a lawyer to represent you with regard to the counterclaim.

You will then have two attorneys: Your initial attorney, the one you hired, will serve to bring your claim(s) against the defendant(s); the attorney hired by the insurance company will serve solely to defend you against the counterclaim and try to prevent a judgment from being entered against you.

> **In theory, these two attorneys have the same goal and should work together to win your case. In reality, unfortunately, sometimes they do not. You do not have to pay the attorney hired by the insurance company because your insurance policy provides that the cost of defending you is covered by your policy. On the other hand, you do not have the right to choose the lawyer defending you, the insurance company does that.**

Although, theoretically, the insurance company could allow (and even pay) your initial attorney to both bring your claim and defend

you against the counterclaim, insurance companies do not typically do that—because they don't like to work with plaintiff's attorneys.

As part of an answer, the defendant might also file a cross claim. A cross claim is a claim by a defendant against another named defendant. For example: A plaintiff sues the driver of a delivery vehicle for a pizza shop as well as the owner of the pizza shop. The driver knows that he or she is liable, but had an agreement with the shop owner to pay for any liability incurred by the driver. Driver might therefore file a cross claim against the shop owner demanding that the shop owner pay the driver for any money the driver has to pay to the plaintiff.

> One way to understand the difference between a counter-claim and a cross claim is that a counterclaim is by a party on one side of the "vs" against a party on the other side and a cross claim is by one party against another party on the same side of the "vs." In other words, a counterclaim is a plaintiff making a claim against a defendant; a cross claim is a defendant making a claim against another defendant or a plaintiff making a claim against another plaintiff.

There is one final concept to add here. Suppose a defendant wishes to make a claim against someone—related to the same litigation—who is not the plaintiff and not a named defendant. In other words, the defendant wants to "bring in" someone who is not yet a party. This is called bringing a third party action.

That, for example, might result in plaintiff vs. defendant vs. third party defendant. Using our pizza driver example, suppose the plaintiff only sues the driver. The driver would then bring a third party action against the shop owner demanding that the owner pay for any liability incurred by the driver to the plaintiff. If the shop owner was already a defendant, the driver would bring a cross claim. If the owner shop owner was not sued by the plaintiff, the driver would bring a third party action.

Motions to Dismiss

Sometimes, either as part of the answer or prior to answering, the defendant might file a motion to dismiss for failure to state a cause of action. As I've explained before, a complaint need only allege enough

basic facts to cover all of the required elements of a cause of action. If the complaint does not allege enough facts to cover every required element, then the complaint has not sufficiently stated a cause of action. If so, the defendant may file a motion to dismiss for failing to allege enough facts in the case to state a cause of action. The judge will then have to decide whether the complaint is sufficient; if it is not, the judge will allow the plaintiff's lawyer to amend the complaint to insert additional facts sufficient to cover all required elements.

Of course, if additional facts do not exist to cover the required elements, then the case will be dismissed.

Keep in mind that defendants' lawyers commonly include a statement in their answer that the complaint fails to state a cause of action. This is usually put in just in case it turns out that there are insufficient facts and the judge may not even be asked to decide whether the facts are sufficient.

If there is a serious question over whether a cause of action was sufficiently stated, the defendant's lawyer will likely file a separate motion to dismiss prior to filing an answer. If that is the case, the answer will not be due until after the judge makes a decision on the motion to dismiss.

Amending the Complaint

Sometimes after the complaint is filed the plaintiff's lawyer will discover new facts or develop new theories of the case that warrant making changes to the original complaint. For example, suppose that after a complaint is filed alleging that a drunk driver ran into the plaintiff's vehicle causing injuries, the plaintiff's lawyer discovers that the owner of the car loaned it to the defendant despite knowing that the defendant was drunk. The plaintiff's lawyer therefore wishes to sue the owner of the car for negligent entrustment.

To do this, the plaintiff's lawyer will want to amend the complaint to add the owner as a defendant with a claim of negligent entrustment. Most courts' rules provide that a complaint can be automatically amended at any time before the defendant has filed an answer. After an answer has been filed, in order to amend the complaint the lawyer will have to ask permission from the judge by filing a motion to amend the complaint.

Most courts' rules are fairly liberal in that they provide that requests to amend the complaint should be granted liberally by judges

assuming that the situation reasonably warrants such an amendment. Rule 15(a) of the Federal Rules of Civil Procedure states:

> Rule 15. Amended and Supplemental Pleadings
>
> (a) AMENDMENTS. A party may amend the party's pleading once as a matter of course at any time before a responsive pleading is served or, if the pleading is one to which no responsive pleading is permitted and the action has not been placed upon the trial calendar, the party may so amend it at any time within 20 days after it is served. Otherwise a party may amend the party's pleading only by leave of court or by written consent of the adverse party; and leave shall be freely given when justice so requires. A party shall plead in response to an amended pleading within the time remaining for response to the original pleading or within 10 days after service of the amended pleading, whichever period may be the longer, unless the court otherwise orders.

What If a Party Dies Before the Case Is Over?

In most cases, it will probably be a plaintiff or potential plaintiff who purchased this book.

I do not mean to raise an unhappy subject, but you may be interested to know what happens to your case if you should happen to die before it is completed. If the case is completed, by either settlement or verdict and the plaintiff dies, the money received simply becomes part of the plaintiff's estate and is distributed in the manner that the plaintiff's other assets are distributed—by will if there was one or by intestate succession if there was not one.

What if the plaintiff dies before a lawsuit is filed or after a lawsuit is filed but before trial? If the plaintiff dies before a lawsuit is filed, then in most jurisdictions the case will be filed by the executor or administrator of the estate of the plaintiff. Likewise, if the case is already filed, the executor or administrator of the estate is substituted for the plaintiff. In either situation, the name of the plaintiff as listed on the pleadings becomes something like "name of executor or administrator as administrator of the estate of name of plaintiff. For example, it might read "JOE SMITH, as administrator of the estate of JANE SMITH, plaintiff."

For the most part and in most places, the estate of the plaintiff retains all of the claims against the defendant as though the plaintiff were still alive. However, you should beware that there may be some

elements of damages or some causes of action that die with the plaintiff and that cannot be brought by the plaintiff's estate, depending on the jurisdiction where the case is brought. For example, in some states claims for defamation can't be brought on behalf of a deceased person.

And, in some states, in order to attribute a death to the actions of a defendant and therefore have a wrongful death case, the death must occur within a certain time from the defendant's actions. In the old days, this was called "the year-and-a-day rule." If the victim did not die as a result of the defendant's actions within a year and a day of the defendant's actions, the death could not be attributed to the defendant. This was mainly applied to criminal cases as to whether a defendant could be charged with murder, but was also sometimes applied to wrongful death civil cases as well.

When a defendant dies, the situation is similar to that of when a plaintiff dies. In that case, the estate of the defendant becomes the named defendant, either when filing the case if it is not yet filed or as a substitute if it was already filed. The executor or administrator of the defendant's estate becomes the spokesperson for the estate and the case proceeds. If the defendant had insurance, the insurance company will continue to provide the defense and will pay policy monies as though the defendant were still alive.

If the plaintiff seeks to collect a judgment from the defendant's personal assets, the claim will proceed as a claim against the defendant's estate, just like other people or companies to whom the defendant may have owed money would make a claim. The plaintiff becomes what is called a "creditor" of the defendant's estate.

> **Of course, if there is no money in the estate because the defendant died with little or no assets, then the plaintiff may be out of luck. Then again, in that case the same would have held true even if the defendant was still alive.**

Discovery

Now that the complaint has been filed and answered by the defendant, your case is in full swing. Next comes an important and also the most time consuming phase of the lawsuit—discovery. Discovery is the process by which each side learns information about the other side's case.

There are two major categories of discovery—written discovery and depositions. Written discovery consists primarily of interrogatories, requests for production of documents and requests for admissions. A deposition involves an attorney meeting in person with a witness who testifies under oath in response to the lawyer's questions and the testimony is recorded by a court reporter.

Let us look at these categories in detail.

Written Discovery/Interrogatories

The first of the written discovery tools that we will look at are interrogatories. To get an idea of what interrogatories are, think back to middle school English. There, you were likely taught that there are four types of sentences: declarative, exclamatory, imperative and interrogative. You will recall that an interrogative sentence is one that asks a question. Thus, interrogatories are written questions presented to another party to a lawsuit which that party must answer, also in writing, usually within 30 days.

The questions asked may be fairly broad and can ask just about anything—as long as the party is not asked to reveal something privileged—that is related to the case or even has the possibility of producing an answer that could relate in any way (no matter how small) to the case.

> **Clients often complain to me that many of the questions being asked by the defendant's attorney in their interrogatories are stupid and irrelevant and sometimes they are. However, they are nonetheless probably permissible and usually have some purpose that you may not have thought of.**

For example, sometimes a defendant will ask a plaintiff to list the name of every blood relative in the county where the lawsuit was filed. This may seem irrelevant and pointless but is actually a common and useful question.

You see, the jury pool will be chosen randomly from the jurisdiction in which the court it located. As such, the defendant wants to have a list of all your relatives who might be called for jury duty so that when the defendant gets the list of potential jurors, it can be compared to your list of relatives. No defendant wants your second

184

cousin or your uncle Joe's business partner to somehow end up on the jury, so they will use this list to try to establish your family members and close connections to them.

In most courts, a party is allowed to ask another party a limited number of questions, commonly 40, although the parties may jointly agree to increase this limit.

(In the Appendices, I have provided a set of sample interrogatories for readers to review.)

To give you an idea of what you will have to do with regard to interrogatories, your attorney will probably send you a copy of the questions sent by the defendant and ask you to prepare answers to each of the questions. Actually, some questions can best be answered by your attorney—such as listing your exhibits, experts, etc.— so the attorney might mark certain questions for you to answer and others for you not to answer. The attorney may or may not call you or have you come to the office to go over your answers and work together to put them into final form.

> My practice is to go through the interrogatories when I receive them. I cross out the ones that only I can answer and place a star next to the ones that I need my client to answer. I then send that copy to the client with instructions to prepare answers to the questions marked with stars. Two to three days later, my assistant calls the client and sets up an appointment for the client to come in and go over the answers with me. At that time, I have the client sit in my office with me and I prepare the final answers in my computer as I discuss them with the client. Then, before the client leaves, I have them review the answers and sign a verification.

When the final answers have been prepared, you will review them and sign a verification swearing that the answers are correct to the best of your knowledge. You will probably be irritated about having to answer these questions.

It might help a little bit to keep in mind that not only will you have to answer interrogatories, but the defendant will have to answer interrogatories sent by your attorney as well.

Requests for Production of Documents

These are just what they sound like. Requests for production of documents are written requests sent to another party requesting that they produce certain documents or copies of them.

For example, in a car accident case the plaintiff might request from the defendant copies of all applicable insurance policies, copies of any statements from witnesses, accident reports and so on. Conversely, the defendant will likely request that the plaintiff produce copies of medical records and bills, tax returns (if the plaintiff is making a claim for lost wages) and similar documents.

> **Be prepared for the defendant to request not only your medical records related to the injury, but also medical records dating back before the accident. This is because the defendant wants to make sure that your medical records from before the accident do not contain references to medical problems you had before the accident.**

In other words, if you are claiming that you have neck pain because of the accident, the defendant's lawyer will want to make sure that you did not have a record of neck pain prior to the accident.

The same goes for tax returns. If you are claiming lost wages, the defendant will want to see past tax returns to make sure the amount you claim you lost is consistent with the amounts you have made in the past. If it is not, you will need to explain why—perhaps you just got a new, better paying job. (See sample requests for production of documents in the Appendices.)

Requests for Admissions

A request for admission is a request to another party asking them to either admit or deny a certain fact. If parties are willing to admit certain facts, it can often reduce the time of trial by limiting the number of facts that have to be proved.

In a car accident case, the plaintiff might ask the defendant to admit that he or she failed to stop at a stop sign or that he or she was not wearing glasses at the time of the accident. The defendant might ask the plaintiff to admit that he or she was not wearing a seatbelt at

the time of the accident or that the plaintiff had an injury to his or her lower back that already existed before the accident.

> Another important effect of requests for admissions is that if the other party denies a fact and the party requesting the admission proves the fact at trial, the party who denied it may be ordered by the judge to pay any expenses incurred in proving the fact.

This is an additional incentive to go ahead and admit facts that are not really in dispute rather than denying everything just to be difficult. (See sample requests for admission in the Appendices.)

Depositions

When you are a plaintiff in a lawsuit, you can expect at least three occasions where you will have to show up somewhere in person for some event related to the litigation. In typical order, those events are: your deposition, mediation and if there is no settlement, trial.

> Sometimes, if the lawyers are particularly hopeful that a settlement can be reached, mediation might take place before depositions in hopes of saving money on the costs of depositions.

The first event, your deposition, is the opportunity for the other side to "lock in," prior to trial, what you are going to say at trial (this will become more clear as you read further). The defendant's attorney will likely take your deposition and your attorney will also probably take the deposition of the defendant at some point. In addition, the lawyers may want to depose other witnesses to the accident—as well as police officers, doctors and anyone else who is likely to testify at the trial.

At your deposition, you will typically sit beside your attorney, across from the defendant's attorney, with a court reporter beside and between you. The defendant may, but probably will not, be present.

At the beginning of the deposition, you will be administered an oath to tell the truth by the court reporter. You are, therefore, "under

oath" during your deposition. After you are sworn in, the other lawyers ask you questions and you respond. The attorneys for each party (if any others) will each get a chance to ask you questions.

> **Although your attorney may ask you questions, these will usually be limited only to helping you clarify any incomplete or confusing answers that you may have given during your testimony.**

Your lawyer will probably prepare you for the types of questions that you will be asked at your deposition. However, just to give you an idea in advance, there are many categories of questions that the defendant's lawyer will ask you. Some lawyers go into more detail than others; so a deposition can last anywhere from a couple of hours to eight hours or even longer, depending on the complexity of the case and your injuries.

Some of the topics that you can expect to be asked about in a typical accident case include:

What were you doing prior to the accident?

What had you eaten that day?

What medications had you taken that day?

Did you have any alcohol or illegal drugs within 24 hours prior to the accident?

Where were you going just prior to the accident?

How did the accident happen?

What did you do immediately after the accident?

What pain or injuries did you feel immediately after the accident?

What were the exact movements of your body during the accident?

Did you hit any part of your body in the accident?

Were your vehicle's airbags deployed during the accident?

Did your car have any mechanical problems prior to the accident?

When did your car most recently have maintenance or repairs prior to the accident?

Were you were offered an ambulance after the accident? Did you accept?

Can you describe any discussions you had with the defendant or any witnesses after immediately the accident?

What questions did the police officers ask you and how did you answer?

Can you describe every doctor or other medical provider that you saw after the accident, beginning on the day of the accident, as well as the treatment provided?

Can you describe any pain and suffering you have had from your injuries?

Did you have any preexisting conditions?

Have you suffered any other injuries since the accident?

What medications have you taken because of pain?

What limitations on life activities have the injuries caused?

Have the injuries affected your ability to work?

Have the injuries affected your relationship with your spouse and family?

What sorts of monetary losses have you suffered because of the accident (amount of lost wages, medical bills, etc.)?

Do you believe any injuries are permanent and what doctors, if any, have told you so?

Why do you believe that the defendant is at fault for the accident?

This is just a small taste of the types of questions you might be asked.

There are a few questions that some lawyers ask that often "trip up" my clients more commonly than others, meaning that my clients simply do not know how to answer. One of those questions is "why do you believe that the defendant is at fault." I do not believe that this is an appropriate question. Some clients confidently say what they think the defendant did wrong, like "he ran the red light and hit me." Others get frustrated and lash out at the questioner.

Another question that really throws many of my clients for a loop is "how much money to you think you deserve for this accident." This question, which in my practice is only asked about 25 percent of the time, almost always leaves my clients speechless. Most of my clients have not thought deeply about that question up to the time of their deposition and do not know how much they think they should get.

It is hard to put a price on pain, suffering and mental anguish—and it's especially hard for the person who went or is going through it, because no amount of money is sufficient.

Of course, I have a few clients who are just plain angry about the accident and immediately answer that question with something like "10 million dollars" even when we have already talked about the settlement range being $50,000 to $75,000.

This question can be important, though, in case it somehow ends up being shown to the jury. If you say that you cannot value it, the jury may be frustrated that they are expected to value it and this might lower what they give. On the other hand if you give some outlandish number, you just look greedy.

> I think it is very important to discuss these questions with your lawyer before the deposition and how you should answer. I am not suggesting that the lawyer put words in your mouth, but rather than the lawyer help you to put your own feelings into words in a manner that is best suited for your particular case and circumstances.

Every word that is said by anybody while the deposition is being conducted is recorded by the court reporter. Different court reporters use different methods to record the information. Some court reporters use stenographic machines that they type on, some have little mask type devices that they speak into, repeating every word that anyone says. Some tape record the deposition either as the sole means of recording or as a backup in addition to another method.

After the deposition, the court reporter will make a written transcript of what was said so that the attorneys will have a written record of the other side's questions and your answers. As for the costs of depositions, the attorney requesting the deposition normally pays for the court reporter as well as the original transcript copy. Other attorneys usually pay only for copies of the transcript that they request.

There are some special kinds of depositions in addition to the typical ones. If the other party requests a deposition duces tecum that means that you are required to bring documents with you to your deposition for the other lawyers to view and/or copy.

In addition, sometimes depositions are videotaped, particularly if the lawyer knows in advance that the witness being deposed will not be able to be at trial in person. Also, sometimes depositions of doctors are videotaped so that the party can save money by not having to have the doctor attend the trial in person, which usually costs much, much

more. (See the checklist on preparing for your deposition in the Appendices section, beginning at page 259.)

Using Depositions

I mentioned that depositions are used to "lock in" your testimony. This is because when you get to trial, if a witness says something different in his or her trial testimony than what was said at their deposition, the other attorney can use the previous deposition testimony to "impeach" the witness. This means that the other attorney can use the discrepancy in the deposition testimony compared to the witness's trial testimony to try to make it look like the witness either lied during the testimony on one of the occasions or else is confused or has a bad memory (and therefore his or her testimony cannot be trusted).

Let me give you a sample dialogue of how impeachment might go to trial:

> Attorney: Please tell the jury, Ms. Smith, what color car the defendant was driving when he supposedly ran the red light and hit your vehicle.
> Plaintiff: It was blue.
> Attorney: Are you sure?
> Plaintiff: Yes.
> Attorney: Do you remember giving testimony at a deposition about eight months ago in your attorney's office?
> Plaintiff: Yes.
> Attorney: And during that deposition I asked you questions and you swore an oath to give truthful answers, is that correct?
> Plaintiff: Yes.
> Attorney: I have here a copy of the transcript from that deposition. On page 57 I asked you what color car the defendant was driving when he supposedly ran the red light and hit your vehicle, could you please read the answer that you gave during that deposition (handing Plaintiff the document).
> Plaintiff: (reading from transcript) Silver.
> Attorney: Thank you. I have no further questions.

Thus, in this example the attorney hopes that the jury will consider Ms. Smith's testimony unreliable because she testified under oath at her deposition that the car was silver and at trial that the car was blue. The lawyer will usually end the questioning or change the subject abruptly after pointing out the discrepancy so as not to give the witness a chance to explain the discrepancy.

If you (or any witnesses in your favor) have been impeached, your attorney will have the opportunity to "rehabilitate" you, which means to provide an explanation for an apparent discrepancy. Perhaps it was dark outside and the color of the car was hard to make out, as opposed to the color of the traffic light (red). Perhaps the car was blue with significant silver trim—so in one answer you focused on the body and in the other focused on the trim. Your attorney will do whatever can be done to make it look like your testimony is reliable by explaining the discrepancies. Perhaps the explanation is so simple that it can even make the other attorney look dumb for making an issue of it.

> **Depositions are also sometimes used when a witness is unavailable for trial. A witness is unavailable for trial if they are deceased, missing or live outside of the jurisdiction of the court such that it is difficult or impossible to force them to come to testify—each state defines "unavailable" differently.**

If the witness is unavailable, the rules often allow the deposition transcript to be read to the jury or, if the deposition was videotaped, to play the video for the jury. The deposition will either be read to the jury verbatim or in some cases the attorney might have someone sit in the witness box and act out the deposition. The attorney will ask the questions and the person playing the part of the deponent will read the answer from the transcript.

Deposition Tips

Under no circumstances should you use the tips I am about to give regarding depositions that are different from the advice that your lawyer gives you. I am simply outlining what I tell my clients in order to prepare them for a deposition. This may give you some points to discuss with your attorney while preparing for your deposition.

> **So, what do I tell my clients in preparation for their deposition? First, I tell them some practical tips to keep in mind. Then, I give them my sermon of three main things not to do: do not lie, do not guess and do not ramble.**

First, there are some practical things to keep in mind at a deposition. In order to keep the court reporter happy, do not interrupt or talk over the other lawyer. The court reporter is making a record of every word said. Therefore, it makes his—or, often, her—job much easier if you let the lawyer questioning you completely finish each question before beginning to answer.

There is a natural tendency to go ahead and give someone an answer once you know the question. However, this is not good in a deposition because if the lawyer does not ask the entire question before the answer is given, either the court reporter has to scramble to keep up or else there will be a gap in the deposition where half a question is asked before the answer is given. That might look like the following:

> Lawyer: Mr. Witness, what time did . . .
> Witness: It happened at about 5 p.m.

Here, the lawyer was trying to ask what time the accident occurred and the witness knew that before the entire question was asked. However, as you can see, by not allowing the lawyer to finish the question, the transcript is incomplete.

There is another—perhaps more important—reason not to interrupt. Good lawyers use the deposition process to test the personalities of the plaintiff or key witnesses. If you interrupt a lot, the other side's lawyer may ask complicated questions designed to exploit your impatience. He (or she) may also use your impatience against you later, during the trial.

So do not be in a hurry. Try to relax and make sure that you do not talk over the other lawyer.

In addition, it is important to give verbal answers. In other words, answer questions with "yes" and "no" instead of with "uh-huh" or "huh-uh" or shaking your head. It makes the court reporter's job more difficult to try to interpret and make a transcript of head shaking and it is often difficult to differentiate between "uh-huh" or "huh-uh." There are many instances when you do not want your positive or negative answer interpreted as the opposite. For example: If you are asked whether you ran the red light, you want to make sure that the court reporter gets an unmistakable answer of "no."

The next advice that I give my clients is to not lie. Moral issues aside, if there is some negative aspect of your case, it is much better to be truthful about it than to lie about it and get caught in the lie. I tell my clients that we can usually find ways to deal with negative aspects of a case, but if the defendant's lawyer can show the jury that you lied about *something*, the jury might not trust you about *anything*.

> Remember, defense lawyers and adjusters are well trained. They do depositions nearly every day—and usually have done for years. If there is a way to catch you in a lie, they will probably find it, so its better just to tell the truth.

Not only should you not lie, but you also should not guess, because guessing wrong can make you look like a liar.

It is human nature to want to please others when they are asking you questions. It is natural to want to know the answer and be able to give it to them even if you are not entirely sure or do not definitely remember. For example, someone might ask you the date that you first visited a neurosurgeon. You think that you recall that it was July 25th of the prior year, but you are not certain. If you answer "July 25th of last year" it will appear in the transcript that you were certain about this date. If it turns out that it was August 8th, then it appears that the things you seem to be certain about may not be correct, thus possibly making you appear to be unreliable in all of your testimony. Perhaps the jury then wonders whether you remember the color of the traffic light at the time of the accident. Thus, if you do not remember something or you simply do not know the answer, say "I do not remember" or "I do not know."

If you think you know the answer or you remember something approximately, qualify your answer. Thus, when asked when you first saw a neurosurgeon, if you are not certain, instead of saying "July 25th of last year" say "I cannot remember for certain, but I think it was around July 25th of last year." By qualifying answers that you are not sure about, you never give a wrong answer; and you create the impression that when you are sure, you say so—and when you are not sure, you say you are not sure. Thus, when you say you are sure the light was green, your memory is less likely to be questioned by the jury.

Finally, I tell my clients to not ramble. By this I mean that it is important to answer the question that is asked fully and truthfully,

but do not go beyond the question asked. "Make the other lawyer do their work" is what I often say.

Do not give the other lawyers more than what they ask for. If you have a prior left knee injury and a lawyer asks you if you have ever had a right knee injury, the correct answer is "no." That is the complete and total answer, not a word more. The correct answer is *not* "no, I have never had a right knee injury, but I sure did hurt my left knee one time." On the other hand, if the lawyer asks if you ever had a prior knee injury, without designating which one, then you must truthfully answer that you had a prior left knee injury.

Take your time! Assuming the deposition is not being videotaped, if you take a little time to think about a question, that time will not likely even be distinguishable in the transcript. Your answer goes on the line after the question—whether you answer in 10 seconds or two minutes. (Of course after a certain amount of time you run the risk of interjections by the lawyer such as "do you need more time?" or "did you understand the question?")

Take the time to process the question and give a complete answer.

There is one caveat to the advice not to ramble. If the lawyer asks you a question that is a trick question—where answering the question without explanation would make you look bad— then go ahead and explain. Make the other side work to get any information that is harmful to your case.

On the other hand, do not appear difficult or arrogant. This will not only look bad in the transcript but the other side might think you will look bad in front of a jury—and this could reduce the amount they offer in settlement. Be polite and have a cooperative demeanor, but make them do their work.

In addition, try to keep your answers concise. Stick to the subject matter of the question asked. If they want to lead you off on a tangent, they can ask you questions to do that.

If, while at the deposition, you realize that you gave an incorrect or incomplete answer, *tell your lawyer then*. Ask to take a break or dur-

ing a regular break tell your lawyer that you forgot something or that you gave a wrong answer. Your lawyer will then have the opportunity, if it is an important issue, to ask you questions at the end of the deposition to allow you to add to your previous answer or to correct the mistake.

> **It is much, much easier to correct a mistake or misstatement before the deposition has concluded than at some later point.**

If you correct the mistake at the deposition, it appears that you had momentary confusion. If you claim months later than an answer was incomplete or incorrect, especially in a moment at trial when the mistake is being used against you, it looks like you are changing your story to help your case—or that you are otherwise generally unreliable. So do not wait until after the deposition has concluded to tell your lawyer if you realize you made an error in your testimony.

Mediation

In many courts, mediations are becoming a regular step in the litigation process. This is due in part to their high success rates. Another tool being used to settle cases, though in a much more intimidating manner, is the offer of judgment (more on that later).

Mediations are becoming more and more popular in the United States and are more and more often being required by judges prior to trial. A mediation is a relatively informal meeting of the parties in an attempt to settle a lawsuit.

> **Do not confuse mediation with arbitration. In an arbitration, the parties choose an arbitrator or several arbitrators, to privately decide a case for them. The case is presented to the arbitrator who acts as sort of a judge and makes a binding decision in the case—and the case never goes to trial.**

At a mediation, a mediator is chosen to offer guidance to the parties to try to help bring them together to reach a settlement. Unlike an arbitrator, a mediator does not make any decisions in your case.

There are several steps in a typical mediation.

First, the plaintiff, defendant(s), their lawyers, insurance adjusters and the mediator will usually meet for an opening session. Do not be surprised if the actual defendant(s) does not attend. Since it is usually the insurance company that makes the decision about whether to pay out money, in personal injury cases the defendants may not be required—though they *are* usually invited—to attend.

In a typical opening session, each side will present the basic facts of their case to the mediator and to each other in the form of a speech or presentation. Each side will try to outline the strong parts of their case and may even point out some weaknesses if it is strategically preferable to do so. Your attorney may or may not ask you to speak (usually about your injuries and pain) during the opening session.

Part of the purpose of the opening session is to put "a human face" on the claim for the insurance adjuster who up to this time has probably never seen you. It is also designed to let the defense attorney know that you will be a sympathetic witness to a jury (assuming that you will be a sympathetic witness to a jury). As such, it is a good idea during this opening session to try not to be angry or cocky or unpleasant—because, if the defendant's lawyer and adjuster think that you will appear angry or unpleasant in front of them, you might not make a good impression in front of the jury. That may actually *reduce* the amount they offer to settle the case.

Also dress nicely for the mediation. You do not want to dress to formally, but you also do not want to dress too casually. Talk to your attorney in advance about what to wear. Keep in mind that the adjuster and defendant's lawyer have probably dealt with hundreds or even thousands of plaintiffs. They will look for weaknesses not only in your case, but in how sympathetic you will look to a jury and/or how much a jury will probably like you.

Second, once all of the parties have summarized their cases in the group session, most mediators will then separate each of the parties into different rooms. You and your attorney will go to one room and each defendant and his or her attorney—along with the insurance adjusters—will go to other rooms. Sometimes if there are multiple defendants, they will stay together and sometimes they will separate,

depending on their wishes and the practices of the mediator. The same holds true if there are multiple, unrelated, plaintiffs.

The mediator will then go from room to room, talking with each party in more detail about their strengths, weaknesses and strategies. One advantage of these separate sessions is that each party can give information to the mediator confidentially, that the mediator will not tell the other side (make sure the mediator knows what information is confidential and what he or she may share with the other side).

Even though the mediator will not tell the other parties your secrets, the mediator will *know* everyone's secrets and may consequently be able to help the parties reach a more informed agreement.

For example: Going into the mediation, the plaintiff's most recent settlement demand was $100,000 and the defendant's most recent settlement offer was $25,000. In the first private session, the plaintiff secretly tells the mediator that they will settle for as little as $70,000 and the defendant secretly tells the mediator that they will pay as much as $60,000. Although the parties may think that they are hopelessly far apart so that settlement is impossible, the mediator now knows that he or she has the ability to settle the case—maybe that day. He or she will therefore get the parties to move their offers up and down and by the end of the day meet somewhere between the $70,000 minimum that the plaintiff will accept and the $60,000 that the defendant will pay. In this case, the mediator will probably work the parties toward a $65,000 settlement.

Third, at some point the mediator will have a good idea of whether the case is likely to settle that day. If the mediator believes that settlement is likely, then he or she will continue to work on trying to reach an agreement. If the mediator concludes that the case will not settle, he or she will end the session and send everyone home.

If the case settles, the parties and/or the mediator might write a summary of the terms of the settlement so there are no disputes later on about the terms of the settlement. If the case does not settle, sometimes the mediator will offer to call the parties at some point in the future to see if any of them have changed their position so that some additional work might accomplish a settlement.

I have settled many cases in the days or weeks after mediation with the continuing help of the mediator.

If mediation was required by the judge, the mediator might also be required to send a report to the judge indicating that the mediation was conducted, as well as the outcome—whether the case settled or not.

There are a few additional facts to keep in mind about mediators:

- Unlike arbitrators, mediators do not make decisions in your case.

- Mediators cannot force anyone to accept or reject a settlement. Their sole purpose is to act as a neutral third party to provide an outsider's perspective and to help the parties try to reach an agreement.

- Mediators are usually paid for their time (usually split by the parties) and may charge well over $100.00 per hour.

- Depending on the rules of your jurisdiction, mediators may or may not have to be lawyers and may or may not have to be certified as mediators.

- A mediator cannot be called to testify about anything that was said at a mediation and, for that matter, nobody can testify about anything that was said at mediation.

> Mediation is confidential. However, there is one exception to this confidentiality. If the parties reach a settlement but later disagree about the terms of the settlement, the mediator might be compelled to testify about his or her recollection of the terms the parties agreed to.

There is one final thing that you should know about mediation. If the case settles, both parties are usually happy that it's over—but typically neither party is happy about the terms of the settlement that was reached. That is the nature of compromise.

The defendant's insurance company must pay more than it wants to and the plaintiff must accept less than they think they deserve. Cases settle because each side moves off of their position so that they can move toward each other and meet somewhere in the middle. If neither side moves or if only one side moves, settlement is just not likely to happen. So if you want to settle a case at mediation, be prepared to be somewhat disappointed, but as long as your settlement is

reasonable—compared to similar cases within the jurisdiction—then you should be happy to have the case over with. In addition, just because a case does not settle at mediation does not mean that the mediation was a failure.

Even when the case does not settle, at mediation the parties gain valuable information about the strengths and weaknesses of each others case as well as a better idea of just how much money it will take to settle the case. Sometimes people just need a few days to consider an offer before accepting it.

High/Low Agreements

Sometimes parties cannot reach a settlement agreement, yet for one reason or another both parties are concerned about what a jury is ultimately going to decide in the case. The plaintiff may be concerned that the jury will not believe his injuries were caused by the accident and be worried that he or she will not get very much money from the jury. The defendant may at the same time be concerned that the jury will believe the plaintiff and also perhaps think that the defendant's negligence was particularly bad and give a really large amount of money to the plaintiff. In this situation, where the parties are especially nervous about the potential outcome, sometimes they might make what is called a high/low agreement.

In a high/low agreement, the parties agree that they will go to trial and let the jury decide the case but—regardless of the amount given by the jury—the defendants will pay a minimum amount of money and also have a limit to the amount of money they have to pay to the plaintiff.

For example: The parties reach a high/low agreement of $200,000 high and $50,000 low. No matter what amount the jury comes back with, the plaintiff will get at most $200,000 and at least $50,000. So if the jury gives $1 million, the plaintiff only gets $200,000. If the jury gives nothing, the plaintiff will still get $50,000. If the jury gives $100,000 (or any amount between the high and low amounts in the agreement), the plaintiff gets the amount of the verdict.

By using a high/low agreement, the parties can have a little less stress about going to trial because the plaintiff knows that he or she

will at least get something no matter what the jury does and the defendant knows that if the jury gives a really huge amount, that the maximum amount that will actually have to be paid is limited to the high amount in the agreement.

Some mediation styles and procedures differ by state, mediator and sometimes even by court, so check with your attorney to make sure you understand the exact nature of how the mediation will be conducted. Also, make sure you take some copies of the settlement calculation sheet in the appendices at the back of this book, so that when offers are made by the defendant you will be able to more easily calculate just how much of the settlement you will get after all fees, expenses and bills are paid. (See checklist on preparing for your mediation in the Appendices.)

Offers of Judgment

First I will explain what offers of judgment are and then I will tell you why some lawyers think the concept can be very unfair to plaintiffs in some jurisdictions.

In the federal court system—and also under many state court rules—a party may, within a certain number of days prior to trial (10 days in the federal system) serve a written offer to the plaintiff to settle the case for a certain amount of money (it is technically a judgment, not a settlement, but for simplicity, we will call it a settlement).

The plaintiff then has a limited number of days to accept the offer or do nothing, in which case it is automatically rejected. If the plaintiff rejects the offer, then the offer is "locked in" and is no longer available for the plaintiff (unless the offeror voluntarily chooses to keep the offer "open").

Here's the important part: If the case goes to trial and the plaintiff does not get an amount from the jury greater than the offer of judgment, the plaintiff is required to pay the defendant's costs accrued from the time the offer was made until the end of the trial.

This can be a lot of money.

Here are the details of the federal process, as described by Rule 68 of the Federal Rules of Civil Procedure:

> At any time more than 10 days before the trial begins, a party defending against a claim may serve upon the adverse party an offer to allow judgment to be taken against the defending party for the money or property or to the effect specified in the

offer, with costs then accrued. If within 10 days after the service of the offer the adverse party serves written notice that the offer is accepted, either party may then file the offer and notice of acceptance together with proof of service thereof and thereupon the clerk shall enter judgment. An offer not accepted shall be deemed withdrawn and evidence thereof is not admissible except in a proceeding to determine costs. If the judgment finally obtained by the offeree is not more favorable than the offer, the offeree must pay the costs incurred after the making of the offer. The fact that an offer is made but not accepted does not preclude a subsequent offer. When the liability of one party to another has been determined by verdict or order or judgment, but the amount or extent of the liability remains to be determined by further proceedings, the party adjudged liable may make an offer of judgment, which shall have the same effect as an offer made before trial if it is served within a reasonable time not less than 10 days prior to the commencement of hearings to determine the amount or extent of liability.

To help this make more sense, consider this example. Plaintiff sues defendant for injuries from an auto accident. They are unable to settle the claim and a lawsuit is filed. The parties continue to negotiate and, as required by the judge, attend a mediation which takes place two months before trial.

At the mediation, the parties are unable to reach a settlement. At the end of the mediation, the plaintiff has lowered her demand to $200,000 and the defendant has raised her offer to $100,000—but they are still $100,000 apart. On the day following the mediation, the defendant sends an offer of judgment to the plaintiff offering to pay $110,000. The plaintiff then has 10 days in which to accept the offer, reject the offer or do nothing, in which case the offer is automatically rejected.

The plaintiff does not respond—and the 10 day timeframe in which to accept closes on September 1. The parties then go to trial and, on December 1 the jury gives the plaintiff $90,000. Because that $90,000 verdict is less than the $110,000 offered by the defendant in the offer of judgment, the plaintiff will not get the full $90,000. She will have to pay the defendant's costs that were incurred from September 1, the day the offer closed, until December 1, the day of the verdict.

If the verdict had been greater than $110,000, then the offer of judgment would be inapplicable and the plaintiff would not have to pay the defendant's costs because the offer of judgment only kicks in

when the verdict is less than (or in some jurisdictions and the federal system, equal to) the offer of judgment.

> One thing that varies by jurisdiction—and that is often the subject of complex court battles—is the definition of "costs." Which costs have to be paid if the verdict is less than the offer of judgment?

The rules frequently say that the plaintiff must pay the defendant's costs, but does not spell out exactly what costs are included. The applicability of some costs are less disputed than others. For example, some of the costs that commonly are included and that the plaintiff must pay if incurred by the defendant after the offer of judgment closes include jury fees, other court fees, deposition expenses, expert fees and expenses, hotel rooms for out of town counsel and experts, copying costs and other clerical costs.

The most hotly disputed question is usually whether *attorney fees* are considered a "cost."

Obviously, the biggest expense for a defendant in the litigation process is attorney fees. Defense lawyers do not work for contingency fees. They normally charge an hourly fee which is almost always well over $100 per hour. Thus, in the interim between the closing of an offer of judgment and the verdict at trial, the defendant could easily rack up many thousands or even tens of thousands of dollars in attorney fees. Thus, plaintiffs' attorneys argue vehemently to not include attorney fees as "costs" and defense attorneys argue equally vehemently that they should be included as costs.

> The theory behind offers of judgment is that they encourage settlements and reduce the number of trials that "clog up" the courts. The idea is that a plaintiff will be more realistic in estimating what a jury will give them when considering settlement offers if they risk the possibility of having to pay a considerable amount of money for the defendant's costs if they estimate the jury's result poorly or unrealistically.

While there are legitimate advantages to offers of judgment in terms of encouraging settlements, there are also some potential unfair-

ness problems. In some jurisdictions, either side can make an offer of judgment. The defendant can make an offer of judgment to the plaintiff and the plaintiff has to pay the defendant's costs if the verdict is less than the offer. In turn, the plaintiff can make an offer of judgment to the defendant and the defendant has to pay the plaintiff's costs if the verdict is more than the offer.

However, in many states—and in the federal system—only a defendant can make an offer of judgment. As such, while there is a pressure on the plaintiff to settle or face paying costs, there is no corresponding pressure on the defendant. The defendant can make an unreasonably low offer of judgment, thereby putting pressure on the plaintiff to accept it—without suffering any possible repercussions if the verdict is more, even much more, than what is offered. (In a few states, bad faith laws allow the plaintiff to get costs and attorney fees if the verdict is significantly higher than the offer; but in most states this is not available.)

This one-sided application of the rules is viewed by many, including me, as blatantly unfair to plaintiffs.

What makes offers of judgment particularly unfair is that juries are so unpredictable. There might be an auto accident case where 100 lawyers would agree that the case has a value of between $100,000 and $200,000. However, those lawyers would also agree that juries are so unpredictable that there is no way to feel comfortable that the jury will give an amount in that range. Thus, if the defendant offers $50,000 to settle the case, the plaintiff has to consider accepting it, even though it is unreasonably low or face the threat of paying the defendant's costs.

Furthermore, one of the reasons that juries are so unpredictable is that insurance and big business interest groups have spent many years and millions of dollars on advertising to convince the general population (from which juries are picked) that the courts are clogged up with frivolous lawsuits. They use billboards, radio advertisements, television advertisements, brochure mailings and other media to spread the message. Because of this, even a plaintiff with a legitimate case has a much more difficult time convincing a jury that their damages are real because the jury comes into the case on the lookout for frivolous cases and otherwise generally cynical toward civil cases.

Thus, the days of a plaintiff having his or her "day in court," of having the unencumbered right to have a jury decide how much a case is worth, are coming to an end.

> Today, a plaintiff cannot rely solely on the merits of having a good case with legitimate damages. Instead, the court system has become a giant casino and the plaintiff stands at the craps table blindfolded. He or she can cash in the few chips he or she has, which represents the offer made by the defendant (no matter how small or unfair) or put those chips on the table and roll the dice (go to trial).

Going to trial today really is not much more certain than rolling the dice. That is not to say that nobody should go to trial and that juries are never fair. There are plenty of reasonable verdicts every day. But you never know what the beliefs of your jury are going to be. Just make sure that you consider all of these factors before you walk away from a settlement that really is arguably reasonable, all things considered, in favor of gambling on a jury.

Going to Trial

Going to trial is the direct and end result of failure. Failure to settle, that is. In the United States, statistically, most cases settle. But there are a lot of cases filed, so even a small percentage of them going to trial is still a lot of cases going to trial.

In my experience some cases are more likely to go to trial than others. For example, I have found that land disputes are often difficult to settle because there is a lot of emotion involved and the parties consequently have trouble compromising. Automobile accident cases where liability is clear less commonly go to trial. Medical malpractice, family law, criminal law and other personal injury cases fall somewhere in between. The more that is in dispute, though, the more likely it is that you are going to end up in trial.

What should you expect if you go to trial? That varies by state and also by whether you are in state court or in a federal court. However, there are some things that are relatively common to trials.

In a typical trial, you will have gotten a trial date early on in the litigation process (although some judges do not schedule a trial date

until after discovery has been completed). Sometimes, if courts have a lot of cases to deal with, your case might actually be put in line with other cases to be tried on a certain date. In other words, there may be five cases set for trial on a given date in hopes that at least four of the cases will settle by the time that day comes and only one of them—if *even* one—will actually be tried.

However, if you are down the list and one of the cases above you actually does go to trial, you may be "bumped." That is the term used to indicate that you will be placed on the list again sometime in the future and may get to try the case then. This can be inconvenient because sometimes a lawyer will fully prepare for trial, subpoena witnesses, send nonrefundable fees to expert witnesses and then find out only a day or two before trial that the case is being bumped. (See the checklist on preparing for trial in the Appendices.)

Burdens of Proof

In order to win your case, you must prove that the facts support your case. Also, it is the plaintiff's duty to prove his or her case, not the obligation of the defendant to disprove the plaintiff's case. However, just how much proof do you have to have or put another way, how convincing do you have to do, in order to win? If a jury says that maybe they believe the plaintiff, is that enough to win? Do they have to be absolutely and totally convinced by the plaintiff in order to rule in his or her favor? This question is really asking what is the plaintiff's burden of proof in order to win. The burden of proof is the level of proof that the plaintiff must provide to the jury in order to win.

U.S. law typically recognizes five levels or burdens of proof, which apply in various aspects of personal injury cases. These include, in increasing order from weakest to strongest: prima facie case; preponderance of the evidence; reasonable certainty; clear and convincing; and beyond a reasonable doubt.

A **prima facie case** begins with an explanation of prima facie evidence, which refers to presenting any evidence at all which is sufficient to suggest any possibility that something is true.

Basically, any evidence at all in favor of a position will provide prima facie evidence. In personal injury cases, this standard of proof is most commonly used with regard to motions to dismiss and motions for summary judgment. If a defendant makes a motion to dismiss or a motion for summary judgment, the plaintiff must show that he or she

has a prima facie case—this means that there is prima facie evidence of each element of the cause of action alleged by the plaintiff. If a plaintiff alleges any evidence to meet all required elements, a motion to dismiss should not be granted.

> On other words, the plaintiff's attorney must present a prima facie case at trial. After the plaintiff's attorney has presented all of his or her evidence—but before the defendant's attorney begins his or her case—the defendant's attorney will make a motion for a directed verdict. This asks the judge to dismiss the case on the grounds that the plaintiff has presented all of his or her evidence and that there is not enough to cover all required elements or that the evidence was not strong enough that a reasonable jury could find in the plaintiff's favor.

If there *is* enough evidence (and very little is required) that a reasonable jury could possibly find in favor of the plaintiff on each required element, summary judgment should not be granted.

Preponderance of the evidence is the basic, default burden of proof in personal injury cases as well as most other civil (non-criminal) cases. The plaintiff must prove all elements and aspects of his or her case (except those which specify a higher standard, explained below) by a preponderance of the evidence.

> A preponderance of the evidence means, in its most basic form, that something is more likely than not.

Other explanations which might help you understand this include: the evidence is more than 50 percent (even if ever so slightly over 50 percent) in favor of the plaintiff; or imagine that the proof is on an old fashioned scale—if the proof tips the scale in the plaintiff's direction at all, no matter how slightly, there is a preponderance of the evidence; or using the same analogy with the scale, imagine the scales are perfectly equal but then a feather lands on the plaintiff's side of the scale—that is all it takes to have a preponderance of the evidence.

For each of the elements of your causes of action, you will have to convince the jury by at least a preponderance of the evidence that they should believe your position.

So You've Been in an Accident...

The **reasonable certainty** burden of proof commonly applies to issues involving future damages. In other words, in a typical personal injury case you will have to prove by a preponderance of the evidence that the defendant is liable for the accident and that the medical bills, pain and other damages suffered from the time of the accident to the trial were caused by the accident.

However, if you wish to claim that you will suffer medical bills, pain, lost wages or other damages in the future—beyond the date of the trial—you will have to prove that it is reasonably certain that you will suffer those damages, not just that it is more likely than not—preponderance of the evidence.

> **Reasonable certainty is more than a preponderance but less than beyond a reasonable doubt. Some lawyers claim that this burden of proof is identical to the clear and convincing burden but just has another name. I will not argue with this—as the difference between the two, if any, is slight.**

Some jurisdictions (that is, states or specific courts) apply a **clear and convincing** burden of proof to certain issues.

> **It is hard to explain what clear and convincing really means. Suffice it to say that, like reasonable certainty, the proof must be more than a preponderance of the evidence, but less than beyond a reasonable doubt. This standard does not commonly apply in most personal injury case issues, although it does not apply in other civil law situations.**

Some examples of situations in which the clear and convincing burden of proof is required: proving that a defendant committed fraud; in certain situations involving wills; in certain situations involving custody of children; in certain commitment proceedings; in certain situations involving defamation.

You have probably heard of the burden of proof of **beyond a reasonable doubt**. As you likely know, this is the burden of proof that must be met by a state or the federal government in order to convict someone of a crime. This standard applies only to criminal cases. It does not apply to any issues in civil cases that I am aware of except for

one obscure issue. Suppose someone is tried for a crime which injures someone else. If the defendant is not convicted in the criminal trial, the injured victim can still sue the defendant for his or her injuries in a civil case. This is because the level of proof required for a criminal conviction is higher than for a civil case.

> In other words, the level of proof might not be high enough to reach the level of beyond a reasonable doubt, but that does not mean that it is not high enough to reach the level of a preponderance of the evidence. So where a criminal case fails, a civil case might nevertheless succeed.

Along those same lines, in some jurisdictions, if a defendant is convicted of a crime, that conviction may in some circumstances be used against the defendant in a subsequently filed civil case. For example, if the defendant assaults the plaintiff and is convicted of the crime of assault, the plaintiff might then file a civil lawsuit in which it might be automatically be established, for purposes of the civil suit, that the defendant committed the assault. In the trial, the plaintiff will not have to prove the assault, only the damages that resulted.

You cannot use a civil verdict to convict someone of a crime, only the converse.

Preparing for the Big Day

For most clients, especially those who have never been to court before, the weeks leading up to the trial date can be scary. During this time, your attorney will be making final preparations for trial. This includes things such as sending subpoenas to witnesses, preparing exhibits, preparing trial notes such as opening statements and closing arguments and questions to ask witnesses, preparing pretrial motions and answering the other parties' pretrial motions.

In addition, your attorney will probably want to begin preparing you for your testimony. It would be wrong for me to suggest to you what you should be specifically doing to prepare, because that is up to the individual strategy of your attorney. However, some of the things your attorney might have you do is to read your deposition transcript and also perhaps the deposition transcripts of the defendant and other witnesses. He or she might also practice your testimony with you. As

part of that practice, he or she may ask you difficult questions that the other attorneys might ask you on cross examination so that you will be prepared. This is a good way to see how you will handle the actual stress of being in the witness box at the actual trial.

I like to set up a miniature, simulated courtroom to use in preparing my clients to testify.

Another important issue, which you should ask your attorney about if he or she does not mention it to you first, is what you should wear to the trial.

What you wear during trial can and should be an important part of your attorney's trial strategy. He or she may want you to convey a certain image to the jury with your clothing. He or she may or may not want you to wear an expensive suit or shiny jewelry. Even the shoes you wear might be important to your attorney.

> I think it is very important that you discuss this with your attorney in detail so that you do not show up to court wearing something that your attorney believes will harm your case. I am always surprised at how many times I see plaintiffs show up to trial wearing clothes that could harm their image with the jury. I am equally surprised at how often their attorney blames them, having just assumed that their client would know how to dress. Do not let this happen. Ask questions.

If you do not discuss the issue with your lawyer and it is the morning of trial, I suggest that you do *not* dress too formally—but do not dress too casually, either. Do not wear jeans or t-shirts. Wear what you would wear to church (if you go) or to a wedding or dinner party.

Men do not necessarily have to wear suits and should not wear a suit that appears to be very expensive. Also do not wear fancy, flashy or expensive looking jewelry. You do not want the jury to think that you do not need money. On the other hand, juries do not like people they perceive as being slobs.

Motions for Summary Judgment

As I mentioned in my discussion of prima facie evidence, at some point—usually as the trial date draws near—the defendant may file a motion for summary judgment with the judge. A motion for sum-

mary judgment is a tool that is designed to kick cases or parts of cases, out of court that have proven during the course of litigation to have no merit—or not enough evidence to meet *any* burden of proof.

Technically, a judge should grant summary judgment—kicking a case or parts of a case out of court—if, given the facts that are *not* in dispute, there is no way a jury could reasonably find in favor of the plaintiff.

This solution will typically apply when the plaintiff either does not have sufficient facts to prove his or her case or is relying solely on a legal theory that the judge decides is invalid.

I'll give an example of each.

First, suppose that the plaintiff's attorney and defendant's attorney agree: that the accident was the fault of the defendant; that the plaintiff suffered a broken wrist which completely healed; on the amount of the resulting medical bills; and how much the plaintiff should receive for pain and suffering resulting from the broken wrist.

However, the plaintiff also claims that he suffered and continues to suffer from post traumatic stress disorder and cannot work as a result. The defendant does not believe that the plaintiff actually suffers from this ailment. Suppose further that the plaintiff is unable to find a doctor who is willing to testify that the plaintiff suffers from post traumatic stress disorder as a result of the accident.

The testimony of a doctor is typically necessary in order to proceed to a jury with a claim that the plaintiff suffers from a disorder and that it was caused by the accident; this plaintiff is unable to produce a doctor to so testify. Therefore, the defendant would be entitled to summary judgment on that issue. The plaintiff and his lawyer would not be allowed to argue to the jury that he suffers from post traumatic stress disorder as a result of the accident.

Similarly, if the plaintiff has not have evidence to cover all required elements of a claim—or has evidence of all elements but not enough that a reasonable jury could find in the plaintiff's favor—then the judge will grant summary judgment on any such claims.

In many jurisdictions, the guidelines for issuing summary judgments are vague and essentially left up to the discretion of the judge. This is one of the biggest reasons that you want to have a fair judge who does not side with defendants whenever possible.

> So, if there is more than one court in which your case can be tried, the reputation of the judge—with regard to issuing summary judgments for defendants—will be an important consideration in choosing your location.

Second, let us look at an example of summary judgment based on an invalid legal theory.

Suppose the plaintiff was hit by a drunk driver and sues a female passenger in the drunk driver's car because she gave alcohol to the driver. Suppose further that both the plaintiff and defendant agree on those facts—and that the plaintiff's *only* legal theory of liability against the defendant passenger is that she had a duty to refrain from giving alcohol to the driver and was negligent for failing that duty.

If the judge rules that under the applicable law the defendant did *not* have a duty to refrain from giving alcohol to the driver, the judge will grant summary judgment and kick the whole case against the passenger out of court.

> You should not necessarily be concerned if the defendant files a motion to have your case or part of it, kicked out of court. Summary judgment motions are commonly filed—and commonly denied. Defense attorneys often file motions for summary judgment just in case the judge is cynical about your claims...or because they get paid by the hour and can bill for the time spent preparing the motion.

On the other hand, remember that just because something is true does not mean that you can come up with evidence to prove it.

So, if a summary judgment motion is filed in your case, take it seriously—but do not immediately assume the worst. Talk to your lawyer about it so that you understand what is going on.

Where Does Everyone Sit?

For many personal injury clients, their own trial is their first ever visit to a courtroom. Lawyers often forget that their clients have no

idea where to sit, what the various parts and people in the courtroom are for and so on. This can be a bit scary, so here is a primer.

Courtrooms come in all shapes and sizes, but most of them have some basic features in common. Pretty much every courtroom will have a bench for the judge, a witness box, a jury box, plaintiff's table and defendant's table.

The judge's bench should stand out, as usually it sits higher than other seats or tables in the courtroom. This traditionally signifies the power and prestige of the judge and court. Usually, near the judge's bench—and sometimes even integrated into it—is the witness box. This is where witnesses sit while they are being questioned.

The jury box is where the jury sits, usually with a good view of the witness box and judge.

Somewhere worked into the scheme will be the plaintiff's table and defendant's table and the court reporter's desk.

If you are first to arrive at the courtroom, you might wonder which table is the plaintiff's table. Traditionally, the plaintiff (as the party with the burden of proving their case) sits closest to the jury box.

If the tables are equally close to the jury box, you may simply have to ask a court officer where each party sits.

There are certain people that you are likely to encounter in court. These typically include the judge, the clerk of the court (who takes care of the administrative business of the court and trial), the court reporter who records everything that is said during the trial and the bailiff (often wearing the uniform of a sheriff's deputy or other law enforcement officer) who is in charge of the overall security of the courtroom.

Courtroom Etiquette

Before going to court, it is good to know some of the traditional rules of etiquette—and lawyers often do not think to explain these to their clients in advance. Although different courts have different specific rules, there are some common rules that the majority of courts I have been in follow…and that you should know about.

First, everyone in the courtroom is traditionally expected to stand when the judge comes in and/or leaves the courtroom. Often, a bailiff or other court officer will announce "all rise" upon the entrance or exit of the judge—but be prepared to do so whether prompted or not, as a sign of respect for the court.

Second, it is traditional for everyone in the courtroom, unless the judge directs otherwise, to stand when the jury is entering or exiting the courtroom.

Other traditions which are less common but that you may encounter include beginning the day with the pledge of allegiance to the American flag, some pre-written introduction to the court session. (Example: "Oyez! Oyez! The honorable court of Lakeshore County is now in session, all persons having claims to bring or motions to make may come forth and be heard.")

Check with your attorney in advance to find out whether food or beverages are allowed in the courtroom and whether personal items, such as cell phones, are not permitted (and therefore might be confiscated by security).

I know many judges who are very upset by cell phones going off in their courtrooms and will confiscate and maybe even have any such phones destroyed.

Jury Selection

Jury selection will be conducted either on the morning of the first day of trial or at some point in advance of trial. In either case, the process will go something like the following.

Once the potential jury pool has arrived and the lawyers and judge are settled in for the day's business, the first major step in the trial of a case will be the selection of a jury. This process is set in motion long before you get to the courtroom. At some point, probably many weeks or months in advance of your trial, notices will be sent to potential jurors that have been selected for jury duty for the time period that your case will be tried.

The manner of selection of these potential jurors is random and varies by jurisdiction. Some means by which the lists are compiled include voter registration records, driver's license and/or identification card lists or some other nondiscriminatory rolls of the jurisdiction's residents. The notices sent to the chosen jurors will indicate that they are to be present at the courthouse on certain dates to potentially be chosen to serve in a jury.

Jury selection will begin with a room full of many more jurors than you will actually use. The large number is one of the safeguards used to ensure a fair jury. The next step will be to narrow down the number who have shown up into a group that will include those who will ultimately serve as the jury.

Each side—plaintiff and defendant—will have a certain number of jurors that it can kick out of the pool for any reason (usually strategic) except for reasons that discriminate illegally based on race, age, etc. These rejections are called "peremptory challenges." Smart lawyers use them to improve the chances of a sympathetic jury.

Most civil juries consist of six jurors (although some jurisdictions still use more, up to 12). Also, there are usually one or two "alternates"—extra jurors that hear the case and deliberate if one of the main jurors gets sick or otherwise has to leave the jury.

> **If we ultimately want to choose six jurors and two alternates to hear a case and each side has two peremptory challenges, then we will need to choose 12 from the group of people who have shown up to come forward to be part of the jury selection process (12 minus 2 peremptory challenges from each side = 6 jurors plus 2 alternates).**

Once the pool is narrowed down from the big group to the smaller group to be chosen from, the rest of the jury selection process from this point is designed to accomplish two things: first, to identify any jurors who have a clear bias to the parties or cases (these potential jurors are often dismissed by the judge); and, second, to help the lawyers decide when to use their peremptory challenges.

When jury selection begins, the judge (or, if the judge plays no part, the first attorney to ask questions) will tell everyone the names of the parties, a basic description of the issues in the case and the names of witnesses who will testify. The jurors will be asked if they know or are related to any of the parties or witnesses (or each other). If they do, the judge must decide whether their relationship or knowledge of a party or a witness is likely to make them biased toward that party.

If so, the judge will dismiss that juror and another juror from the original pool will be randomly selected to replace the dismissed juror. Dismissing a juror on this basis is called dismissal "for cause." There are no limits on how many jurors a judge may dismiss for cause.

Other reasons that a judge might dismiss a juror for cause are that they work for an insurance company; they have religious or other beliefs that prevent them from giving money to a plaintiff; they have a physical or mental disability that would affect their ability to be a juror; or any other reason that would clearly prevent them from being a fair juror.

Once the potential jurors have been asked questions related to clear and obvious bias, the lawyers will take turns asking the jurors their own questions. This process is called *voir dire*.

In a personal injury case, the plaintiff's attorney will often want to know whether any jurors think it is wrong to sue—whether they have moral or religious objections to lawsuits in general. They might also want to know whether a juror thinks there are too many lawsuits or that the system is being abused, whether the jurors are capable of giving significant amounts of money if the plaintiff proves her case and so on.

The defendant's attorney will often ask whether any juror thinks that someone should automatically get compensation when they are injured by someone else or whether any juror is predisposed to assume the defendant is liable just because a lawsuit was filed.

How far and on what subjects lawyers are allowed to inquire vary by jurisdiction and is often very much left to the discretion of the judge.

Understand as you watch your attorney go through this process that this is his first opportunity to create a relationship with the jury. You should talk with your attorney in advance about how he or she wants you to present *your*self during this process. He or she may want you to sit a certain way, make eye contact or not make eye contact with the jurors, make sure you do not look bored or twiddle your thumbs or doze off during selection, etc. Jury selection is your chance to make a first impression on the jury.

I prefer to spend quite a bit of time on *voir dire*, sometimes as much as an hour, to try to build a relationship with them. Of course, at the same time, I have to be careful not to bore them.

At the end of questioning, the lawyers—in some order determined by the rules of the court—will select which jurors they want to eliminate from the jury using their peremptory challenges. The remaining jurors will become the jury and alternates.

Once this final group is chosen, the judge will usually dismiss the rest of the potential jurors who showed up that day, have the jury take an oath to try the case fairly, etc., and then take a break to allow jurors to get parking permits, make calls to let people know they will be part of the jury…and so forth.

Opening Statement

When the jury has been chosen and is sitting in the jury box, the presentation of the case will begin with opening statements. The plaintiff, having the burden of proof, usually goes first.

> **I will begin by explaining the distinction between opening statements and closing arguments. The names actually give away this distinction. Opening *statement* is a statement; a closing *argument* is an argument. In other words, arguments are not appropriate in opening statements.**

In an opening statement, the attorney summarizes for the jury what facts he or she intends to prove during the course of the trial. The speech will usually include an introduction to what the case is about, introduction of the plaintiff, a summary of each witness and what they are expected to testify about and a summary of the documentary evidence that will be presented. Naturally, the summary presented by the plaintiff's counsel will be presented in a favorable light to the plaintiff and the defendant's opening will be presented in a favorable light to the defendant.

Although some inferences are typically made in the opening statement as to what the attorney wants the jury to find based on the evidence, it is technically improper to tie any "facts" into the legal principles involved. This is because the judge does not instruct the jury about what laws are applicable in the case until after all of the evidence and testimony has been presented.

To illustrate this sometimes difficult distinction, in opening statement, the plaintiff's attorney might tell the jury:

> Ladies and gentlemen of the jury, you will hear testimony from the plaintiff, as well as three disinterested witnesses to the accident, that the defendant, Mr. Jones, ran the stop sign. The evidence and testimony will show that he did not slow down, but rather sped up as he approached the intersection and that as he drove through the stop sign, he crashed into Mr. Smith's car.

It would be inappropriate in the opening, but proper in closing argument, for the following, similar speech:

> Ladies and gentlemen of the jury, in this state, it is illegal by statute to run a stop sign. Also, in this state, people are liable for damages caused by failing to follow their legal duties. The evidence in this case is clear that Mr. Jones breached his statutory duty to Mr. Smith by running a stop sign and crashing into Mr. Smith's car on March 12 of last year. As such, you should find in favor of and give damages to Mr. Smith.

Do you see the difference? In the first speech, the attorney sticks just to the facts. In the second, the attorney tells the jury what duties the law imposes and argues that certain conduct of the defendant has breached such a duty. Argument must be saved for closing argument.

Finally, in most courts, the defendant has the right to defer his or her opening statement until after the plaintiff's attorney has put on all of his or her evidence. In other words, the defendant's lawyer may choose to give his or her opening statement immediately after the plaintiff's lawyer...or wait until the plaintiff's attorney has put on all witnesses and evidence and then give opening statement right before putting on his or her evidence.

This is almost a moot point because it is *extremely* rare for the defendant to defer opening statement.

Testimony

After each side has given their opening statement, the questioning of witnesses will begin.

Witness testimony is the highlight—the "meat and potatoes"—of the trial. All of the plaintiff's witnesses will testify and then, when the plaintiff is totally done presenting witnesses, the defendant's witnesses will testify. Occasionally, a defense witness may testify during the plaintiff's case, out of order, if necessary to accommodate a reasonable schedule. This is particularly true of doctors and other expert wit-

nesses. When—after each side has given its opening statement—it is time to present witnesses, the judge will tell the plaintiff's lawyer something like "call your first witness." The plaintiff's lawyer will then announce the name of the first witness and, if in the courtroom, the witness will come forward. Otherwise, the bailiff or some other court official will go out of the courtroom into the hallway to bring the witness into the courtroom.

This is a good place to talk about the concept of "witness sequestration." This may sound like a painful type of surgery, but it is just a complicated word for an easy concept.

Most courts have a policy that witnesses should not hear each other testify, because it makes it too easy to orchestrate lies. Therefore, witnesses will often not be allowed to sit in the courtroom during the testimony of other witnesses until after they have testified. They are therefore said to be "sequestered" from the courtroom and have to wait in the hallway or a witness room if provided. Many courts make an exception to the requirement of sequestration for expert witnesses, under the theory that often their testimony is based to a large degree on the testimony of other witnesses.

For example, it may be useful for an expert who heard another expert testify earlier to comment on the validity of the earlier expert's testimony. Also, once a witness testifies, he or she is usually allowed to remain in the courtroom and hear the testimony of other witnesses.

One final note: all named plaintiffs are allowed to be in the courtroom during all testimony. This is another reason why it is good for an injured plaintiff's spouse to bring a loss of consortium claim. If the plaintiff's spouse is not a plaintiff, they can be sequestered and therefore not allowed to be in the courtroom to comfort and support the plaintiff. If they bring a consortium claim, they can be there.

So, the plaintiff's attorney announces his or her witness, the bailiff gets them from the hallway and brings them into the courtroom. What next? The witness will then be asked to swear an oath—administered by the judge, a court clerk, the court reporter or some other court

official. A typical oath will ask the witness to swear that they will "tell the truth, the whole truth and nothing but the truth...." The witness will then be seated and questioning will begin.

"Direct examination" consists of the questions asked by the attorney who called the witness to testify. Direct examination will typically begin by asking the witness background questions such as his name, where he lives, where he works, where he went to school, etc. Then, the witness will be asked questions more pertinent to the case. For example: If the witness saw the accident, the plaintiff's lawyer will ask him to describe what he saw, anyone he talked to, etc.—in order to show the jury what information that witness has to offer.

Once the attorney who called the witness is finished asking questions, he or she will sit down and "pass the witness" to the other side. The lawyers for the other side will then be entitled to cross examine the witness. The attorney cross examining the witness will usually ask questions to discredit testimony that, on direct examination, was harmful to her client's case—and highlight testimony that was helpful to her client's case.

For example: If the witness was called by the plaintiff's attorney on direct examination and testified that she saw the defendant's car run a stop sign, the defendant's counsel on cross examination might ask how the witness knows it was the defendant's car, how far away from the intersection was she standing, at what point did she begin watching the intersection and so on. In other words, anything at all that might discredit the witness.

> The goal of cross examination is not usually to make the witness look like a liar (juries often get angry with an attorney who is "picking on" or "bullying" a witness). The goal is to make it look like the witness might not have a reliable memory or might not have perceived the event as clearly as it seemed during the direct examination.

Another example: If, on direct examination, the witness testifies that she thought the car running the stop sign was green and the defendant's car was actually blue, the defendant's counsel will want to point out to the jury that the witness's memory is flawed as to the color of the car and therefore might be flawed as to other details, such as whether the car stopped at the stop sign.

One of the big differences between direct and cross examination is that leading questions are typically not allowed during direct examination but *are* allowed during cross examination.

What is a leading question? A leading question is a question that suggests an answer to the witness. If I ask a witness to "describe the accident as you recall it" that is not a leading question. On the other hand, if I ask a witness "you saw the defendant's car run the stop sign, didn't you," this is a leading question because it suggests the answer—that the witness did see the car run the stop sign—to the witness.

Again, leading questions generally are not allowed on direct examination but are allowed on cross examination—however, there are a few exceptions to this rule worth mentioning:

1) leading questions may be asked on direct examination about the witness's background information that is not specific to the causes of action of the case. For example: An attorney may ask questions on direct examination such as "you are 32 years old, is that right?" "and you live in Phoenix, correct?" "and you have three daughters?" and so on;

2) most jurisdictions will allow a party to ask leading questions on direct examination of another party. For example: If the plaintiff's attorney calls the defendant to testify, he or she may usually ask the defendant leading questions even though it is during direct examination;

3) many courts allow leading questions on direct examination when the witness has been certified by the judge as an expert witness.

This brings us to another important issue. All parties may be forced to testify. In a criminal trial, defendants do not have to take the stand and testify because of their rights against self-incrimination under the 5th Amendment to the U.S. Constitution.

This is not true in a civil trial. All parties to a civil case who are asked to testify must do so. However, the 5th Amendment to the constitution provides that a person does not have to incriminate themselves and does not have to testify as to matters which may tend to incriminate them to a crime. So, even in a civil case—and even though

a party has to take the stand—a person does not have to testify as to criminally incriminating information.

Make sure you understand the distinction here. In a criminal trial the defendant does not have to take the stand. In a civil trial, the defendant must take the stand, but does not have to testify about anything that would implicate him in a crime. However, there must be a genuine threat that the witness may be prosecuted in order to refuse to testify based on the 5th Amendment.

> **If a witness has already been tried and found not guilty of a crime, he cannot refuse to testify about issues that would incriminate him about that crime. However, if the information could potentially incriminate the witness to *another* crime for which the defendant could potentially be charged, then he may invoke the 5th Amendment and refuse to testify.**

After cross examination is completed, the attorney who called the witness is usually then allowed to perform a "redirect" examination of the witness in order to follow up on issues that were raised on cross examination. Whether re-cross examination is then allowed by the other attorneys—and whether any additional rounds of questioning may follow that—is usually up to the judge.

There is one last wrinkle about calling witnesses that I will mention. In some courts, if your attorney calls the defendant to the stand to testify during your case, the attorney for the defendant may have to make a choice. He or she may either cross examine the defendant and then call the defendant *again* to testify during the defendant's case or choose to go ahead and perform direct examination right then and there—even though it is during your case.

> **In other words, the defendant's lawyer may not perform two direct examinations of the defendant—one when the plaintiff calls the defendant and then another during the defendant's case presentation.**

If the defendant's lawyer elects only to cross examine the defendant after your lawyer performs direct examination, that cross examination will be limited to the issues raised during the direct examina-

tion and additional issues will have to be raised later when the defendant's lawyer calls the defendant to testify. Different courts follow different rules in this situation.

Expert Testimony

There are two general categories of witnesses, fact witnesses and expert witnesses. Fact witnesses are witnesses who testify about things that they have experienced—things they saw, heard, smelled or felt and can recount to the court. Expert witnesses provide opinions.

Fact witnesses can sometimes give opinions about limited issues without being qualified as an expert on a subject. For example, a fact witness might be allowed to testify, based on what she saw, that in her opinion another person was drunk or seemed upset. In other words, they can give opinions that any intelligent person might form.

Expert witnesses, on the other hand, give opinions on subjects that everyday people are typically unable to understand on their own. For example, an orthopedic surgeon might be brought to court to give an opinion as to whether a plaintiff's back injury will have permanent consequences or whether that plaintiff will require surgery in the future. A professional surveyor may be brought to court to give an opinion about the location of a boundary line between two pieces of property. An automotive engineer might be brought to testify in a product liability case that an airbag improperly failed to deploy in an accident and so on.

> **Anyone can give an opinion about whether a person seemed drunk or upset. Only an expert can make a medical prognosis.**

In order to be permitted by the judge to give expert opinions, a witness must be qualified as an expert. In other words, the judge must certify the witness as an expert. To convince the judge that a witness is qualified as an expert in a particular field, the attorney will question the witness, before any opinions are given, about that person's education, experience and specialties. Then, the judge will determine whether the witness is qualified as an expert and therefore may give expert opinions; the judge may also rule on what subjects the expert may offer opinions.

Sometimes, to save time, the other lawyers will stipulate (that is, agree), that a witness is an expert—and this saves some of the time required to qualify the expert. This may be a trick, though. The defendant's lawyer may stipulate that a witness is an expert and then argue that, because of the stipulation, the plaintiff's attorney should not be allowed to spend a lot of time having the expert testify about his or her impressive credentials.

> If the defendant's side has an expert with weaker credentials, the lawyer may use this stipulation trick to argue that credentials are irrelevant. I think that most judges would still let your lawyer bring up your expert's credentials, even if it is stipulated that the witness is an expert—but you never know.

You Can't Mention Insurance at Trial

In most jurisdictions, it is impermissible to tell the jury whether or not a defendant has insurance to pay for any jury verdict. The theory behind this rule is that jurors will be more likely to give large amounts of money to a plaintiff if they know that some big insurance company with deep pockets is going to pay.

> Jury verdicts are supposed to be based solely on the facts and not whether a defendant is rich or poor or has insurance. So, it is generally against trial rules to mention that a defendant has insurance—or that you have uninsured or underinsured motorist coverage. In fact, if insurance is mentioned (either accidentally or intentionally), the judge may declare a mistrial. And you will have to start over again.

There are a couple of exceptions to the rule that insurance cannot be mentioned. First, if a witness for the defendant happens to tell the jury that there is insurance, the judge will probably not declare a mistrial, although he or she could. Second, if a relevant issue in the case is whether or not the defendant owned or maintained a piece of real property or a car and the defendant denies owning it, the plaintiff

could introduce evidence that the defendant had an insurance policy covering the property or car. In that case, the plaintiff is using the insurance coverage to prove ownership, which the defendant denies, rather than to encourage the jury to give more money.

> **I always argue to the judge that the jury should be instructed that the parties are not allowed to mention insurance because it is irrelevant. I do this because I do not want the jury to infer from the lack of mentioning of insurance that there is no insurance and consequently give less money. I at least want them to know that we are not allowed to talk about it.**

The Jury Charge

Once all of the witnesses have testified and all evidence has been presented, the next step is for the judge to "charge" the jury. This means that the judge will read what are called "jury instructions" to the jury which explain the law to the jury and instruct them on how to apply the facts to the law.

Remember: The judge determines what laws apply; and the jury decides what the true facts are. In other words, the jurors must decide what facts from the trial they believe (based on who they thought told the truth and their analysis of the evidence) and then plug those facts into the legal framework explained by the judge in the jury instructions, in order to reach a final verdict.

> **This gives the judge a lot of influence. A judge might instruct the jurors that if they believe that the evidence weighs ever so slightly in favor of the plaintiff that the defendant breached a duty to the plaintiff which caused injuries, they should find in favor of the plaintiff. However, if the evidence weighs ever so slightly in favor of the defendant that he did *not* breach any duties that injured the plaintiff, the jury should find in favor of the defendant. The judge may emphasize the "ever so slightly" language in order to encourage jurors to make a decision in a close or difficult case. This is one tiny example of the types of jury instructions judge can provide.**

The jury instructions are often long and repetitive and sometimes it takes an hour or more for the judge to read the entire charge to the jury. This can be one of the more boring parts of the trial for the attorneys—unless they use this time to work on preparing or adjusting their closing arguments. (Some courts may wait even longer—until the lawyers have all made their closing arguments—to charge the jury.)

Closing Arguments

In most situations, after the instructions have been read to the jury, the attorneys will give their closing arguments. This is the opportunity for the attorneys to take the testimony and evidence that have been provided during the trial and tie them to the law that was read in the jury instructions, in order to argue why the jury should believe their side and find that the facts apply to the law in their favor. It is the last chance to "win over" the jury.

> **A good closing argument does not leave any room for doubt. The attorney should explain to the jury, succinctly but without sounding cocky, exactly what the jury should find on each issue and why.**

In an automobile accident case, your attorney will want to explain why the defendant is liable for the accident, why you have no comparative or contributory fault for the accident, summarize how the you were injured—including the amounts of medical bills and description of the pain and suffering you have gone through as a result of the injuries.

> **If allowed by the judge, I like to show the jury an enlarged copy of the verdict form that it will be filling out and show jurors how to fill it out in the plaintiff's favor. I do this partly to encourage them to rule in my client's favor—but also to make sure that they understand how to read and fill out the verdict form, which can sometimes be complex and confusing.**

Some judges put time limits on closing arguments, some do not—and some require the parties to agree in advance on a time limit.

Jury Deliberations

Once closing arguments are completed, the jury is sent to the jury room to deliberate—that is, to talk about the evidence and testimony and attempt to reach a verdict. The jury is given the exhibits that were admitted into evidence, usually given a written copy of the jury instructions and a verdict form. The verdict form asks the jury a series of questions that lead them to an ultimate verdict.

> **Jury deliberations are absolutely private. They are not recorded and nobody can be in the room with the jurors. Not you, not the lawyers, not the judge. Nobody.**

While you are waiting for the jury to reach a verdict, you will be very tempted—and your attorney might also be tempted—to talk about whether the amount of time that has passed is favorable or not favorable. Then, when the verdict has been reached by the jury, but before it is read in the courtroom, there is an immediate desire to make a prediction about the result based on the amount of time it took. This thinking usually goes something like:

> ...if the jury comes back quickly, then they probably found for the defendant because they did not have time to calculate damages, so they must have found completely against us. On the other hand, if they are out for a long time, they are probably on our side because it takes a lot of time to decide how much money to give.

In my opinion, such predictions are fruitless and emotionally painful. Sometimes juries come back quickly with a big verdict for the plaintiff because the jurors all quickly agree to find for the plaintiff and for how much; on the other hand, sometimes juries do come back quickly because they found for the defendant and against the plaintiff. Conversely, sometimes jurors spend two or more days deliberating and end up finding for the defendant. In that case they were not calculating how much money to give, they were in disagreement and it just took a long time for some of them to change their minds and

reach an agreement. On the other hand, sometimes they are out for a long time because they are calculating how much to give.

> **There really is no way to know what the jury is actually doing until you hear the final verdict.**

If you are passing the time by guessing what the jury is doing, your suffering will probably increase dramatically if the jury decides to ask a question.

Yes, sometimes juries ask questions. They usually do this by writing their question on a piece of paper and sending it to the judge, typically by way of a clerk or bailiff. Generally, when the jury asks a question, the judge will call the lawyers to the courtroom (if they are not told in advance that the jury simply has a question, everyone gets excited because they think the jury has reached a verdict) and read the question to the lawyers. The lawyers and the judge will then discuss how they all think that the judge should reply to the jury.

Finally, the judge will either call the jurors into the courtroom and give them an answer or else go back to the jury room and give them the answer. For the most part, everything that the jurors are allowed to be told is included in the jury instructions. Therefore, a common answer that judges give to jury questions is that he or she cannot tell them anything more—that they are to deliberate and reach a verdict based on the instructions given to them in the jury charge.

The Verdict

Assuming that the jurors are not hopelessly unable to agree (called a "hung jury" which results in a mistrial and necessity of trying the case over again to another jury) the jury will eventually reach a verdict. The lawyers and parties will be called back to the courtroom and the jury paraded into the jury box. The jury foreperson (chosen at the beginning of deliberations by the jurors) will then read the verdict (usually after the judge looks it over).

Usually, either the foreperson will read the entire verdict form, questions and answers, verbatim—or else the judge or clerk will read the questions and the foreperson will give the answers that the jury decided. A few judges read the entire verdict themselves.

When this is finished, the judge or one of the attorneys, may request that the jury be "polled." This is a process whereby each individual juror is asked to confirm out loud that he or she voted for the particular details of the verdict as it was just read. Assuming all jurors indicate that they did vote as such, the trial is over. The official verdict will be reduced to a writing called a "judgment." The judge then "enters" the judgement by making it part of the court file.

I hope you win. If not, remember that easy cases do not usually go to trial. For one reason or another, your case was difficult. It will be less painful to lose if you understood from the start that there is a possibility that your case might lose.

Appeals

Shortly after the trial is over, the losing party will generally make a motion to the judge asking him or her to set aside the jury's verdict and order a new trial.

Keep in mind that sometimes the plaintiff loses even when he or she wins. If the jury finds in favor of the plaintiff, but awards an unreasonably low amount of money, the plaintiff might consider themselves to have lost the case.

For example: You and your lawyer predicted that the jury would give between $50,000 and $100,000—and you spend $10,000 in litigation costs, not to mention the time and headaches involved with preparing for trial, you will probably consider an award of $20,000 a loss. This is especially true if you turned down a settlement offer for more than that.

There are several reasons why a judge might agree to set aside the verdict and order a new trial; these reason might include that the jury could not have reasonably found as they did given the evidence or that the judge made some error in ruling during the trial—such as allowing evidence that should not have allowed. Unless the judge thinks the jury's verdict was unreasonable or that he or she now realizes that he or she made an error, the motion will be denied.

The only recourse for the losing party then is to appeal to an appellate court. If either the plaintiff or defendant (or both) decides to appeal, this is accomplished by writing an appellate brief and filing it with an appropriate appellate court.

> **Appellate courts are not trial courts. There are no trials there. No witnesses testify and there are no juries. The sole purpose of appellate courts is to determine whether the trial judge made any errors of law regarding the trial and to take action to fix those errors if their were.**

Some states have more than one level of appellate court, while other states have only one, usually called the state's "supreme court" (except in New York, as I have noted before). Appellate courts have higher authority than trial judges to determine what the law is or how the law should be applied in a given circumstance. It is sort of like the chain of command in the military where each level answers to the level above, all the way to the highest level court.

States have many more trial courts than appellate courts. As such, there can sometimes be different interpretations and applications of law by different trial judges throughout a state.

For example: Different judges might make very different interpretations of a statute and therefore apply the law in different ways. One of the purposes of appellate courts is to create consistency by deciding how the law should ultimately be applied in the state. Then, once the appeals court publishes a written decision on a matter of law, all of the trial judges in the state must respect and apply the law in the manner outlined by the appellate court (unless an even higher appellate court, if there is one, overturns the first appellate court's decision).

> **On matters of U.S. Constitutional or federal law, state judges must follow decisions of the U.S. Supreme Court or the highest federal court in the court's jurisdiction which has given an opinion on the issue.**

Another purpose of appellate courts is to prevent improper decisions by judges based on "home cooking." Sometimes, especially in

more rural areas, there is a fear that there might be a camaraderie among local lawyers and the judge.

The fear is that when a party who is not from the area appears in the court, the judge might tend to favor—intentionally or not—the local parties and lawyers. In other words, if a decision could reasonably go either way, the judge might choose the side of the local plaintiff or lawyer. So another purpose of appellate courts is to correct unfair rulings made by judges, whether for home cooking or for any other improper reason.

Sometimes judges just make mistakes—they are human.

Instead of having a trial, in an appeal the attorneys write documents, called appellate briefs, that outline to the appellate court why they believe the trial judge made an error or errors. The attorney for the other side then responds by arguing why they believe that the trial court judge did not make those errors. Sometimes both parties believe the trial judge made errors—but different errors. So, each side files an appeal and then each side responds to the other's.

In addition to the written arguments, appellate briefs will often include as attachments to their briefs copies of trial transcripts, copies of evidence used at trial and so on for the appellate judges to review.

The appellate court will sometimes make a decision based only on the writings submitted by the lawyers. However, in most cases the attorneys will have the opportunity to go to the appellate court and "argue their briefs" in person. In arguing their briefs, the lawyers will go to the appellate court, which consists of several judges rather than just one.

Each lawyer will prepare a speech emphasizing the more helpful parts of the arguments in favor of their respective positions. However, very little of the speech usually occurs because the judges have the right to—and typically do—spend most of the argument time asking the lawyers questions.

The lawyers will often not get very many words of their speech out before they are interrupted by the judges with questions. Appellate argument can actually be a pretty intimidating process because the lawyers are on the spot to answer very specific and often difficult questions. The judges really keep them on their toes. So, the lawyers must be well-prepared and have studied all possible laws and cases related

to the issues involved in the appeal. Appellate judges love to play "devil's advocate" against each lawyer so that all possible arguments for and against each position are covered. Each lawyer must know the arguments against their position and be able to argue convincingly why those arguments against their position should not carry the day.

After the briefs are argued, be prepared to wait. Appellate courts do not render decisions on the day of the arguments. Instead, it can be many weeks or months before the court makes a decision. Then, the court will issue a written document called an "opinion" which outlines its decision regarding the appeal.

> **If you check out the Web site of your state's highest court you can likely find a recent opinion example. Or check out the U.S. Supreme Court's Web site.**

In general, one of only a few things will happen as a result of the decision of the appellate court:

1) The appellate court might rule that there were no mistakes (or no important mistakes) by the trial judge and that whatever happened in the trial court stands. In other words, the judge was not biased, the jury was reasonable and the judge interpreted and applied all laws correctly—or any mistakes had no effect on the ultimate outcome.

2) The appeals court might find that the trial judge made a mistake and that the mistake was important enough that the case should be retried and may include instructions to the trial judge regarding how to rule on an issue of law. In that event, the case will be "sent back" to the trial court for a new trial. The result of the original trial is erased and everything starts over (or perhaps a new trial is conducted only on the amount of damages, but not liability). A new jury is picked and the trial happens all over again.

3) In some rare cases, particularly those involving claims that a jury's verdict was unreasonably high or that punitive damages were awarded but were not proper, the appeals court might order that the result of the trial court be upheld but that the amount of the verdict should be reduced. This is called a "remittitur."

For example: A jury verdict contains an amount for medical bills in the amount of $50,000—even though the plaintiff only claimed $10,000 in medical bills. Rather than order that the case be retried, the appeals court might order that the medical bills portion of the verdict be reduced to $10,000 but that the rest of the verdict stand.

> In theory, the court could order a higher amount than what the jury gave (this is called an additur), but this is extremely rare and has potential constitutional implications. As such, in that case, the appeals court is much more likely to order a new trial instead, unless the defendant agrees to an additur.

If there is more than one appeals court in the state, the case might then be appealed again to a higher level court. If the appeal was to the highest court, its decision cannot be appealed. However, even if the trial was in state court, if one side believes that the judge violated rights under the U.S. Constitution or violated or incorrectly applied a federal law, that party might be able to appeal the state judge's actions in a federal appeals court.

Interest on Judgments

If you end up going all the way to trial and get a verdict from the jury in your favor, many state laws provide that you are entitled to interest on that money.

There are two kinds of interest that may apply, depending on state law. First, prejudgment interest is interest on the verdict calculated either from the date of the accident or the date of the filing of the complaint. Second, post-judgment interest is interest on the judgment that accrues from the date of the verdict until such time as the money is actually paid.

> In other words, if the defendant files an appeal and loses, he or she must pay you interest for the time during the appeals process that you were not paid. Often this interest rate is provided by statute; and it is often much higher than what the money could have earned in a bank.

Understanding Hearsay

Now that I have discussed the sequence of events and procedures that make up a personal injury trial, there are a few final topics that I should mention. These are broader issues that can affect how a trial proceeds.

It seems as though everyone has some idea of what hearsay is. I assume that most people get their understanding of hearsay from television or movies. There have been many times that a client or witness has told me something along the lines of "I heard John Smith say something, but it is all hearsay."

> Hearsay rules are fairly complicated. So, most non-lawyers do not fully understand how hearsay works and the ways that it can and cannot be used in court. Do not automatically assume that a statement made by someone is hearsay and therefore useless.

Basically, hearsay is a statement that was previously made outside of court and then later offered in court for the truth of the matter asserted. This will make more sense as you read further. One thing that many people do not realize is that a hearsay statement does not have to be spoken.

Hearsay can be written or spoken. In other words, if someone writes a letter, that letter may be hearsay.

Many people believe that hearsay simply can never be used in court. This is not the case. There are many exceptions in which hearsay can be used in court. First and most common, is the exception that allows what are otherwise hearsay statements to be offered in court that are from an opposing party. In other words, the plaintiff can typically use hearsay from the defendant and the defendant can use hearsay from the plaintiff. For example, if the defendant says "I ran the stop sign" at the accident scene, that statement may be used in court by the plaintiff even though it might otherwise constitute hearsay. Some examples of additional exceptions, found in the federal hearsay rule, include, from Rule 803 of the Federal Rules of Evidence:

> (1) Present sense impression.—A statement describing or explaining an event or condition made while the declarant was perceiving the event or condition or immediately thereafter.

(2) Excited utterance.—A statement relating to a startling event or condition made while the declarant was under the stress of excitement caused by the event or condition.

(3) Then existing mental, emotional or physical condition.—A statement of the declarant's then existing state of mind, emotion, sensation or physical condition (such as intent, plan, motive, design, mental feeling, pain and bodily health), but not including a statement of memory or belief to prove the fact remembered or believed unless it relates to the execution, revocation, identification or terms of declarant's will.

(4) Statements for purposes of medical diagnosis or treatment.—Statements made for purposes of medical diagnosis or treatment and describing medical history or past or present symptoms, pain or sensations or the inception or general character of the cause or external source thereof insofar as reasonably pertinent to diagnosis or treatment.

(5) Recorded recollection.—A memorandum or record concerning a matter about which a witness once had knowledge but now has insufficient recollection to enable the witness to testify fully and accurately, shown to have been made or adopted by the witness when the matter was fresh in the witness' memory and to reflect that knowledge correctly. If admitted, the memorandum or record may be read into evidence but may not itself be received as an exhibit unless offered by an adverse party.

(6) Records of regularly conducted activity.—A memorandum, report, record or data compilation, in any form, of acts, events, conditions, opinions or diagnoses, made at or near the time by or from information transmitted by, a person with knowledge, if kept in the course of a regularly conducted business activity and if it was the regular practice of that business activity to make the memorandum, report, record or data compilation, all as shown by the testimony of the custodian or other qualified witness or by certification that complies with Rule 902(11), Rule 902(12) or a statute permitting certification, unless the source of information or the method or circumstances of preparation indicate lack of trustworthiness. The term "business" as used in this paragraph includes business, institution, association, profession, occupation and calling of every kind, whether or not conducted for profit. ...

(8) Public records and reports.—Records, reports, statements or data compilations, in any form, of public offices or agencies, setting forth (A) the activities of the office or agency or (B) matters observed pursuant to duty imposed by law as to which

matters there was a duty to report, excluding, however, in criminal cases matters observed by police officers and other law enforcement personnel or (C) in civil actions and proceedings and against the Government in criminal cases, factual findings resulting from an investigation made pursuant to authority granted by law, unless the sources of information or other circumstances indicate lack of trustworthiness. ...

(18) Learned treatises.—To the extent called to the attention of an expert witness upon cross-examination or relied upon by the expert witness in direct examination, statements contained in published treatises, periodicals or pamphlets on a subject of history, medicine or other science or art, established as a reliable authority by the testimony or admission of the witness or by other expert testimony or by judicial notice. If admitted, the statements may be read into evidence but may not be received as exhibits. ...

(21) Reputation as to character.—Reputation of a person's character among associates or in the community.

The following additional exceptions from Rule 804 of the Federal Rules of Evidence are applicable only if the person who made the statement is not available to come to trial to testify:

(1) Former testimony.—Testimony given as a witness at another hearing of the same or a different proceeding or in a deposition taken in compliance with law in the course of the same or another proceeding, if the party against whom the testimony is now offered or, in a civil action or proceeding, a predecessor in interest, had an opportunity and similar motive to develop the testimony by direct, cross or redirect examination.

(2) Statement under belief of impending death.—In a prosecution for homicide or in a civil action or proceeding, a statement made by a declarant while believing that the declarant's death was imminent, concerning the cause or circumstances of what the declarant believed to be impending death.

(3) Statement against interest.—A statement which was at the time of its making so far contrary to the declarant's pecuniary or proprietary interest or so far tended to subject the declarant to civil or criminal liability or to render invalid a claim by the declarant against another, that a reasonable person in the declarant's position would not have made the statement unless believing it to be true. A statement tending to expose the declarant to criminal liability and offered to exculpate the accused is not admissible unless corroborating circumstances clearly indicate the trustworthiness of the statement.

The hearsay rule can be frustrating if it prevents you from using someone's statement in court that would be very helpful to your case. However, there are often ways around the hearsay rule—so make sure you tell your lawyer everything that you heard anyone say. Automatically assuming that someone's statement cannot be used because it is hearsay could cost you a valuable addition to your case.

Privileges

The concept of privileges deals with two situations—either a witness's right to refuse to testify or a plaintiff or defendant's right to prevent a witness from testifying about certain communications made between the plaintiff or defendant and the witness.

One of the most common privileges involves the right against self incrimination, discussed earlier. Because the right against self-incrimination involves a witness's right to refuse to testify, it is a privilege. However, there are many other privileges which may apply in civil cases. Although not a complete list, some of the more common privileges that apply in personal injury civil cases include the spousal, attorney/client, physician/patient and priest/penitent.

Let us consider each in some detail:

- The **spousal privilege** applies more commonly in criminal cases than in civil cases. A criminal defendant can often prevent his or her spouse from testifying about anything that was said in confidence (while nobody else was present) during the marriage. Sometimes the privilege even extends to things that were said even *before* they were married. Conversely, a spouse who is a witness can often simply refuse to testify about anything said by the spouse. In other words, either spouse can usually invoke the privilege.

 The spousal privilege applies less frequently in civil cases. In other words, many courts do not allow spouses to refuse to testify about spousal communications when they are called as witnesses in a civil case. So, in a civil case, a spouse *can* be called to testify about statements made by the other spouse and the spousal privilege cannot be invoked by either party. Check with your attorney to see if spousal communications are privileged in civil cases in your state.

One detail that should be understood with regard to the spousal privilege as well as the other privileges listed below is that they apply only to confidential communications. That means that the privilege might not apply if the communication was not intended to be confidential. To that end, it is typically presumed that a communication is not confidential if it was said in the presence of a third person not in the scope of the privilege. In other words, the privilege would apply to the doctor/patient context even if a nurse was present and the attorney/client privilege would not be broken if a paralegal were present. However, if someone is playing golf with their spouse, their hairstylist and their cousin, the statements made would not be protected by the spousal privilege. Similarly, if someone is playing golf with their attorney, their hairstylist and their cousin, the statements made would not be protected by the attorney/client privilege.

- The **attorney/client privilege** is one of the most difficult barriers to penetrate. Just about anything that a client tells his or her lawyer in confidence, shy of telling the lawyer that he or she plans to commit a crime, will be privileged. In addition, the client may prevent the lawyer from testifying and the lawyer can and must, refuse to testify on behalf of the client. One common exception worth noting is that if a client sues or makes a complaint against a lawyer, the lawyer may usually break the confidentiality requirement to the extent necessary to defend the lawsuit or complaint.

- I call the next privilege the **physician/patient privilege** for simplicity. However, depending on state law, the privilege might include not only medical doctors and their patients but also might apply to psychologists, counselors and social workers and *their* patients. In fact, your state's law might apply to various other types of medical providers as well. In other words, the privilege may or may not extend to chiropractors, physical therapists, dentists and so on. This privilege is often limited to statements that are made in the course of medical treatment. So just about anything you tell your attorney is privileged, information you tell to your physician that has nothing to do with treat-

ment—such as "I robbed the mini-mart last night"—might not be privileged if it has nothing to do with your treatment.

- The **priest/penitent privilege** applies not only to priests, but to any type of religious leader recognized by the court or by law. Thus, not only would a Catholic priest be covered, but so would a Baptist minister, a Jewish rabbi and so on. This privilege is not as common as the spousal, attorney/client and physician/patient privilege, but many if not most states provide for the privilege.

Not every state recognizes all of the above privileges. In addition, each state may apply the privileges in different ways depending on the circumstances and type of case. As such, if you want to know what privileges might apply in your case, ask your lawyer.

Immunities

Much like you cannot get a cold if you have immunity to it, you cannot be sued for a type of lawsuit for which you have immunity. This is best explained through examples.

One common type of immunity is a employer's Workers' Compensation immunity. Employers are immune from being sued by employees for injuries they suffer on the job, even if caused by the employer's negligence. Usually, fellow employees have the same immunity for negligent injuries they cause on the job.

Another common form of immunity is sovereign immunity. Back in the old days, the king and queen—the sovereign—could not be sued by their subjects. This was termed "sovereign immunity." As monarchies became replaced by other forms of government, sovereign immunity continued to apply to the new forms of government and for some reason retained the name "sovereign" immunity.

In the United States, the federal government, as well as each state government has the ability to declare itself immune from lawsuits. Many state constitutions and/or state codes do in fact provide that the state is immune from lawsuits.

Despite these immunities, however, each state and the federal government has waived their immunities at least to some extent. Some allow lawsuits to be brought against the government. Others do not allow regular lawsuits but have set up special courts in which claims against the government can be brought. Often these courts limit the amounts and types of damages that can be collected.

So You Won—But Can You Collect?

Winning your case does not necessarily mean that you will get money. Usually, in a personal injury case, a defendant has insurance available to pay any verdict that you get in court. However, this is not always the case. Sometimes defendants do not have insurance because they simply did not buy any—or their policy does not cover the type of situation that you sued them for.

For example, many policies do not cover liability for dog bites. So, if the defendant does not have insurance and you do not have applicable insurance of your own—such as uninsured or underinsured motorist coverage in an auto case—your only option is to try to collect your judgment out of the defendant's personal assets.

Unfortunately, defendants in this position often will either not have many assets or not have assets that someone else is not in line ahead of you to get their hands on. These defendants may hide their assets or, more frequently, file for bankruptcy and have your judgment wiped clear.

In some states, certain types of judgments cannot be erased in bankruptcy. Judgments for actions such as battery or other intentional torts—or for accidents caused by driving under the influence—often cannot be wiped out by bankruptcy.

Otherwise, you may be left with a verdict that you can frame and hang on your wall, but that is all the value it has.

The key here is to know something about the defendant before you proceed to trial. Your lawyer should take the lead in any such investigation. An uninsured person teetering on the verge of bankruptcy isn't worth suing in the first place.

Beyond that, collections are a topic for another book.

6 Legal Terms You'll Need to Know

Adjuster. This is a person hired by an insurance company who investigates claims, reviews statements and medical records and ultimately agrees to any settlement with a claimant. An adjuster is often an employee of the insurance company, although there are also private insurance adjusters who are contracted by insurance companies to handle claims.

Affidavit. This is the written equivalent of sworn testimony. An affidavit is a document containing information that is then signed by someone who swears to the accuracy of the information typically by signing under oath before a notary public or equivalent.

Anti-Stacking. This is the part of an insurance policy that prevents you from collecting from multiple coverages just because you have several cars. In other words, you might have three cars, each with $100,000 in coverage, but you cannot "stack" those coverages to get $300,000 in coverage when there is an accident, you are limited to just the $100,000. Different states have different anti-stacking laws.

Arbitration. Arbitration is a process whereby two or more parties to a dispute present the facts and circumstances of a case to an arbitrator who makes a decision in the matter for the parties. In essence, the arbitrator acts as sort of a judge. Sometimes arbitration decisions are binding, meaning that the parties cannot challenge the decision of the arbitrator and sometimes they are nonbinding, meaning that one or more of the parties may be able to challenge the decision or possibly even disregard it altogether.

Attorney in Fact. When someone signs a power of attorney, the person to whom they give powers to act on their behalf is called an attorney in fact. An attorney in fact does *not* have to be a lawyer.

Bad Faith. This is an act committed by an insurance company or adjuster which is considered improper and designed to harass, intimidate, delay or push a claimant into a settlement for less than their case is clearly worth. In a some states, a claimant can sue an insurance company for bad faith and recover what are often significant damages, even punitive damages. In other states, individuals cannot sue under bad faith laws. Instead, only the state's insurance commissioner can punish the company or adjuster for acts of bad faith.

Bodily Injury Coverage. This is the insurance coverage in an automobile insurance policy that pays others for the negligence of the policyholder or others insured under the policy. In other words, if I wreck into you and it is my fault, my bodily injury coverage pays you for the injuries I caused to you. My property damage coverage would pay for the damage to your car. We often refer to the combination of bodily injury coverage and property liability coverage as "general liability coverage."

Burden of Proof. Essentially, this is the level of convincing that one has to do in order to win their case. In other words, in order to win a case, a certain amount of evidence is required. Common levels or burdens, of proof include prima facie case, preponderance of the evidence, reasonable certainty, clear and convincing evidence and beyond a reasonable doubt.

Claimant. This is simply someone who makes a claim to an insurance company to collect some type of insurance coverage.

Class Action. This is a case brought on behalf of a group of plaintiffs that is so large that it would be impractical to list them all individually in the case. In that situation, a few plaintiffs, called class representatives, are listed in the case on behalf of all those persons that have been wronged in a similar manner. For example, a class action might be brought by a few class representatives on behalf of themselves and all those people who purchased defective widgets and were injured by the defect.

Clear and Convincing Evidence. This is one of the burdens of proof. The meaning of clear and convincing evidence is difficult to explain. Basically, clear and convincing evidence is a level of proof greater than a preponderance of the evidence but less than beyond a reasonable doubt.

Collateral Source. A collateral source is a source of payment of bills, expenses, wages, etc., that an insured person receives from any source other than his or her own funds or those of another party to the accident. For example, if a plaintiff's health insurance pays his or her medical bills, that health insurance is a collateral source. Similarly, if Social Security pays a plaintiff lost wages due to disability from an accident, then Social Security is a collateral source.

Common Law. The system of laws based on written court decisions and customs as opposed to a civil law system which is based on codes.

Comparative Negligence. As contrasted with contributory negligence, comparative negligence is the rule that if you are in an accident that is primarily the fault of others, but you are partly to blame, your verdict should be reduced by the amount of your own negligence. For example, if someone rams into the rear of your car as you turn and you do not have your turn signal on, a jury might find the person who hit you 80 percent at fault for not stopping and you 20 percent at fault for not using your turn signal (assuming your were supposed to be using your turn signal at the time). In that instance, whatever the jury gives you will be reduced by 20 percent, the amount of your own fault. Different states have varying rules regarding comparative negligence. In some states, if your fault for the accident is more than 49 percent (or 50 or 51 percent, depending on the state), you cannot recover anything. In a "pure comparative" negligence state, you recover even if you are 90 percent at fault, there is simply 90 percent of your verdict cut away. So you only get 10 percent of the verdict.

Complaint. The document that is filed with the court that commences a lawsuit and explains to the defendant(s) what the case is about and what damages are claimed.

Consortium. Loss of consortium are those losses suffered by family members of a personal injury victim. The loss of consortium suffered by a spouse typically includes the loss of help around the house, loss of a social companion and loss of a sexual partner. The loss of consortium suffered by the children of the victim includes loss of household services, parental affections and recreation.

Contributory Negligence. This is a dreadful, archaic, outdated and ridiculous rule that is still the law in a handful of states including Alabama, North Carolina, Virginia, Maryland and the District of Columbia. Under this rule, as contrasted with the comparative negli-

gence rule, if you are found to be even one percent at fault in an accident, you cannot recover anything. You get zero. Clearly, this is very harsh and unfair.

Court Reporter. The court reporter is the person in the courtroom who makes a written record of everything that is said during official proceedings in the courtroom. Court reporters are sometimes referred to as stenographers. Court reporters also record testimony at depositions.

Cross Examination. When a witness is called to testify, the first attorney to ask them questions performs a "direct examination." Other attorneys in the case then have the opportunity to ask questions related to that testimony. This is called cross examination.

Declarations Page. The document provided to you by your insurance company, usually making up part of your bill, which outlines what insurance coverages you have purchased. Declarations pages usually contain your name, a description of each vehicle covered, the types of coverages that apply to each vehicle covered, the limits of each coverage, amounts of deductibles and perhaps a list of endorsements and discounts or surcharges applied. In addition, they usually detail the price or premium as it is called with regard to insurance policies, that each coverage costs.

Defendant. Much like a defendant in a criminal case is being prosecuted by the state, a defendant in a civil action is the person or company being sued by someone, who is called the plaintiff.

Defense Lawyer. Here is one of the misnomers in law. Most people think of "defense lawyers" as representing criminals. However, among lawyers, the term "defense lawyer" usually refers to someone who defends defendants in civil cases, often on behalf of insurance companies. Criminal defense lawyers are usually specifically called "criminal defense lawyers" instead of just "defense lawyers."

Demonstrative Evidence. Demonstrative evidence is non-spoken evidence that is shown to a judge or jury to help aid in explanation of something. For example, to aid the testimony of an orthopedic doctor in explaining the manner in which the plaintiff's arm was broken, the doctor might use a model of an arm bone during his or her testimony. The model of an arm bone would be an example of demonstrative evidence.

Deposition. The testimony of a witness (party or non-party to the lawsuit), taken before trial and recorded by a court reporter (also sometimes videotaped) and typically reduced to transcript form. The depo-

sition is used mainly to find out what a witness knows and is likely to testify to if called as a witness in court. In some situations the transcript or parts of the transcript, will be read to the jury at trial (or the videotape played) either to impeach a witness or if a witness cannot come to court to testify in person.

Deposition Duces Tecum. A deposition in which the witness is asked to bring certain documents to the deposition to be viewed and/ or copied.

Diminution in Value. When a car is damaged in an accident, but not totaled, its ultimate value for trade in or sale is reduced even if it is fully repaired. This reduction in the value of a previously damaged vehicle is called diminution in value of the vehicle.

Direct Examination. The questions asked of a witness by the person who calls the witness to the stand to testify. Questioning subsequently done by other parties' lawyers is called cross examination.

Discovery. The process whereby each party to a lawsuit finds out information and receives copies of documents and records related to a lawsuit from the other parties. The most common discovery tools include interrogatories, requests for production of documents, requests for admissions and depositions.

Discovery Rule. An exception to statutes of limitations that sometimes allows someone to file a lawsuit beyond the statute of limitations period if they had no reasonable way of discovering that they had the right to bring the lawsuit previously.

Economic Damages. Economic damages, also sometimes called "special damages" or "specials" are damages that can be easily quantified by a monetary figure, such as medical bills, lost wages, property damage and the like. This is contrasted with noneconomic damages which cannot easily be quantified, such as pain and suffering and emotional distress.

Excess Coverage. Also commonly called "secondary coverage" is insurance that does not apply until some other coverage, often called "primary coverage" has been used up. In other words, in a state where the insurance follows the car, if you are driving my car and have an accident that is your fault, my insurance will be primary and pay for the injuries you caused. However, if my policy is not big enough to pay all the damages, your policy (if you have one) might then step in and pay the "excess" after mine has run out. My insurance is "primary" and yours is "secondary" or "excess."

Exhibit. This is any type of physical evidence used in a trial and shown to the jury. It might include things such as medical records and invoices, photographs of the damaged vehicles, photographs of injuries or possibly even the car itself. If an exhibit is "admitted into evidence" then the jury may usually take it to the jury room with them to use during deliberations.

Expert Witness. These witnesses are certified by the judge as experts on a given subject may give opinions to the jury regarding technical issues that are within their area of expertise.

Fact Witness. These witnesses may testify only about things that they have experienced. Opinions by fact witnesses are limited to issues that *any* person would be qualified to give an opinion on—such as whether another person appeared to be upset or appeared to be drunk.

First Party Insurance Benefits. These are insurance benefits paid to an injured person from an insurance policy that was purchased by the injured person or under which the injured person is otherwise an insured, as opposed to the tortfeasor's insurance. The tortfeasor's insurance would pay "third party insurance benefits."

Functional Capacity Evaluation. This is a test, usually performed by a physical therapist or orthopedic doctor, to determine to what extent injuries have limited your ability to move your arms and legs, lift heavy objects and function without pain. This is often used to determine a percentage amount that a person has become disabled because of injuries.

Friendly Lawsuit. This is a lawsuit between parties who are not adversaries in reality. For example, if a wife is injured by the negligence of her husband in an auto accident, she might sue him to get insurance benefits even though the outcome may benefit both of them. Or if a passenger is injured in an accident that was the fault of the driver, who is a friend, this might result in a friendly lawsuit.

Gap Insurance. If a vehicle is declared a total loss and the amount owed on the loan for the vehicle is greater than the value of the car, gap insurance pays the difference in order to pay off the loan.

General Liability Coverage. The insurance coverage that pays for liability incurred by the insured. This coverage includes liability for both bodily injury and property damage caused by the negligence of the insured.

Guardian Ad Litem. A person appointed by a judge to represent the interests of another person. For example, if a child has a lawsuit against a parent for negligence in a car accident, the judge might

appoint a guardian ad litem for the child to represent the interests of the child and make sure the child's interests are treated fairly.

Hearsay. According to the Federal Rules of Evidence (801(c)), hearsay is defined as "a statement, other than one made by the declarant while testifying at the trial or hearing, offered in evidence to prove the truth of the matter asserted." Despite what many people think, hearsay is sometimes allowed in court.

Hostile Witness. Sometimes a witness is asked a question over and over and never actually answers the question directly. If this happens repeatedly, the judge may declare the witness as a hostile witness, which gives the attorney the right to ask leading, yes or no questions, even on direct examination and the witness is ordered by the judge to answer the yes or no questions directly.

Hung Jury. If a jury cannot reach an agreement on a verdict the judge may eventually declare the jury to be hung. If this happens, there is a mistrial and the case must be tried again to a different jury.

Immunities. Sometimes the law provides that certain people or entities may not be sued by certain other people or entities. In that case, the person who cannot be sued is said to have immunity from the lawsuit. For example, "sovereign immunity" applies in some states where it is not permissible to sue the state. In many states, employers cannot be sued by their employees for injuries suffered on the job because those injuries are covered by the state's workers compensation system. In that case, the employer is "immune" from lawsuits by employees for injuries sustained on the job.

Impeachment. The discrediting of a witness by making it appear that the witness's testimony is not reliable. Common methods of impeachment include showing that the witness made a statement in the past that is different from what the witness is saying at trial, so as to make it appear either that the witness is lying or has a bad memory or in some instances, as allowed by law, pointing out that the witness has been convicted of a certain crime or crimes and therefore is not trustworthy.

Independent Medical Examination (IME). Sometimes also called a Defense Medical Examination (DME), this is a medical examination performed by a doctor hired by the insurance company or attorney for a tortfeasor/defendant. This is often done to make the insurance company or attorney feel more assured that the claimant's doctors are not making up or exaggerating injuries because they have a close relationship to the claimant and want to see them get lots of money in their

claim. Unfortunately, it commonly has the opposite effect in that the doctors chosen by insurance companies are often known to be very cynical and make findings that tend to be in favor of the insurance company and against the injured claimant.

Intentional Tort. This is a specific type of tort which is committed not accidentally, but on purpose. Often intentional torts are also crimes, such as assault and battery and theft and also include the torts of fraud and defamation, among others.

Judgment. This generally refers to an order of a judge saying that one person has to pay another person money (or does not have to, depending on the verdict). This is what results from a trial. For example, if you have a jury trial and the jury gives you one thousand dollars against John Smith, the judge would issue you a judgment against John Smith in the amount of one thousand dollars. You can often then have John Smith's wages garnished (withheld) or property sold or record the Judgment as a lien on John Smith's property or property that he may get in the future until the judgment is paid off.

Jurisdiction. This term refers to the geographical area and/or subject matter covered by a court. In other words, jurisdiction refers to what types of cases can be filed in the court and also where the events giving rise to the case must have occurred in order to be permissible to file in that court. The breadth of the term can vary. In other words, one might refer to the "jurisdiction" of a court or on a broader scale refer to the "jurisdiction" of all courts within a state or the even broader scale of the "jurisdiction" of the United States legal system.

Jurisprudence. Sometimes this term is used as a philosophical term and sometimes it is used as a technical legal term. As a philosophical term, jurisprudence refers to the reasoning, purpose or moral basis of laws and systems of law. As a technical term, jurisprudence refers to a body of law. For example, one might say that the jurisprudence of New York provides that it is negligent to talk on a cell phone without a headset while driving a car.

Jury Instructions. The instructions given by the judge to the jury at the end of a trial which explain the law to the jury and indicate how the facts, as determined by the jury, should be applied to the law in order to reach a verdict.

Jury Nullification. Sometimes juries do not appear to follow the law or the overwhelming evidence and instead make their decisions based on emotional or other reasons. This failure to decide the case based on the law and the facts is called jury nullification.

Leading Questions. Leading questions are questions which suggest an answer. For example, "you ran the stop sign, didn't you?" is a leading question—but "did you run the stop sign?" is not. In the first example, the answer, yes, is suggested. In the second, the question is asked without suggesting the answer to the witness.

Learned Treatise. A book or treatise, which provides information relevant to a case and is generally recognized as being a trusted source of information. For example, the Oxford Dictionary may be considered a learned treatise for the purpose of defining the meaning of a word.

Letter of Protection. A letter given by an injured person's attorney to the injured person's doctor which promises the doctor that if any money is made in the case, that the attorney will issue payment out of the money received directly to the doctor for his or her bills before releasing any money to the injured person.

Life Care Plan. This is a report outlining the moneys that will have to be spent to care for a person throughout the remainder of their life due to injuries which are permanent or long term in nature.

Lis Pendens. Sometimes a plaintiff has reason to believe that a defendant being sued might try to sell his or her real property so that if the plaintiff wins, the plaintiff cannot obtain a lien against the real property. If there is a real threat that the defendant might do this, some states allow plaintiffs to file what is called a lis pendens. This is a notice attached to the chain of title of the defendant's real property that puts potential purchasers on notice that there is a lawsuit pending. If a lis pendens is properly filed and someone purchases the property anyway, the plaintiff still might be able to have the property sold to pay the verdict, even though someone other than the defendant now owns it.

Litigation. The steps and processes involved with a lawsuit is called litigation.

Loss of Earning Capacity. The quantified loss of a person's ability to earn wages because of an injury. For example, a surgeon who normally does 50 percent examinations and 50 percent surgeries and has a hand injury might have a 50 percent or more loss of capacity to earn wages and therefore a 50 percent loss of earning capacity. Someone who is completely paralyzed from an injury would of course have a 100 percent loss of earning capacity and therefore be "totally disabled."

Maximum Degree of Medical Improvement. This does not always mean that a claimant is fully healed. Rather, it refers to the point

when injured people's doctors say that they have gotten as better as they are going to get—and this is how they will be for the rest of their lives.

Mediation. A meeting between parties to a lawsuit and a mediator whereby the mediator, unlike an arbitrator, makes no decision in the case but simply attempts to help the parties to reach a settlement agreement.

Med-Pay/PIP. This is a type of no-fault insurance that pays your medical bills, related to an accident (and sometimes lost wages). It is first party insurance, so it comes from your own policy or if you are in someone else's car, the owner's policy. It is not paid by the tortfeasor. In some states, if you collect your medical bills from the tortfeasor, you often have to pay back some or all of the med-pay that was paid on your behalf. The theory is that if you got to keep both, you would be paid twice. In some states, you never have to pay back med-pay, but usually in those states, you cannot collect the cost of a medical bill from both med-pay and the tortfeasor. In other words, in those states, the tortfeasor gets a credit for the med-pay paid on your behalf.

Mistrial. A mistrial occurs when something occurs that prevents the trial from continuing any further—and the trial must therefore be restarted again at a different time with a different jury. Sometimes this occurs when one of the attorneys or parties becomes injured or very ill during a trial so that it cannot continue. It can also occur when something happens to taint the jury. For example, an attorney might say something to the jury which the judge had forbidden or is otherwise improper. If having heard this information would prevent the jury from making a fair decision, a mistrial may be declared by the judge.

Motion. Any request by an attorney for the judge to take some action on a matter is called a motion. For example, an attorney might make a motion asking the judge to prevent another attorney from showing a certain document to the jury. The judge then makes a decision about the motion and that decision is called a "ruling." A motion can be made in writing or orally in court.

Motions In Limine. These are motions filed shortly before a trial begins and typically involve issues related to the trial itself such as motions to prevent certain documents from being shown to the jury or to prevent a witness from saying something not permitted by the court rules.

Negligence. Basically, doing something careless. More technically, doing an act in breach of a duty imposed upon you by law with regard

to your actions toward others. The most common duty is that everyone must act in a reasonably prudent manner toward others.

No-fault. Most personal injury lawsuits require a showing that another person was at fault for the injury—that they were in some manner negligent. In a "no fault" situation, liability is imposed, so to speak, without regard to who is at fault or whether anyone in particular is at fault.

Non-Economic Damages. Sometimes also referred to as "general damages," and in contrast to economic damages, noneconomic damages are those damages for which a dollar amount cannot specifically be assigned. For example, unlike medical bills, a specific dollar amount cannot be assigned to pain and suffering, embarrassment, annoyance and the like. It is usually up to the claimant to decide how much this is worth to them in trying to settle a claim or up to the jury if the case goes to trial.

Notarize. The act of placing a signature and stamp on a document by a notary public indicating that the document is authentic or that the signature of the person who signed it is authentic, that the person's signature was made under oath as to the truth of the information in the document or any of the other functions that a notary might perform under the notary law of the notary's state.

Notary Public. A person permitted by law to notarize documents or perform other notarial acts as provide by state notary law.

Objection. When an attorney believes that another attorney is taking an action that is contrary to the law or rules of the court, the attorney makes an objection to the action of the other attorney. The judge must then decide whether the action is indeed improper. For example, an attorney might ask a witness what he or she heard someone else say. This may be a reason to make an objection that the question asks for information that is hearsay.

Order. Simply put, an order is a decision or instruction given by a judge. An order can be in either written or oral form. For example, a judge might order a defendant to produce documents or might order that certain evidence is inadmissible.

Parties. Anybody who is either a plaintiff or a defendant in a lawsuit is said to be a party to the lawsuit.

Peremptory Challenge. During jury selection, each party is typically allowed to reject a certain number of potential jurors for any reason other than discrimination on the basis of race, gender, etc. These rejections are called peremptory challenges.

Personal Injury. For purposes of this book, a personal injury is an injury caused by the improper actions or inactions of another person.

Personal Injury Protection. See Med-pay/PIP.

Plaintiff. The plaintiff is the person in a lawsuit who is making claims against the defendant(s).

Power of Attorney. A document that someone (who must be mentally competent at the time) signs which gives another person the legal authority to make decisions or take actions on their behalf. The document must clearly spell out what powers are given, such as writing checks, withdrawing money from bank accounts, selling property, bringing and settling lawsuits, etc. Sometimes powers of attorney are designed so that the powers begin immediately and last for a specified time or indefinitely until revoked. In contrast sometimes powers of attorney are designed so that the powers do not begin unless or until the person becomes mentally incompetent or otherwise unable to perform those acts themselves. A medical power of attorney is a similar document which gives another person the power to make medical decisions if the maker becomes unable to make those decisions himself or herself. The person given powers under a power of attorney is called an "attorney in fact" but does not have to be a lawyer, despite the title.

Preponderance of the Evidence. One of the levels or burdens of proof and the one that most typically applies to a personal injury case. A preponderance of the evidence is less than clear and convincing evidence or beyond a reasonable doubt levels and is a level of proof that falls in one person's favor even ever so slightly over another's favor. There are many ways to describe this level of proof. Sometimes it is said that a preponderance of the evidence is 50 percent plus anything. Sometimes a scale (the old fashioned kind with two hanging sides, like the scales of justice) is used for explanation wherein a preponderance of the evidence is anything, even as little as a feather, that tips the scales toward one side or another. So if the evidence is precisely equal, 50/50 for both sides, then neither side has a preponderance of the evidence. But if there is even the slightest tip toward one side, beyond 50 percent, then there is a preponderance of the evidence.

Prima Facie Case. In every lawsuit the plaintiff is required to prove certain things by a preponderance of the evidence. It is the jury's job to decide if the plaintiff has proven those things by a preponderance of the evidence. For example, in order to win, a plaintiff might have to prove four things by a preponderance of the evidence.

The plaintiff must offer evidence of each of those four things for the jury to consider and determine if the preponderance is met. The offering of evidence of each of the four things that have to be proved is called making a prima facie case. If the plaintiff only puts on evidence to cover three of the four things that have to be proven, then the plaintiff has not made a prima facie case and the judge will dismiss the case without the jury even considering the evidence. Thus, by the end of the plaintiff's case, he or she must offer evidence of each of those four things. It is the jury's job to decide if the plaintiff has proven by a preponderance of the evidence that the evidence of his or her causes of action is true. A prima facie case just means that there is some evidence to cover each of the four required elements.

Privileges. Sometimes, information that someone is told by another person is privileged, meaning that the person cannot be forced to reveal that information. For example, information that people tell their attorneys which is not common knowledge may be privileged, as is medical information between a doctor and a patient. States vary as to what relationships and information is privileged. Some other privileges that apply in some states are clergy/penitent privilege, husband/wife privilege and counselor/patient privilege.

Prothonotary. An old fashioned term, still used by some courts, to refer to the clerk of the court.

Proximate Cause. An event can have many causes, some more connected to it than others. However, in order for someone to be liable for causing injuries to another, their actions must be a proximate cause of the injuries. In other words, it has to be one of the primary causes of the injury, with more than just a minor connection.

Punitive Damages. These are damages assessed against a party to punish that party for committing particularly bad conduct and to hopefully deter them and others from committing similar behavior in the future.

Records Release. This is a document that you sign allowing someone else, your attorney for example, to get confidential records about you, such as medical records or employment records.

Release. Generally, an agreement not to take any further legal action against someone with regard to a particular legal matter. When parties settle, typically one party will pay another party and the party who is paid thereby agrees to not take any further legal action regarding the matter that was settled. This agreement is usually reduced to writing in the form of a "release."

Reserve. The amount of money that an insurer estimates it will have to pay in a claim for expenses such as attorney fees, costs, payments for property damage and personal injury damages and so on. This amount is often updated as new facts are learned or as injuries and prognosis become more clear. The significance to insurance companies of reserves is that insurance companies are entitled to invest money collected in the form of premiums in the stock market and other investments. However, the law requires that the insurance company keep an amount of money available on hand to pay claims. Reserves serve as the estimates of those claims and therefore the amount that the insurance company must have on hand and not stuck in investments.

Rebuttal Witness. Generally, the plaintiff presents all of his or her witnesses and then the defendant presents all of his or her witnesses and then the case is over. However, on a limited basis, the plaintiff may call additional witnesses, called rebuttal witnesses, after the defendant has presented all of his or her witnesses, for the sole purpose of contradicting something that a defendant's witness said but that was not covered during the plaintiff's presentation.

Remittitur. Sometimes a judge believes that the verdict of a jury is an unreasonably large amount of money. In that case, the judge could set aside the jury's verdict and order a new trial or the judge can reduce the amount of the verdict him or herself. If a reduction is made, it is called a remittitur.

Res Ipsa Loquitur. In some rare cases, it can be assumed that a defendant was negligent even though there is no specific proof or explanation as to how or why. In that case, the plaintiff does not have to prove that the defendant was negligent, as it is presumed. Res ipsa loquitur translates loosely from Latin as "the thing speaks for itself." For example, suppose that an airplane crashes and the passengers are killed. Because, absent inclement weather, airplanes usually do not just fall out of the sky without either negligent maintenance, a negligent product defect or negligent piloting, a family member bringing a wrongful death claim may ask the judge to presume that either the airline or the manufacturer was negligent, even though evidence of a specific act of negligence cannot be proved.

Rule of 7. Traditionally and in many states still today, there are presumptions based on age as to whether a child can be found negligent. Under the traditional rule, called the rule of 7, a child up to age 7 was conclusively presumed incapable of negligence, a child from 7

to 14 was presumed incapable of negligence, but could be found negligent if it was proved that he or she was more mature than the typical child of their age and a child over 14 could be found negligent just like an adult.

Ruling. A generic term to refer to the decision of a judge on an issue or by the judge. For example, one might say that the judge made a ruling in favor of the plaintiff on a motion. Rulings are often presented as part of an "order."

Sequester (Witness/Jury). To sequester a witness means to disallow them from the courtroom during the testimony of other witnesses so that they do not hear other testimony before they testify. To sequester a jury means to forbid them from going home during the trial so that they do not get tainted by hearing news stories or discussing the case with others during the breaks from trial.

Service of Process. The process of serving certain documents upon people or businesses. For example, when someone files a lawsuit, the complaint and summons (process) must be served upon the defendant(s).

Single Limit Policy. An insurance policy that provides one maximum amount of money that it will potentially pay out, rather than being broken down into separate per person/per accident/property damage categories.

Subpoena. A court document commanding a person to be at a certain place at a certain time. Failing to abide by a subpoena can result in possible criminal punishment if the person does not have a good reason for failing to comply.

Subpoena Duces Tecum. A subpoena that commands a person to be at a certain place at a certain time and to bring certain specified documents with them as well.

Summons. In most states, the document that is served upon a defendant along with a complaint and commands the defendant to file an answer within a certain specified period of time.

Statute. A law, in written form, created by a legislative body rather than a court.

Statute of Limitations. The time limit within which a lawsuit must be filed. Limits vary by state and within each state vary by type of case. For example, the statute of limitations for an auto accident might be two years. That means that the victim must sue the at fault driver within two years or the right to sue is lost.

Statutory Law. This is law that is created by the government, in the form of statutes that are published in book form. It is different from case law or common law, that is found in opinions written by courts.

Structured Settlement. A settlement that is to be paid over time rather than immediately and all at once. For example, a structured settlement might be designed to pay the plaintiff $100,000 per year for twenty years.

Subrogation. Sometimes when an insurance company or other entity pays medical or other expenses on your behalf, they are entitled to get their money back if you collect money from the tortfeasor This is called a right of subrogation. It is simply the right of the payor to be paid back in certain circumstances.

Summary Judgment. Sometimes a judge determines that the plaintiff does not have enough evidence to continue in a lawsuit. It might be that the plaintiff is unable to present minimal evidence to cover each required element of the claim or that the judge rules that because the evidence is so sparse that no reasonable jury could possibly find in favor of the plaintiff. If that is the case, the judge may award summary judgment to the defendant, thereby ending the case.

Third Party Benefits. Benefits paid to a person by an insurance policy that the person receiving the benefits did not purchase himself or herself. If your insurance policy pays you, it is a first party benefit. If the defendant's insurance policy pays you, it is a third party benefit.

Tort. A tort is a breach of the law by one person against another person in the form of a legally wrongful act which causes an injury.

Tortfeasor. A tortfeasor is simply someone who commits a tort. For example, if another car runs into your car and it is the other driver's fault, the other driver has committed a tort and is therefore called a tortfeasor.

Trier of Fact. Whoever decides what the true facts are or who is telling the truth. If a case is tried to a jury, the jury is the trier of fact. If a case is tried to a judge alone, the judge is the trier of fact.

Underinsured Motorist Coverage. This is a type of insurance that pays you, up to your limits of coverage or the amount of your claim or judgment, whichever is lower, whenever a tortfeasor does not have enough insurance to pay the entire value of your claim or judgment. For example, if you are in an accident and you have a claim with a settlement value of $100,000 and the tortfeasor only has $50,000 in

coverage, your underinsured motorist coverage, if you have any, will pay the additional $50,000 or your limit if it is less than $50,000.

Uninsured Motorist Coverage. This type of insurance coverage is available to you when you are in an accident that is the fault of another person who does not have any insurance at all.

Verdict. The ultimate decision rendered by the jury or if tried to the judge, by the judge.

Verdict Form. The document given to the jury to fill out during their deliberations. The verdict form contains questions which the jury answers and together comprise the jury's verdict.

Verification. A document wherein someone swears under oath (notarized) that the information contained in another document is true to the best of his or her knowledge.

Voir Dire. When selecting a jury, the attorneys are often allowed to ask questions to potential jurors in order to determine if the jurors have biases that might tend to favor one side or another. This process of questioning potential jurors is called voir dire.

So You've Been in an Accident...

Appendices

So You've Been in an Accident...

Appendix 1: Questions to Ask at Various Stages

Things to Ask When Interviewing an Attorney

Attorney's Background

Where did you go to law school, undergraduate school, etc.?

What year did you graduate from law school?

How long have you been practicing personal injury law?

How many cases of this type have you handled?

How many cases of this type have you tried?

In what state(s) are you licensed to practice law?

What legal organizations do you belong to?

What other organizations do you belong to?

Have you ever been disciplined by the State Bar or anyone else?

> If so, when, for what were you disciplined, what was the outcome?

Do you know the tortfeasor in any manner?

Other things that may be important to the potential client?

Fees and Costs

Will you take my case on a contingency fee arrangement?

> If so, what percentage do you charge?

Do you charge a fee for handling my med-pay/PIP claim?

Does the contingency fee include costs?

> If not, what costs am I responsible for?

What are typical costs for:

> Obtaining medical records and invoices
>
> Photocopying
>
> Facsimile charges
>
> Telephone charges
>
> Electronic research
>
> Mileage and other vehicle costs
>
> Meals, hotels, etc.
>
> Court costs
>
> Expert fees
>
> Deposition costs
>
> Mediation costs
>
> Other costs

Is your fee calculated before or after costs are deducted?

What am I responsible for if we don't recover anything?

What will you charge me for if I decide to stop using your services before the case is complete?

So You've Been in an Accident...

Handling the Case

Will you be handling my case—or will another lawyer in your firm be handling it?

 If not you, then who?

Will you handle my property damage claim?

What type of work will your staff do in my case?

Are you good about returning client phone calls?

How much will I be able to talk with you about my case?

What is your e-mail address?

Does your firm have a Web site?

How often will I receive updates from you?

What events will I have to attend in person?

Approximately how long do you expect my case will take to complete?

 If we are able to settle early?

 If we settle at mediation?

 If we have to have a trial?

What is your confidentiality policy?

Do you think my case will likely require hiring experts?

 Medical

 Economic

 Accident Reconstruction

 Other

How long will you keep my file after my case is over?

On Medical Bills

Do you provide letters of protection to medical providers who accept them?

Do you handle my med-pay/PIP claim or do I have to do that myself?

Questions to Ask the Attorney You've Hired

What do I need to be doing now?

 And later?

What do I need to do or provide to you to help you with my case?

How often should I update you on my medical treatment?

What if someone contacts me about the accident or my case?

What should I do about my medical bills?

Questions to Ask about a Property Damage Claim

What am I entitled to in this State regarding property damage to my car?

At what point does the insurance company have to declare my car a total loss?

Am I entitled to be paid for diminution in value?

What do I need to do to establish diminution?

If my car is totaled, how is the insurance company required to determine the value of my car and what other damages do they have to pay me?

Questions for Your Attorney about Medical Care

How much do my medical bills total?

Am I entitled to money for future medical bills or pain and suffering?

What is the least amount that you think I should accept in settlement?

How much money do you think we should initially demand to settle?

What are the tortfeasor's insurance limits?

What are the limits of other available insurance?

What are the good aspects of my claim?

What are the negative aspects of my claim?

Has the tortfeasor or his insurance company admitted that the tortfeasor is at fault?

If liability is an issue, what is the other side claiming that I did wrong?

Appendix 2: Preparations at Various Stages

Preparing for a Deposition

Find out from my lawyer where and when the deposition will take place.
Find out if and when my lawyer wants to prepare for the deposition with me.
What else does my lawyer want me to do to prepare for my deposition?
What does my lawyer want me to wear to my deposition?

Preparing for Mediation

Find out from my lawyer where and when the mediation will take place.
Find out if and when my lawyer wants to prepare for the mediation with me.
Consider and discuss with my lawyer the least amount that I am willing to accept in a settlement.
What else does my lawyer want me to do to prepare for mediation?
What does my lawyer want me to wear to mediation?

Preparing for Trial

Ask my lawyer when and where the trial will begin.
How many days does my lawyer think the trial will last?
Do I need to attend any court hearings before the first day of trial?
When and where does my lawyer want to prepare for trial with me?
Does my lawyer have a list of possible jurors that I should look over to see whether I know any of the possible jurors?
What does my lawyer want me to wear to trial?
Are there any customs of the court or rules of the judge that I need to know about (such as food and drinks in the courtroom, wearing of hats, possession of mobile phones, etc.)?
Is there anything, such as depositions or medical reports, that I should read to prepare for trial?

Appendix 3: Daily Medical Treatment and Pain/Suffering Diary Form

Today's Date

Today I visited the following doctors/medical providers:

Name
Description of examination and what the doctor told me:

Name
Description of examination and what the doctor told me:

Name
Description of examination and what the doctor told me:

Description of the pain I suffered today:

Because of my pain and injuries, I was unable to/had difficulty doing the following activities today:

Today, I spent the following amounts of money on medical visits, medicine, and other accident related issues:

Appendix 4: Settlement Evaluation Worksheet

Use this worksheet to ask your attorney the questions that you will need answered in order to understand how much of a potential settlement YOU will receive if you accept it, and where the rest will go.

AMOUNT OF PROPOSED SETTLEMENT $_____

Deductions:

ATTORNEY FEES ($_____)

COSTS ($_____)

MEDICAL BILLS TO BE PAID ($_____)

SUBROGATION (med-pay; health insurance, medicaid, medicare, workers compensation, etc.) ($_____)

OTHER DEDUCTIONS (including taxes, if applicable) ($_____)

TOTAL DEDUCTIONS ($_____)

TOTAL AMOUNT OF SETTLEMENT REMAINING FOR YOU $_____

Appendix 5: Form to Fill Out After Independent Medical Examination

As soon as possible after your examination, fill out the following form in as much detail as you can remember. During the examination, answer the doctor's questions related to your injuries but do not discuss the case, and do not discuss liability. Try not to ask the doctor any unnecessary questions.

Remember, this doctor was hired by the defendant and IS NOT ON YOUR SIDE. At best, the doctor is on nobody's side—and, at worst, he is biased in favor of the defendant.

It is important that you are presented well in the report. Dress casually but nicely. Be polite, smile, and do not complain. Answer the doctor's questions in a friendly and cordial manner. The doctor's report will probably describe you. We would prefer that it describe you as a well dressed person who was cooperative and polite, rather than uncooperative, argumentative, difficult, or other such terms.

Name of Doctor:
Time of Appointment:
Time You Arrived:
Time You Were Taken To Exam Room:
Time Doctor Began Exam:
How many people were in the waiting room?

Did You Speak With Anyone In the Waiting Room?
 If So, About What?

Describe Any Questions Asked By Anyone Other Than the Doctor As Well As Your Answers:

Describe the Examination Performed by The Doctor:

What Questions Did the Doctor Ask and What Were Your Answers?

Describe Anything Else That Either You or The Doctor Said or Talked About:

What Tests, If Any, Did The Doctor Perform (x-rays, MRI, CT, blood, etc)?

Describe the Doctor's Demeanor (friendly, angry, etc.—use your own words):

Did The Doctor Do Anything Which Increased Your Pain? Describe:

Note Anything Else You Believe To Be Significant Which Was Not Noted Above:

Appendix 6: Sample Attorney's Fee Agreement

FEE AGREEMENT

For and in consideration of the agreements and provisions herein,_____(client) and _____(attorney) do hereby agree as follows:

1. Attorney shall represent client in recovering compensation for damages suffered as the result of an automobile accident which occurred on December 14, 2005, at or near _____ (location of accident) in the county of _____, state of _____.

2. The attorney's fee for services rendered shall be 33.333 percent of all sums recovered. Provided, that if for any reason the case must be tried more than one time, the attorney's fee shall be increased to 40 percent of all sums recovered in consideration of the significant additional work that will be required of attorney. These percentages shall be calculated based on the gross sum of all monies recovered prior to any deductions. If there is no recovery of damages for client, attorney shall not receive an attorneys fee, but shall be entitled to reimbursement by client of costs expended, as outlined herein.

If the parties agree on a structured settlement, the attorney's fee shall be calculated using the above percentages but shall be based on the present value of the structured settlement and the entire fee shall be due at the time of settlement—the attorney's fee may not be structured without the express written consent of attorney.

3. Attorney shall have a lien upon all money collected on behalf of client in the amount of attorney's fee.

4. If attorney fees and costs are awarded by the court, to be paid by another party, they shall operate as a credit toward the attorney's fee as provided herein. If the court orders sanctions to be paid to attorney by another attorney, all of said monies shall be paid to attorney and shall not operate as a credit toward any attorney fees provided herein nor otherwise be applicable to any attorney fee calculations herein. Provided, that if the court awards sanctions to another party, against attorney, that no such sanctions shall be charged to client in any manner. Attorney agrees to advance all costs and expenses incurred by attorney in furtherance of client's lawsuit or claim. Provided, that upon completion of the case by resolution or cessation of representation of client by attorney, client shall reimburse attorney for all such costs and expenses. Attorney shall have a lien upon all monies recovered in the amount of such costs and expenses.

5. Client agrees that attorney is agreeing to represent client based on certain assumptions regarding the facts and circumstances of client's case and upon the belief that client has a reasonable chance of recovering damages. If at any time attorney in good faith believes that pursuing the claim further is not likely to result in the client recovering damages or that the amount likely to be recovered does not justify the time and costs associated with pursuing the claim, or if it

otherwise becomes illegal or contrary to the rules of lawyer ethics to continue to represent client, attorney may withdraw from representing client upon giving client reasonable notice of attorney's intent to withdraw.

6. Client understands that attorney may discuss client's case with other employees of attorney's law firm and also with other attorneys and client waives any attorney client privilege to the extent that such privilege would prohibit attorney from having such conversations. Client also understands that employees of attorney as well as experts and consultants may work on client's case and client waives any privileges to the extent that such privilege would otherwise prevent attorney from engaging such persons and entities to work on the case.

7. Client authorizes attorney to withhold funds received on behalf of client and use those funds to pay attorney fees provided herein, costs and expenses incurred by attorney in furtherance of client's case, medical bills to be paid directly to the medical providers by attorney using said funds, and any subrogation that is due from client to be paid directly to the subrogation lienholder by attorney using said funds.

8. Client understands and agrees that attorney shall store client's file for a period of five years from the completion of the case (settlement, verdict, etc.) and that after five years attorney shall destroy said file unless client makes a written request for that file prior to the expiration of said five year period.

We have read and understood this contract. Witness the following signatures:

Date:

Client's signature

Date:

Attorney's signature

Appendix 7: Sample Engagement Letter

Dear Client:

Thank you for hiring our firm to represent you with regard to your personal injury case. I assure you that we will make every effort to keep you informed, answer all of your questions, and strongly represent your interests. I am sending you this letter to summarize the provisions of the fee agreement which you signed at my office when you hired our firm to represent you. Although I explained each provision of the agreement in detail at our meeting, I want to summarize some of those explanations to avoid any confusion down the road.

Our firm has agreed to represent you with regard to recovering damages for personal injuries you suffered as a result of being in an accident on October 14, 2005. Our firm will initiate contact with all applicable insurance companies and/or defendants, follow your medical treatment, attempt to settle your claim, and if we do not reach a settlement, file a lawsuit against the applicable parties.

Our fee for representing you will be one third (33.333 percent) of any money or things of value recovered on your behalf. If for some reason, such as a mistrial being declared, a hung jury or a successful appeal resulting in more than one trial having to be conducted, our fee is 40 percent because of the significant additional work involved. All such sums recovered will be paid to our firm, deposited in a trust account, and distributed from that account. From those funds we will pay our attorney fees, costs and expenses that we have advanced, your outstanding medical bills, and any subrogation liens.

The remaining funds will be distributed to you in the form of a check. Interest earned on the funds in our trust account is paid to the state to be donated to provide free legal services to the poor.

We will advance all costs and expenses required to pursue your case, such as the costs of experts, court filing fees, obtaining medical records, photocopying, and so on. If we win the case, we will pay ourselves back for these costs out of the monies received. If we lose the case, or our representation otherwise ends, although you will not have to pay us any attorney fees for our time, you will be responsible for reimbursing us for the costs that we expended in furtherance of your case.

Please note that if client requests that attorney withdraw from representing client, and client ultimately receives funds from his or her claim, client shall pay attorney an amount equal to $125.00 per hour for the time attorney expended on client's case prior to client's request that attorney withdraw.

Although we took your case based on our belief that you have a claim that is worth pursuing, the outlook can change as the claim progresses. Sometimes we find out that we do not have enough evidence to prove that the other driver was at fault, or we find out that there is no insurance available and the defendant has no assets, or some other unanticipated factor might develop to make it impractical to continue pursuing your case. In that case, we may choose to withdraw from representing you further. Also, sometimes we find out that for one reason or another the

rules of lawyer ethics make it so that we cannot continue to represent you. For example, we cannot sue someone that we previously talked with or represented. When you contact us we do a search to see if the potential defendants have any relationship to our firm. However, if we find out after signing you up that there is an additional defendant that we did not initially know about, and that defendant has a prior relationship to our firm, we would be required by law to stop representing you. If we withdraw from representing you for any reason, we will do everything in our power to make sure that your interests are protected and that you have the opportunity to hire a replacement attorney without harming your interests.

Again, thank you for hiring our firm to represent you. We will keep you updated throughout every step of your case. If you have any questions, do not hesitate to call or e-mail. We pride ourselves on responding to our clients as quickly as possible.

Very truly yours,

Attorney

Appendix 8: Sample Statement of Client Rights

The Following is the Statement of Client Rights which applies to cases taken on a contingency fee basis copies from Florida Rule of Professional Conduct 4-1.5

STATEMENT OF CLIENT'S RIGHTS FOR CONTINGENCY FEES

Before you, the prospective client, arrange a contingent fee agreement with a lawyer, you should understand this statement of your rights as a client. This statement is not a part of the actual contract between you and your lawyer, but, as a prospective client, you should be aware of these rights:

1. There is no legal requirement that a lawyer charge a client a set fee or a percentage of money recovered in a case. You, the client, have the right to talk with your lawyer about the proposed fee and to bargain about the rate or percentage as in any other contract. If you do not reach an agreement with 1 lawyer you may talk with other lawyers.

2. Any contingent fee contract must be in writing and you have 3 business days to reconsider the contract. You may cancel the contract without any reason if you notify your lawyer in writing within 3 business days of signing the contract. If you withdraw from the contract within the first 3 business days, you do not owe the lawyer a fee although you may be responsible for the lawyer's actual costs during that time. If your lawyer begins to represent you, your lawyer may not withdraw from the case without giving you notice, delivering necessary papers to you, and allowing you time to employ another lawyer. Often, your lawyer must obtain court approval before withdrawing from a case. If you discharge your lawyer without good cause after the 3-day period, you may have to pay a fee for work the lawyer has done.

3. Before hiring a lawyer, you, the client, have the right to know about the lawyer's education, training, and experience. If you ask, the lawyer should tell you specifically about the lawyer's actual experience dealing with cases similar to yours. If you ask, the lawyer should provide information about special training or knowledge and give you this information in writing if you request it.

4. Before signing a contingent fee contract with you, a lawyer must advise you whether the lawyer intends to handle your case alone or whether other lawyers will be helping with the case. If your lawyer intends to refer the case to other lawyers, the lawyer should tell you what kind of fee sharing arrangement will be made with the other lawyers. If lawyers from different law firms will represent you, at least 1 lawyer from each law firm must sign the contingent fee contract.

5. If your lawyer intends to refer your case to another lawyer or counsel with other lawyers, your lawyer should tell you about that at the beginning. If your lawyer takes the case and later decides to refer it to another lawyer or to associate with other lawyers, you should sign a new contract that includes the new lawyers. You, the client, also have the right to consult with each lawyer working on your case and each lawyer is legally responsible to represent your interests and is legally responsible for the acts of the other lawyers involved in the case.

6. You, the client, have the right to know in advance how you will need to pay the expenses and the legal fees at the end of the case. If you pay a deposit in advance for costs, you may ask reasonable questions about how the money will be or has been spent and how much of it remains unspent. Your lawyer should give a reasonable estimate about future necessary costs. If your lawyer agrees to lend or advance you money to prepare or research the case, you have the right to know periodically how much money your lawyer has spent on your behalf. You also have the right to decide, after consulting with your lawyer, how much money is to be spent to prepare a case. If you pay the expenses, you have the right to decide how much to spend. Your lawyer should also inform you whether the fee will be based on the gross amount recovered or on the amount recovered minus the costs.

7. You, the client, have the right to be told by your lawyer about possible adverse consequences if you lose the case. Those adverse consequences might include money that you might have to pay to your lawyer for costs and liability you might have for attorney's fees, costs, and expenses to the other side.

8. You, the client, have the right to receive and approve a closing statement at the end of the case before you pay any money. The statement must list all of the financial details of the entire case, including the amount recovered, all expenses, and a precise statement of your lawyer's fee. Until you approve the closing statement your lawyer cannot pay any money to anyone, including you, without an appropriate order of the court. You also have the right to have every lawyer or law firm working on your case sign this closing statement.

9. You, the client, have the right to ask your lawyer at reasonable intervals how the case is progressing and to have these questions answered to the best of your lawyer's ability.

10. You, the client, have the right to make the final decision regarding settlement of a case. Your lawyer must notify you of all offers of settlement before and after the trial. Offers during the trial must be immediately communicated and you should consult with your lawyer regarding whether to accept a settlement. However, you must make the final decision to accept or reject a settlement.

11. If at any time you, the client, believe that your lawyer has charged an excessive or illegal fee, you have the right to report the matter to The Florida Bar, the agency that oversees the practice and behavior of all lawyers in Florida. For information on how to reach The Florida Bar, call 850/561- 5600, or contact the local bar association. Any disagreement between you and your lawyer about a fee can be taken to court and you may wish to hire another lawyer to help you resolve this disagreement. Usually fee disputes must be handled in a separate lawsuit, unless your fee contract provides for arbitration. You can request, but may not require, that a provision for arbitration (under Chapter 682, Florida Statutes, or under the fee arbitration rule of the Rules Regulating The Florida Bar) be included in your fee contract.

Appendix 9: Sample Complaint

IN THE CIRCUIT COURT OF KENT COUNTY, TORTSYLVANIA

JANE DOE
Plaintiff,

vs. Civil Action No: 04-X-XXX
 Judge: Doe

JOHN CARWRECKER,
Defendant.

COMPLAINT

Comes now the Plaintiff, Jane Doe, by counsel and makes a complaint against Defendant John Carwrecker, as follows:

1. The Plaintiff was at all times relevant herein a resident of Kent County, Tortsylvania.

2. The Defendant was at all times relevant herein a resident of Kent County, Tortsylvania.

3. On or about March 30, 2005 the Plaintiff was driving his vehicle in a lawful and prudent manner southbound on Route 52 near the town of Roumaki, Tortsylvania.

4. At said time and place the Defendant, John Carwrecker was driving his vehicle northbound on Route 52 near the town of Roumaki and did so in such a negligent, careless, and reckless manner as to cause a collision between his and the Plaintiff's vehicle.

5. As a result of the wrongful conduct of the Defendant, as aforesaid, the Plaintiff suffered personal injuries and damages consisting of past, present and future medical and related expenses; past, present and future lost wages and loss of earning capacity; past, present and future pain and suffering, mental anguish, and loss of ability to enjoy life.

WHEREFORE, the Plaintiff demands judgment in his favor and against the Defendant in such sum above the court's minimum jurisdictional requirements as will provide just compensation and otherwise make the Plaintiff whole.

The Plaintiff demands a trial by jury on all issues.

Joan S. Plaintifflawyer
10 Main Street
Capital City, Tortsylvania 12345

Appendix 10: Sample Summons

UNITED STATES DISTRICT COURT

District of _____

SUMMONS IN A CIVIL ACTION

Plaintiff

V.

Defendant

CASE NUMBER:

TO: (Name and address of Defendant)

YOU ARE HEREBY SUMMONED and required to serve on PLAINTIFF'S ATTORNEY (name and address) an answer to the complaint which is served on you with this summons, within days after service of this summons on you, exclusive of the day of service. If you fail to do so, judgment by default will be taken against you for the relief demanded in the complaint. Any answer that you serve on the parties to this action must be filed with the Clerk of this Court within a reasonable period of time after service.

_____ _____

CLERK DATE

(By) DEPUTY CLERK

RETURN OF SERVICE

Service of the Summons and complaint was made by me[1].

DATE

NAME OF SERVER (PRINT)

TITLE

Check one box below to indicate appropriate method of service

[] Served personally upon the defendant. Place where served:

[] Left copies thereof at the defendant's dwelling house or usual place of abode with a person of suitable age and discretion then residing therein

Name of person with whom the summons and complaint were left:

[] Returned unexecuted:

[] Other (specify):

STATEMENT OF SERVICE FEES
TRAVEL
SERVICES
TOTAL

DECLARATION OF SERVER

I declare under penalty of perjury under the laws of the United States of America that the foregoing information contained in the Return of Service and Statement of Service Fees is true and correct.

Executed on
Date
Signature of Server
Address of Server

FN 1. As to who may serve a summons, see Rule 4 of the Federal Rules of Civil Procedure.

Appendix 11: Sample Answer

IN THE CIRCUIT COURT OF KENT COUNTY, TORTSYLVANIA
JANE DOE
Plaintiff,

vs. Civil Action No: 04-X-XXX
 Judge: Doe

JOHN CARWRECKER,
Defendant.

ANSWER ON BEHALF OF DEFENDANT, JOHN CARWRECKER

Comes now, the defendant, John Carwrecker, by counsel, and for his answer to the Plaintiff's complaint states as follows:

ANSWER

With respect to the specific allegations contained in the complaint, the Defendant states as follows:

1. The Defendant is without sufficient information or knowledge to form a belief as to the truth of the allegations in paragraph 3 of the Plaintiff's complaint.

2. The Defendant denies the allegations in paragraph 4 and 5 of the Plaintiff's complaint.

3. The Defendant admits the allegations in paragraph 1 and 2 of the Plaintiff's complaint.

4. The Defendant denies any remaining allegations of the Plaintiff's complaint which were not specifically admitted herein.

AFFIRMATIVE DEFENSES

First Defense

The Plaintiff's complaint fails to state a claim upon which relief may be granted.

Second Defense

All or some of the Plaintiffs injuries were caused by the actions of the Plaintiff or others, not the Defendant.

Third Defense

The Defendant pleads the affirmative defenses of, assumption of risk, comparative negligence, and reserves the right to assert additional affirmative defenses as discovery progresses.

WHEREFORE, the Defendant, John Carwrecker, prays that this Court dismiss the Plaintiff's complaint with prejudice and that the Defendant be awarded judgment for his costs, expenses, and attorney fees expended in responding to this

civil action, and such other relief as the court may deem appropriate.

The defendant demands a trial by jury on all issues

Joseph A. Defenselawyer
5 Main Street
Capital City, Tortsylvania 12345

Appendix 12: Sample Letter of Protection

Dear Medical Provider:

I represent one of your patients, John Doe, with regard to injuries that he received in an automobile accident on March 30, 2005. It is my understanding that you have provided treatment to Mr. Doe for these injuries. I am currently pursuing a claim on behalf of Mr. Doe relating to the aforementioned accident.

Please let this letter serve as my agreement that if you would be willing to forego collection of Mr. Doe's account balances, then if and when a settlement or verdict is reached in Mr. Doe's case, I will satisfy your accident related invoices out of any funds received before releasing any funds to Mr. Doe.

My client and I thank you for any forbearance that you are willing to give in this matter. If you have any additional questions or concerns, please do not hesitate to contact me.

Very truly yours,

Lawyer

Appendix 13: Sample Interrogatories

IN THE CIRCUIT COURT OF KENT COUNTY, TORTSYLVANIA

JANE DOE
Plaintiff,

vs. Civil Action No: 04-X-XXX
 Judge: Doe

JOHN CARWRECKER,
Defendant.

PLAINTIFFS' FIRST SET OF INTERROGATORIES TO DEFENDANT

Pursuant to the provisions of Rules 33 and 34 of the Tortsylvania Rules of Civil Procedure, Plaintiff, by counsel, hereby requests that the Defendant answer and respond, in writing and under oath, to each of the following Interrogatories, and that his answers be served upon the undersigned within thirty (30) days after service of these interrogatories upon him.

INTERROGATORIES

INTERROGATORY NO. 1: Please list the name(s), address(es), and telephone number(s) of all persons assisting in the answering of these discovery requests.

ANSWER:

INTERROGATORY NO. 2: Please state your full name, date of birth, current address, place of birth, and whether you are currently a U.S. Citizen.

ANSWER:

INTERROGATORY NO. 3: Please state the full name of your wife, if applicable, and names, ages, and addresses of your children, if applicable.

ANSWER:

INTERROGATORY NO. 4: Please fully describe any medical ailments you suffered from on the date of the accident and whether you were under doctors care for any of those ailments.

ANSWER:

INTERROGATORY NO. 5: Please describe in detail everything you recall about the accident which forms the basis of this lawsuit.

ANSWER:

INTERROGATORY NO. 6: Please list all medications and alcoholic beverages that you consumed in the 24 hours preceding the accident, including the time of consumption and the amount consumed as well as, with regard to medications, the reason for consumption.

ANSWER:

INTERROGATORY NO. 7: Please identify (including name and address) all experts that you intend to call in the trial of this matter and for each expert provide the subject matter on which the expert will testify, the substance of the facts and

opinions on which they will testify, and a summary of the grounds for each opinion.

ANSWER:

INTERROGATORY NO. 8: Please list the name, address, and telephone number of all persons who may have information related to this case, and for each one please provide a summary of the information they are suspected to have and also indicate whether you intend to call the person as a witness at the trial of this action.

ANSWER:

INTERROGATORY NO. 9: Please describe in detail all exhibits that you intend to use in the trial of this matter.

ANSWER:

INTERROGATORY NO. 10: Please state the total limit amount, in U.S. Dollars, of all insurance coverage applicable to any liability that may be found on your part as a result of this accident.

ANSWER:

INTERROGATORY NO. 11: On the date of the accident, were you required to wear eyeglasses in order to operate a motor vehicle, and if so, were you wearing them at the time of the accident?

ANSWER:

INTERROGATORY NO. 12: If you have ever been a party to a lawsuit of any kind, please list the name of the court, the names of the parties, the civil action number, a summary of the allegations of the lawsuit, and the disposition of the lawsuit.

ANSWER:

INTERROGATORY NO. 13: If you have ever been convicted of any crime, please provide the date of the conviction, the crime that you were convicted of, the county and state where you were convicted, and a summary of the sentence you received.

ANSWER:

INTERROGATORY NO. 14: If any of your responses to any of the Plaintiffs' First Requests for Admissions is other than an unequivocal admission, please explain the reason why the Defendant's response is other than an unequivocal admission.

ANSWER:

INTERROGATORY NO. 15: Please list the names and addresses of any persons that you, your attorney, or your insurance company have taken statements from (other than you) with regard to the facts or circumstances of the accident which forms the basis of this lawsuit, as well as the date said statements were taken.

ANSWER:

Joan S. Plaintifflawyer
10 Main Street
Capital City, Tortsylvania 12345

Appendix 14: Sample Request for Production of Documents

IN THE CIRCUIT COURT OF KENT COUNTY, TORTSYLVANIA

JANE DOE
Plaintiff,

vs. Civil Action No: 04-X-XXX
 Judge: Doe
JOHN CARWRECKER,
Defendant.

DEFENDANT'S REQUESTS FOR PRODUCTION OF DOCUMENTS

Comes now the Defendant, by counsel, and requests that the Plaintiff provide copies of the following documents, or allow inspection of said documents at a convenient time and place.

1. Produce all of the Plaintiff's medical records from 1996 to the present.

2. Produce all medical invoices which the Plaintiff claims were incurred as a result of the accident which forms the basis of the Plaintiff's complaint.

3. Produce any other documents which you intend to offer at trial in support of any economic losses which were not otherwise produced in response to Request No. 2.

4. Produce copies of any reports produced by expert witnesses on your behalf in this matter.

5. Produce transcripts of any recorded statements that you have taken of any witness in this matter.

6. Produce a copy of your current driver's license.

7. Produce copies of any photographs and/or videotapes depicting the accident, the accident scene, and/or any injuries that you claim resulted from the accident.

Joseph A. Defenselawyer
5 Main Street
Capital City, Tortsylvania 12345

Appendix 15: Sample Request for Admission

IN THE CIRCUIT COURT OF KENT COUNTY, TORTSYLVANIA

JANE DOE
Plaintiff,
vs.

Civil Action No: 04-X-XXX
Judge: Doe

JOHN CARWRECKER,
Defendant.

DEFENDANT'S REQUESTS FOR ADMISSIONS

Comes now the Defendant, by and through counsel, and requests that the Plaintiff answer, in writing, the following requests for admissions:

1. Admit or deny that you do not have any permanent injuries that were caused by the accident which forms the basis of your complaint.

2. Admit or deny that you did not lose any wages as a result of the accident which forms the basis of your complaint.

3. Admit or deny that you will not lose any wages in the future as a result of the accident which forms the basis of your complaint.

4. Admit or deny that no physician has given an opinion to a reasonable degree of medical probability that your lower back pain was caused by the accident which forms the basis of your complaint.

5. Admit or deny that you were exceeding the posted speed limit at the time of the accident which forms the basis of your complaint.

Joseph A. Defenselawyer
5 Main Street
Capital City, Tortsylvania 12345

Appendix 16: Sample Settlement and Release

In consideration of the sum of $_____ cash in hand paid to the Plaintiff, John Smith, by Gigantic Insurance Co. Inc., said Plaintiff hereby releases Defendant Joe Jones, from any and all past, present and future claims, of any kind whatsoever, arising out of an accident which took place on March 30, 2005 near Jetson, New York. Plaintiff John Smith understands that this release is intended to compensate Mr. Smith for all injuries and damages suffered in said accident, whether presently known or become known in the future. Mr. Smith understands that if in the future it is discovered that his injuries were greater than previously believed, that he CANNOT reopen his claim. This release is a complete release of ALL claims arising out of said accident. Furthermore, Mr. Smith intends this release to be binding upon his agents, heirs, and assigns. It is further understood that the amount stated above is the total amount in consideration of this release and that each party shall bear its own respective attorney fees and costs.

John Smith, Plaintiff

Sample Settlement Disbursement Statement

Client: Jane Doe
Case: Doe v. Carwrecker

Total Settlement:	$90,000
Attorney fees (1/3)	($30,000)
Subtotal	$60,000
Costs	($1,500)
Subtotal	$58,500
Memorial Hospital	($3,000)
Orthopedic Doctor	($2,500)
Physical Therapist	($7,000)
MRI Center	($3,000)
Subtotal	$43,000
Total Disbursement to Client:	$43,000 Check No. 12991

Appendix 17: State Bar Contact Information

Not all of the State Bars and Bar Associations are affiliated with their respective state governments. However, in states without government affiliation, there is typically a private bar association which performs many of the same functions, such as a lawyer referral service. (Note: If any of the Web site addresses listed have changed since publication, contact the state Bar to find out the new address.)

Alabama
State Bar Phone Number: 334-269-1515
Referral Service Phone Number: 1-800-392-5660
Main Web site: www.alabar.org

Alaska
Bar Association Phone Number: 907-272-7469
Referral Service Phone Number: 907-272-0352
Main Web site: www.alaskabar.org

Arizona
State Bar Phone Number: 602-252-4804
Main Web site: www.azbar.org

Arkansas
Bar Association Phone Number: 501-375-4606
Referral Service Web site: www.arkansasfindalawyer.com
Main Web site: www.arkbar.com

California
State Bar Phone Number: 415-538-2000
Main Web site: www.calbar.org

Colorado
Bar Association Phone Number: 800-332-6736 or 303-860-1115
Referral Service Phone Number: Denver/Boulder: 303-831-8000
Main Web site: www.cobar.org

Connecticut
Bar Association Phone Number: 860-223-4400
Main Web site: www.ctbar.org

Delaware
Bar Association Phone Number: 302-658-5279
Referral Service Phone Number: 800-773-0606 or 302-478-8850
Main Web site: www.dsba.org

District of Columbia
State Bar Phone Number: 202-737-4700
Referral Service Phone Number: 202-296-7845
Main Web site: www.dcbar.org

Florida
State Bar Phone Number: 850-561-5600
Referral Service Phone Number: 1-800-342-8011 or 1-800-342-8060
Main Web site: www.flabar.org

Georgia
State Bar Phone Number: 800-334-6865
Main Web site: www.gabar.org

Idaho
State Bar Phone Number: 208-334-4500
Referral Service Phone Number: 208-334-4500
Referral Service Web site: www2.state.id.us/isb/pub_info/lrs.htm

Illinois
Bar Association Phone Number: 800-252-8908
Referral Service Phone Number: 217-525-5297
Lawyer Referral Service Web site: www.illinoislawyerfinder.com

Indiana
Bar Association Phone Number: 800-266-2581
Main Web site: www.inbar.org

Kansas
Bar Association Phone Number: 785-234-5696
Referral Service Phone Number: 1-800-928-3111
Main Web site: www.ksbar.org

Kentucky
Bar Association Phone Number: 502-564-3795
Main Web site: www.kybar.org

Louisiana
Bar Association Phone Number: 800-421-5722
Main Web site: www.lsba.org

Maine
Bar Association Phone Number: 207-622-7523
Referral Service Phone Number: 1-800-860-1460
Main Web site: www.mainebar.org

Maryland
Bar Association Phone Number: 800-492-1964 or 410-685-7878
Main Web site: www.msba.org

Massachusetts
Bar Association Phone Number: 617-338-0500
Referral Service Phone Number: 617-338-0610
Main Web site: www.massbar.org

Michigan
State Bar Phone Number: 517-346-6300 or 800-968-1442
Referral Service Phone Number: 1-800-968-0738
Main Web site: www.michbar.org

Minnesota
Bar Association Phone Number: 612-333-1183, or 800-882-6722
Referral Service Web site: www.mnfindalawyer.com
Main Web site: www.mnbar.org

Mississippi
State Bar Phone Number: 601-948-4471
Main Web site: www.msbar.org

Missouri
State Bar Phone Number: 573-635-4128
Referral Service Phone Number: 573-636-3635
Main Web site: www.mobar.org

Montana
State Bar Phone Number: 406-442-7660
Referral Service Phone Number: 406-449-6577
Main Web site: www.montanabar.org

Nebraska
Bar Association Phone Number: 402-475-7091 or 800-927-0117
Main Web site: www.nebar.com

New Hampshire
Bar Association Phone Number: 603-224-6942
Referral Service Phone Number: 603-229-0002
Main Web site: www.nhbar.org

New Jersey
Bar Association Phone Number: 732-249-5000
Main Web site: www.njsba.com

New Mexico
State Bar Phone Number: 505-797-6000
Referral Service Phone Number: 1-800-876-6227
Main Web site: www.nmbar.org

New York
Bar Association Phone Number: 518-463-3200
Referral Service Web site: Follow link from Main website
Main Web site: www.nysba.org

North Carolina
Bar Association Phone Number: 919-677-0561; 1-800-662-7407
Referral Service Phone Number: 800-662-7660
Main Web site: www.ncbar.com

North Dakota
Bar Association Phone Number: 701-255-1404
Referral Service Phone Number: 701-255-1406
Main Web site: www.sband.org

Ohio
Bar Association Phone Number: 800-282-6556; 614-487-2050
Main Web site: www.ohiobar.org

Oklahoma
Bar Association Phone Number: 405-416-7000
Main Web site: www.okbar.org

Pennsylvania
Bar Association Phone Number: 1-717-238-6715
Referral Service Phone Number: 800-692-7375 or 717-238-6807
Main Web site: www.pabar.org

Rhode Island
Bar Association Phone Number: 401-421-5740
Referral Service Phone Number: 401-421-7799
Main Web site: www.ribar.com

South Carolina
State Bar Phone Number: 803.799.6653
Referral Service Phone Number: 1-800-868-2284
Main Web site: www.scbar.org

Tennessee
Bar Association Phone Number: 615-383-7421
Main Web site: www.tba.org

Texas
State Bar Phone Number: 800-204-2222; Local: 512-463-1463
Main Web site: www.texasbar.com

Utah
State Bar Phone Number: 801-531-9077
Main Web site: www.utahbar.org

Virginia
State Bar Phone Number: 804-775-0500
Referral Service Phone Number: 804-775-0808; 800 552-7977
Main Web site: www.vsb.org

Vermont
Bar Association Phone Number: 802-223-2020
Referral Service Phone Number: 1-800-639-7036
Main Web site: www.vtbar.org

Washington
Bar Association Phone Number: 206-443-WSBA
Main Web site: www.wsba.org

West Virginia
State Bar Phone Number: 304-558-2456
Referral Service Phone Number: 304-558-2456
Main Web site: www.wvbar.org

Wisconsin
State Bar Phone Number: 608-257-3838
Referral Service Web site: www.legalexplorer.com/lawyer/lawyer-hire.asp
Main Web site: www.wisbar.org